IN
SEARCH
OF
GENIUS

IN
SEARCH
OF
GENIUS

BY WILLIAM FIFIELD

WILLIAM MORROW AND COMPANY, INC.
NEW YORK · 1982

Library of Congress Cataloging in Publication Data

Fifield, William, 1916–
 In search of genius.

 Includes index.
 1. Artists—Europe—Interviews. 2. Arts, Modern—
20th century—Europe. 3. Creation (Literary, artistic,
etc.) I. Title.
NX543.F5 1982 700′.92′2 82-8193
ISBN 0-688-03717-8

Printed in the United States of America

First Edition

1 2 3 4 5 6 7 8 9 10

BOOK DESIGN BY ALBERT SQUILLACE

For my sons,
John Lawrence and Brian Robert

FOREWORD

This is a book about shamans, the makers of dreams. They have a common sign by which they may be known: they do nothing that need be done at all, in the ordinary way of looking at things. Those who convey information, tell a story, amuse, tell a jest well, fulfill the obligations of art or beauty, in the way expected in the place and time, are artists, but these have a totemic function: in an age in which one can believe in nothing at all, they provide magic. Theirs is the shamanic power, and that they have it is the way they may be known. It is the response evoked which identifies them—as with the shaman. Another doing what might seem very much the same thing wouldn't have the power at all.

When the power transcends cultures, na-

tions, even, finally, time, it is known as Genius. And that is a good name for it. "Super artist" or "real" artist would miss the point. It is an incantation. The small, subtle accents of its rhythms are what make it work, and these are too personal to be separated from the wizard. "A genius is one whom other people consider a genius"—that is perhaps truer than was meant. A shaman is a wizard whose charms work. Describing his techniques will tell you much, but it is in that his charms work that he is a shaman. Another's wouldn't.

CONTENTS

1.

PICASSO,
DALÍ,
MIRÓ,
GRAVES,
AND
OTHERS

In 1935 Picasso wrote to Sabartés, "I am powerful and alone." It was the bellow of the wounded bull. He had just left his wife, Olga. The cry of the strong animal burst from him. At that time he made the painting of the Minotaur dragging off the cart carrying the dismantled effects of a broken household and a gored horse. Picasso's painting is always the direct account of his daily life—his pregnant sayings are not *humour noir*, though he is certainly ironical. Something in him has let him be direct, unobscure; or possibly it is only that the *toro*-force has obliged him to bring everything under his hand and make it hew straight, like true wood. That, then, would not be his genius but an attribute of it, for the genius of Picasso is all of Picasso: seven decades, some twenty-three thousand possible days, in the devotion of art. And women.

These men—Cocteau, Picasso—of that Montparnasse-revolution generation speak, to some extent, a private language, which must be deciphered. Cocteau, for instance, spoke of the *faux* ("false") classicism of Ingres often enough; you had to be with him a long time, and much exposed to this, before you saw it was praise, not derogation. It had already come about with some of those men that Delacroixism (romantic expressionism) could end only in chaos, and so they favored the classicism of Ingres, ovoid and smooth, but it had to be *false.* The good Ingres had to have made what Cocteau said he himself made—portraits of a novel, portraits of a *pièce de boulevard,* never novels, never a popular play. That way you got a formalism—machine against anarchy—and retained the old freshness of novelty, which touches the artistic gonads. Picasso with women—in their sequence, which you can plainly read in his pictures—is, as is Dalí, incestuous. But in the reverse of the case of Dalí, Picasso is mating with a series of daughters. And that might be the intensest love, the agonized protectiveness making the life stand up in its hard assertion. But the end is not pleasant, for the daughter will grow up.

In that 1935 Miró, too, was in crisis, not because he had broken with love but, apparently, because he had wed, and, apparently, because he had succeeded as painter. His painterly expression is as inverted as Picasso's is forthright, and he is indeed—kindly, mannerly, courteous, gentle, silent often enough—a most strange, a most complex, man. He rises every morning at eight and

rushes to his work in the studio Josep Lluís Sert
built him. (Josep Lluís is Catalan for José Luis, as
Joan is Catalan for Juan.) In the modern studio,
which seems to have nothing to do with Miró in
the symbols of his work, this or that canvas inter-
ests him. "I am somewhere between the endless re-
vision of Leonardo and the serial production of
Picasso," he said in 1968—and now attacks a
canvas, at random seemingly, "like a mad dog."
He functions by the recognition process of Pi-
casso—"I find first, seek afterward"—but, pru-
dent, Roman, not Andaluz, he is not content to
leave his strewings, and he is secretive in his mind.
He is a person of privacy, very hidden in the re-
cesses of his mind, as he is in the recesses of his
primitive labyrinths and cosmologies finally—the
primitive order of the mind, "eloquent" silence.

 The sexual life of the artist is absolutely
crucial; it is the *point tournant.* Is there any aspira-
tion so powerful as sex, at least on the part of the
man? Did not Anatole France write that love is
nothing but sex? She is the magnet; she is, also, the
self outward, distilled or aspired to, where it can
be seen, as can canvas or poem. It is not just any
woman the artist chooses, although accident may
play its role in the collisions. Probably Dalí has
that curious quiver in the base of the penis, the
potential erection, every time he gets a scolding, a
fulfillment of the longed-for, deserved scoldings
never received. Is he outrageous *only* because he
gains headlines?

 The public Dalí is fun, until the tragedy

emerges. He tells how he turned down García Lorca: "I thought he was a great man and I ought to offer him that round little *o*, but I didn't want to." This is "Dalí talk," of course. García Lorca was certainly not yet "a great man" when the two of them were at Cadaqués—Lorca was twenty-eight, Dalí twenty-two. But that doesn't mean the refusal of sphincter didn't occur. I rather think it probably did. Dalí says he has had congress only with Gala, his wife. As to the congress with Gala, you do not ask the inventor of a conjuring trick *anything* about it, not even so commonplace a question as whether or not her husband fucks her. Especially not when she is the muse (as politely put) of Surrealism: girl friend of Max Ernst, wife of Paul Eluard (her eyes could *look through steel*, Eluard said), wife of Dalí—three of the Big Four. (The fourth was Breton.)

They are childless. Gala is a decade older than Dalí, which means she is in her eighties.* The decade advantage means something else, too; combined with her sex, approximately female, something *very important.* I do not know if the self-declared impotence is partial or total, but that it exists is evident everywhere in his art (in his *Angelus* after Millet, for example). It is pitiful, really, because it is a double impotence, and the weakness of a very strong man. It is implicit in his attributing to impotence the quality of source of strength, the agent of power in Hitler, Leonardo, Napoleon.

* She died at eighty-eight in June 1982.

Beyond it is something undeniable, that his marriage is essentially incestuous. He was the son of a mother he adored and despised because she spoiled him. He married a woman older than himself and more powerful, a woman who would dominate him. Herewith his comportment when, at age twenty-four, he met her, the wife of Eluard: after dressing and redressing a dozen times, he shaved his legs with butter, to the quick because he liked the coloring of the blood; thrust a geranium behind his ear; added a fish tail and goat shit mixed in oil; but he lost his courage, washed himself, redressed conventionally, and ran to her, holding daisies and a geranium, and stood in front of her, speechless.

Miró married Pilar Juncosa in 1929; he was in his middle thirties then, making his commitment when prudently well on, as peasants do. And the choice was prudent. She was of a family to whom he was distantly related on his mother's side. Even today they have a fine emporium in Palma alongside a little stone medieval church, in a dark lane, and there they sell rugs. She coasts through life, full-sail-belled breasts, calm. She makes him seem smaller than she, though probably they are the same size. It may be something in her carriage—the assured matron, the forge-through of the Spanish woman who knows that all will separate before the majesty of her breast and fall together again behind.

It is easy enough to see the use to each other of Rossellini and Anna Magnani. When they

would quarrel in great outrage, and she would, as he told me, like in an early Chaplin sequence, "end it by dumping a plate of sp˜ghetti on my head"—that is exhilarating, that keeps you going, that is a *modus operandi*. And probably it is better than when one comes to you meekly because of your integrity (Ingrid Bergman)—"Integrity!" Rossellini exploded to me one Easter. "I fight always to try to lose it! I don't want this. I want to do like other people. But when I compromise it is like I touch a snake; it is *physical*"—and thus fixes on you a responsibility, quenches your freedom with that kind of geld knife native and unconscious to many women. In the labyrinths of Miró you would find such women, in their primal, cruel state.

In life Graves found one—and it thrust his gonads to the verge of what Cocteau called "the spiritual erection without which there is no art"; dissipated the boredom of Majorca which, say what one will, is its primary quality; and produced the White Goddess poems. For Graves, white is black, in the primitive way of looking—so white was bad. He claims now in these latter years to have found a Black Goddess—that is, a good woman; that is, a young woman good but capable of startling the poetical prick up, like the head of a young goat. But probably it is delusion, willed, or momentum from the first real vivid experience that got him going as a poet, the good abuse, the sudden coming into existence of things, out of sheer ennui.

Miró has an intense privacy, a stubborn in-

dividualism. When he sat in the councils of Surrealism in the twenties he said nothing, always concurred, and nobody guessed why. It *ought* to have been Josep Dalmau, his first dealer in Barcelona, one's own place, who launched him, not Paris. He is revenging himself on Paris to this day. "I am not a Surrealist and never was," he says now. It is probably true for Miró.

The Miró household, out Génova way, above the superway running out from Palma, behind the grotesque Apartamientos Impala, is seemly as can be. The Sert studio, modern architecture, white, louvered, and waffle-walled, cannot disturb the implacable tranquillity of this house, which has set its face against time, in the direction of silence. The twenty years in Paris never were. When their only child Dolores was born, two years after their marriage, Miró commenced painting child as *monster*. He lives a life of domestic placidity with Pilar, yet if you can solve their distortion those gross stalks are the stalks of the concupiscence of man seen as the stalk of a horse, and the vulva is depicted, haired, with revulsion, a few strands on the barren mound; the scrotum is there again and again, reticently put. He is modest and never intrudes anything, but his zest for the organs of generation, which do, more than any other thing, breach the walls of the solitary, results, despite him, in obscenity. "I am tragic," he told me. "Everything disgusts me. I find life absurd." And so he has written in his little book *I Am a Gardener.*

* * *

Braque would, at times, lie flat on his back on a cot he had in his studio, smoking a cigarette, his canvases ranged all around him, face to the wall. Suddenly he would jump up, run to a canvas, apparently selected at random, turn it around, and look at it. This was a process so similar to Leonardo's that it effaced time and brought the two men side by side across four centuries, superimposed into one image. Why did he do it? I asked.

"In order to see it. *See* it. I always start with an idea—an intention. I must paint until that idea entirely disappears. I surprise the canvas, see it suddenly, and then *see* it. When the intention of it is no longer there, the painting is finished."

And so Leonardo. He started *The Last Supper* on the refectory wall in Santa Maria delle Grazie in Milan for several reasons. One was that the old Byzantine Suppers—painted even in his time by Ghirlandaio, Andrea del Sarto in the Convent of the Annunziata in Florence—were, having been painted in the waning of an old Byzantine manner, worn out, insofar as startling anyone into *looking* was concerned. Ghirlandaio had confessed this unknowingly by painting in wonderfully plumaged birds—which took the eye. In consequence, Christ, in the crucial moment of his messiahship when he passed on the gravity of his mission to his disciples, and Judas, full of the tangled remorse, self-justification, and finally overmastering greed characteristic of him (or of any man full of a crime of which he does not approve), fell into second

place—for the eye—which would be like magnif-
icently painting in the trees overhanging the scene
of an auto accident that has just occurred. No,
plainly that wouldn't do.

Leonardo saw that the Supper could not
be painted in the flat, like a Byzantine frieze. That
was all right so long as people believed in it, be-
cause then they did not *see* it; but now people
knew—Ghirlandaio and del Sarto must have—
that folk do not sit at table in a long flat row,
Judas alone, with a subtlety not piercing, not
likely to cause the spiritual erection Cocteau
would cite, placed on the other side. And, asked
Leonardo of himself, who apart from Judas—and
everybody since the Betrayal, including the paint-
ers—knew at that time Judas belonged on the
other side? Did Judas arrange the seating order?
No, something had passed out of existence for art,
because it had become evident.

To this Leonardo brought something en-
tirely inappropriate. He knew he had to group the
disciples in clumps of terror, to get them out of
that infernal *sitting,* when Christ has said he is to
be betrayed by one present. He hit on the idea of
gathering them in trapezoids—three, three, and
three. Most unlucky. He loved mathematics better
than painting. His idol was Luca Pacioli, of Borgo
San Sepolcro, the great mathematician; apart
from a sort of begrudging homosexual admiration
of Botticelli, Leonardo admired no painter. He
preferred algebra, which, and because it is an ab-
straction, wholly detached from reality, and with-

out meaning except in itself, does not change. And a Universal Genius hates change, because it is *he* who changes.

Certain geniuses—Tolstoy, Picasso, Leonardo, Shakespeare—have what is called universality, but it is had at a price, because in order to have it you have to have nonexistence; in order to be everyone, you have to be no one. This extreme motility is rare, rarer than that rarity "genius" itself—a lumping-together term upon the application of which to specific cases no two people would everywhere agree—and it is, too, a very special form of permeability. Cocteau was permeable—extremely permeable—but he didn't have it. He was always Cocteau, though frequently "inhabited." Picasso, however, as you watch him paint, seems to make sudden jumps; he follows the hand, does not guide it, and you cannot escape the feeling that the image is working itself upward through the brush.

Leonardo had, of course, individuality as a man; yet there was an inhumanity about him that induced in him a silvery sadness. And nonparticipation in humanity is the principal quality of the man said to be the most universal who ever lived. He put the disciples, for all these reasons, into piles of geometrical trapezoids. It is said he used to run across Milan from "the horse," which he was making over in the Castello Sforza for Ludovico il Moro, simply to stand and *look* at those trapezoids. He eventually got rid of them, for everybody but him (though if you have been told they were once there, you will never again be able to cease seeing

them; otherwise, it would never occur to you to suspect their existence).

COCTEAU: THE "SECRET ARCHIVE"

His adopted son Dermit said, "He has chosen you to make his testament," the unspoken tears not speaking, for implied was that he was going to die. We all knew it—Dermit, Cocteau. *Me?* Well, I couldn't explain it except that I have good ears. All unconsciously, I had shown Cocteau that. He is *quick* (that was a greater—was the greater—part of his trouble). Others would have seemed more qualified, and yet perhaps I surpassed them in ears. He said to me: "You wonder why I show you such great friendship *at once?* But that is how friendship forms. You know all you need to know about a person *at once.* (Very occasionally you are fooled.) And then you spend the years forgetting what you know of him little by little."

I have my "secret archive." For the considerable amount I have written about him, I have never opened it once. I have never opened it since his death in October 1963. I have done this because I want to preserve for myself the original shock of freshness I experienced when the notes were made. Much of Cocteau astonished me, but I have become accustomed to his way of looking— as I did to Picasso's. Picasso's "jokes" are not jokes; Cocteau, in the years I knew him, had entirely abandoned his "frivolity," though he was, in public, a little bit stuck with his public character, even then, when amid *le tout-Paris.*

For this book I will open the "secret file." You see Cocteau groping for the truth of life. Even in the overt stuff he gave me, knowing it would be published or transcribed (we did make a record album of *Conversations with Cocteau*), you can see he was doing something like that. But, in the late Cap Ferrat night, he would sometimes go behind the mask that was almost ceasing to be a mask and show me the naked heart. He won, briefly, in those moments, his everlasting battle against the head. In my opinion—I have nothing to recommend me in this except very close observation, "behind the curtain"—Cocteau will be remembered finally as a philosopher—"essayist," they say of him at this stage.

The good artist evokes, touches the marimba bars of memory no doubt; the genius cares nothing about pleasing you, or even himself, some irresistible force driving him toward the new. "Never repeat yourself," Picasso told me. "Never try to"—an imperishable dynamic; sad, because it is based on nonbelief in the final reality of anything.

Some of these men strove desperately to understand themselves in my presence—Cocteau, Marceau; others tried on their fairly black humor; but I have penetrating eyes, and at last they gave it up, all save two. No, one and a half. The half was Graves: he has a lot to hide. He told me unexpectedly, at Deyá, most of it (all great artists are exceedingly lonely); and then he "threw me out": that is, politely declined to see me again. I did

bring him and Miró together, the two greatest
men in Majorca, who had never met over forty
years; maybe that's why Graves tolerated my im-
pertinence so long.

And the other was Giono. If you think Dalí
is ironic!

Giono, however, told me a great deal, and
all of it true, so far as it went. It is easy to flush a
Dalí—if you can get his ear in the frantic hubba-
hubba, at rock decibel. But a man who suavely,
coolly, tells you what is undoubtedly simple truth,
at its surface level, as a kind of diabolical sport of
deceiving you, is *difficult.* I shall do what I can to
bring forward these things, though we shall at mo-
ments seem to be seeing "the public Dalí" or "the
public Graves." And then we shall plunge down.
For, taken together, the Upper world and the
Under world comprise the whole world.

A publisher recently asked me: "Why do
you trouble to set down the thoughts of these men
who have so often set down their thoughts them-
selves? Who are *you*?" Nobody. I was thus able to
be the Socratic gadfly, the stealthy Indian who
somehow turned up *inside* the stockade—and then
had to be dealt with.

If you have read the *entire* works of Dalí, as
I have, you will not need to visit Dalí to see what
he is. How many have? You will see how the
"camembert" Dalí was manufactured, even why.
If you are terribly astute you can see these men
(the graphic ones) even in their total art. But total.
Of all these geniuses who have written, only one,

Miró, has told the simple truth—in a tiny book, *I Am a Gardener,* that is hardly known. And even it is only the truth "about painting" and says nothing—he is too modest and polite for that—about the real Dostoyevskian *anguish* imprisoned within the seemly man.

Even Dalí's *Fifty Magic Secrets of Painting* is true, for *painting* is what he cares about and always has. Genius is a *human* function. So it is as global as human life; yet it is partial because it is the human outlook—and in its greatest manifestations, which have rung the bell of the human heart in all languages and all cultures down the ages, is the outlook of *a* human, his variant of what must somehow be the reality of things, though we will never ascertain it. It is not the breadth of perception of reality that sounds the clarion within us, but its humanity—the more a man is himself, the more he is us all. For the less he accommodates, the more he is human.

Picasso puts his faith in the hand, let it do what it will! He said to me: "What right have critics to judge what I make? I do not permit that to myself." And he said to me—of each scrap taken from the studio floor and put into the canon, rejects of the day—"I must have had some reason for doing that. There must have been some reason I did it." For a moment he looked at me, his lips caught in and held by his teeth. Had I, perhaps, an explanation for these strange things? So he makes a serial motion-picture film of the creative totality that cannot be seen except overall, as Leonardo held variation in the vise of one canvas, so

that you can see the recession of shapes giving into shapes, even into shapes that are not there.

Miró cultivates solitude. Kindly; but, if it is really threatened, with ferocity—a savagery that he should have had of his wife a child—a consequence of the loathing of the organs of generation which produced this intrusion, his, and that of his wife with whom he has lived in tranquillity for fifty years. Not his is the art of Picasso, which is like a rain of arrows from an entire battalion. "I almost never do a picture at one blurt like Picasso," he told me. For Miró, the unendurable tension of Leonardo, which is the suspension of opposed walls of incompatibles, has transferred inside. He does not fight his battle on the canvas. He ripens his revisions inside, in the unconscious, where he is thwarted, and then—"like a mad dog"—sets down a brushstroke or two. Attack, of that sort, is hesitation.

I believe genius is a stance, a "shape." So does Picasso. I should not have undertaken the writing of this book if the latter were not so. I would not launch on these many pages, or ask you to, freighted merely by what I think genius is. But I know what Picasso thinks it is, Dalí thinks it is, Miró thinks it is; what it *is* in Ortega; what Graves thinks and has written it is; what Giono scornfully denied of it (owing to his formation) and so never wrote a word about it but possessed it; what Cocteau thought and a hundred times said in nearly as many contradictory ways it *might* be; what Marceau kinetically knows it is—all this because I

troubled to find out. I went as an emissary. I do not pretend Dr. Livingstone exists, but I found him. And he said, "Mr. Innocence, I believe?"

I hope so. What other armament has one, since Socrates walked the agora?

Creation is translated into conveyable form *in the minute of doing*—so Picasso believes. So too does Miró. Marceau feels this physically. He told me that when he creates a routine, he mimes in front of a mirror, a certain intention in his head; but his body is cleverer than his mind, and what it spontaneously adds becomes the real context.

Miró has written it plainly: "The painter and the painter contemplating his painting are not the same man." Picasso said to me, in that shrugging, offhand, end-of-discussion way he has, "You cannot separate the violinist from his violin." So you will not find creation in stasis, in any one thing.

Genius seems to be a shape, a posture, an attitude of vision. If we think about it we will see that this is not strange. It is simply a human being taking a human position in a very intense, or a very concentrated, or a very refreshed, way. We respond to it because we are human beings. The genius thinks it is "right"—whatever the concessions and conventions of his day may be—because he is a human being.

This is, of course, genius in art. Art has for referent only human attitude. It has no outward extra-human referent. It always begins by someone being very human about something; it is de-

graded into decadence by modification, the art form having become the object at the cost of the *object*—which could have been a woman's back, a story to tell that would invoke an original experience of awe, or fear, or wonder—and then the decadent art is refreshed (overthrown) by an individual who is simply too human to put up with the copying, rewarded or not. The cycle starts again.

There is the push back to origins. The farm at Montroig in Catalonia, where Miró has his roots in the red soil as surely as the carob tree he admires is deep-rooted down, looks out on lifting plateaus of carob and olive to the final rise of the mountains. There Miró one day said, "Genius is childhood willfully regained"—regained by the act of will. And he said art was ascendant in the caverns of the Stone Age and has been falling ever since. To regain childhood by the act of will would seem to be the effort to escape all that has occurred since, to bridge a wound that simply will not heal. The Stone Age, however, had a strong art corrective. You will notice there are no backgrounds in cavern art; except for a sorcerer or two, no men. Art in that day was neither decorative nor narrative, but was rather the seizing of the prey in the concentrated sight of magic, as a hunter fixes his buff in the gunsight and certainly does not look at the thorn trees. The modern artist is always striving to get out of the conjunctival position, pan closer in—the "and" "and" "and," the "but" "but" "but," imply distance and withdrawal, falsify what we know to be the world, fabricate emotion when not cold. We cannot spread out our

fingers like a strong hand in the soil, as Miró would have it when he prefers the carob tree to the flower "because it is more firmly rooted."

Miró says: "I find more truth in stones than in people." And it is because stones do not talk to each other, influence each other, have the good sense to stay apart. When you "pan up close" to Miró, you will pass inside to the Zurbarán sobriety (a quality he cites in his favorite painter), having left the comic Miró behind long since. You'll find him chaste—and he is too chaste to overlook what we (for the present) know the world is, though it goes against his elemental feelings. Leonardo had said it by 1505, but we couldn't hear. Now the "genius" knows he has nothing but juxtaposition to make his truth stand up, like a house of cards.

Of course the old definitions of genius are not without merit—genius is sweat, genius is grease in the elbow, genius is perfectionism or refusal to do less than the best, genius is intelligence. But they are peripheral. A genius nearly (but not quite) always must sweat; but sweating will not produce works of genius—it must be a genius who sweats. Genius is perfection achieved ultimately; but to achieve perfection ultimately, or even immediately in which case it will be a lesser perfection unless you are within the very first circle of genius, requires genius. We must take exception to the last of these definitions. Acquaintance with genius will sustain in no man the belief that intelligence has much to do with it—certainly not in art.

One has a creepy feeling that it is rather harmful—or that, in the highest geniuses, they have had it and have had to overcome it. In *The Act of Creation* Arthur Koestler seems to suggest that this is true even of genius in science. It would be an *odd* twist, for surely science is not human but the opposite.

Cocteau told me, with his typical wit, that a genius is one who tries to do what the others do and cannot, and Picasso told me that genius is individuality. He had elaborated on this earlier to Sabartés during the war when he said, "Genius is individuality plus two sous of talent." Many say Braque is a greater genius than Picasso in terms of quality, and if history bears this out, it will, in this, accord tribute to Braque's having met greater *resistance.* Picasso is not a man of resistances, as we shall see; but it would be mad to deny his individuality, and history as long as time lasts (human time in art) will not deny it. Lurçat told me, slamming his fist on the table at Aix-en-Provence, that Picasso will undoubtedly be thought of a thousand years hence as he is now—the greatest genius in art of our age and one of the greatest of all ages—and we have the precedent that both Leonardo and Michelangelo had in their lifetimes the reputation they have now. Will Braque prove a Piero della Francesca? He could; or he could not.

Originality would quite obviously have to be *you* (or accident). Where else could the heretofore inexistent come from? At first this seems to be

an unchallengeable proposition. Ultimately, it must be, probably. "Creation is autobiography, inevitably, unconsciously or consciously, even when you try to prevent it," Cocteau said. But there is contrivance, the genius copying himself (*every* genius will do this at least some of the time). Calculation: even Picasso calculates—did—then he ceased. If "late phase" is always so great, and tardily understood—as it was for Titian, Beethoven, Mozart, Rembrandt, Michelangelo, Goya—it might be because of this; Graves confirmed this, using his own case. Both Henry Moore and Miró try to escape this by putting their referent in the inanimate—pebbles picked up on the beach, crags happened upon. Helpful, but useless. It liberates preference from ulteriority, but it remains preference. *This* rock is the most "human-resounding," not *that* one, in Moore's or Miró's opinion.

The case of Dalí is therefore particularly challenging because, when we consider the genius, we implicitly attach sincerity to choice. If Miró did not *sincerely* prefer that to the other pebble, would he in that instant not be Miró? No.

Dalí fixes you as perhaps no one else (I speak of the man) by the recession of images. He is the one self-avowed genius of the men who may perhaps be considered to have genius, and it is consequently a natural tendency to deny Dalí genius. Dalí knows this; he will tell you he *therefore* asserts it. "My sole business in life is to make people talk about Dalí. It is a matter of indifference what they say." If it were only so simple!

He said, further, "I started calling myself a genius and by virtue of that I became one." He didn't, naturally, in the outward sense that he appears to mean it. But at the interior of the problem of Dalí is a quixotry of recessions that maddens the researcher, if he does Dalí the honor (it is *not* what Dalí wants—and yet it is) of taking him seriously. Obviously the outward Dalí is a piece of cheese. And yet—

I happened once to be all alone with Dalí for twenty minutes. The presence in which I found myself greatly surprised me. He wasn't *at all* the Dalí I had seen both at Port Lligat and in Paris, and in all his books. And yet perhaps all the rest is his hysteria that he *is* this Dalí; and so the false Dalí, by the hysterical necessity of it to him, declares the real Dalí.

The study of genius through living geniuses cannot be other than a quest. I began it because years spent in study of Leonardo and Michelangelo for another book had ended finally in more questions than answers. It was surprising that the very many who had written about them had never really given them a thought, and that, going beyond their artworks, it was only by looking in Michelangelo's poems and Leonardo's notebooks that you could find answers, or *real* questions of their creativity, that had any resonance. And yet there remained many questions unanswered—and neither Michelangelo nor Leonardo available to be asked them. I went, then, first to Picasso, and that was the beginning.

"What, then, are you *doing* here?" he finally asked me, sensing that I was up to something.

"I am trying to catch genius on the wing."

He exploded, naturally. "That is the only way *to* catch it!" he evaded (making a very sound point, however). Then he added, "Well, you shouldn't have come here." He was a bit rueful.

What I replied, I think, arrested him; was, fundamentally, the point of departure, the beginning. I did not say, "Oh, master, how should I seek genius but by coming here?" Nor did I say what would have been much more fashionable: "No, of course not. Ha! Ha! Ha! Ha!" I have seen any number of people subsequently—well, everybody who goes there—take approximately that attitude, as if Picasso were *just anybody*. I find this absurd. It is true he encourages this. What I did say was: "Maybe you are not a genius; one cannot know. But if *you* wanted to see a living genius, *today*, where would you go?" He looked at me a minute, frowning perplexedly at this new idea. "*Bien*," he said. "That is true."

Cocteau is perhaps the most revealing on genius. Or perhaps Dalí is. Or perhaps Picasso. Or perhaps Giono. Cocteau, because he himself was in search of the principles of creation his entire life, was the interpreter, in some ways very nearly the inventor, of his extraordinary circle of friends—Nijinsky, Modigliani, Apollinaire, Picasso, Stravinsky—himself very verbal and extremely permeable. So, in a way, Cocteau was a

host of all those people who could be seen almost better in him than in themselves, and himself did not exist. And *they* were, some of them, to some extent, what he told them they were. He codified them for themselves. Picasso is "Virgil" to the *Comédie Humaine* of genius because he least disputably possesses creative genius; Dalí because more than any other he reveals himself—but I do not speak of the Dalí he intends to reveal; Giono because the writing Giono was in later life all the Giono there was, so the exhibit was very pure; none of the circus of Picasso, Dalí, Cocteau, Graves; and the nearest correspondent would be Miró—or, in a special way, Marceau.

In the past, a horse lover liked to have a fine representational rendering of the best thoroughbred of his stable, and even today an accurate full face of a beautiful nude, with the flesh texture of Ingres or Correggio, will probably get a viewing, but it is doubtful that figuration goes much beyond this now. Art today is the distortion of the hand. Subject—and, in consequence, skill of accurate rendering—is disappearing. And this has a particular, problematic, and, finally, enigmatic bearing on the problem of Dalí.

It bears too on Robert Graves and is one of the reasons why only very late in life, in the reverse of the usual, he has reached lyrical florescence. He said to me, "There is not a modern poet who knows anything about versification." He meant there was not any but one. His neglect (he spoke to me of it bitterly in 1952), now tardily though very

fully rectified, springs from the fact that he commenced in conformity. "I was born in the Victorian Age," he told me, "and that is a hard thing to live down. It takes years of maturity to learn *totally* to ignore critics." But he *does* write, finally, in his Black and White Goddess series, remarkable poetry, and he makes Auden, for instance, by comparison seem geometrically sterile. In Graves, these injustices of judgment induce only a testy savagery, broken by boyish blue-eyed glints very peculiar for his over seventy years, whereas Dalí, who can render as could Velázquez and Vermeer (and only Picasso among the contemporary), is maddened.

I knew one of Graves's White Goddesses fairly well, and Graves (on the condition that I wouldn't name names) told me what he *really* thought of her. If he disliked her *so,* with a negative love, why did she unclench the love poetry probably loveliest of our time?

Koestler finds, in the elaborate superstructure of his book, *The Act of Creation,* that genius is *originality.* That is, it is not the how of doing but the why. He points out the curious complexity lying within art forgery; and with this we shall have further to do, for one of those I have watched most closely on this of "creation" was my friend and neighbor, a distinguished and now latterly celebrated forger of Matisse, Picasso, Braque, and others. Supposing that a forger of Matisse would have to know more about Matisse, for instance, than would Matisse, the question is relevant. It is,

if you really venture into it, a cave full of mocking laughter, an elbow nudge into your serenity if you think you know what you think. Why *should,* asks Koestler, a van Meegeren Vermeer be demoted simply because circumstance has forced van Meegeren to confess its real origin: his own hand? It convinced all art experts until then; in what sense, then, was it not a Vermeer? If it ever was, why isn't it now? Are we judging canvas, or reputation of canvas? Our logic tells us that if a van Gogh is falsely signed van Gogh, it is not a van Gogh—but this is simply not true unless the falsity be discovered. *Right You Are If You Think You Are* a Pirandello play is titled in English, correctly translated out of Italian it would have been *A Thing Is, If It Appears to Be.* I have thought, if an art forger can produce (remember he is not copying pictures; he is producing new "works" of the specific painter) to the conviction of every expert, and so, presumably, every layman, Picasso *and* Modigliani *and* Vermeer, is it not difficult to resist the feeling that, as *painter,* he is superior to Picasso, or Modigliani, and so on, because he can do what each can and also what both can?

What is left the Genius? Take care. You are about to say "originality." But you will find the blue mountains of Leonardo's *Mona Lisa* in Verrocchio, his teacher; you will find the babes of Botticelli in Filippo Lippi. Doubtless the long giraffe neck of Modigliani has something to do with Modigliani *and* Gainsborough, *and* Parmigianino, Michelangelo, Donatello. I do not say Modigliani got it from this succession; I do not know. But nei-

ther would he, unless he got it intentionally. In this case, if he remembered, and chose to, he would know. [But the absorption rate of certain few humans is incomprehensible. Thus at their true centers where they really *are,* not at the outside where they loosely, approximatingly talk or think, the absorption rate is unbelievable—compared to all other humans.] Anyhow, Michelangelo definitely got the neck from Donatello, and Parmigianino got it from him. That I know. I don't know about Modigliani.

The most famous easel painting of the century is Picasso's *Les Demoiselles d'Avignon.* Now, where did the girls come from? Picasso set out to paint some whores and sailors in the whorehouse on the Calle Aviñó (as it is written in Catalan), located not far from the studio he occupied as a boy painter in Barcelona. Many commentators still write that they are the *mademoiselles* of Avignon in France, where Picasso did indeed sojourn with a mistress, Marcelle Humbert, five years *after* he had painted the picture. By this title and selection of site he promoted a confusion and very likely revealed something about the habits of his own youth, which indeed is corroborated by many sources. But where did the girls come from? The timid or polished or sensible artist revises from himself outward into the world, as Cocteau says he kills the *vif* (translation: the quick)—you very naturally blunt your spear so that you can march among ranks without sticking anybody. But Picasso does just the opposite. He suppressed the

sailors by progressive repainting; rather, he left one or two of them as whores, which is one of the reasons you get some pretty masculine whores. Now, David Douglas Duncan unearthed, some years ago, at Vauvenargues, the preliminary sketches for *Demoiselles*, and they are heads of Picasso. I myself sat with Picasso at Mougins, and there was behind him on the wall a portrait I had not seen there (he was always changing his pictures about). It was a self-portrait, in 1907 when he did *Demoiselles*. I had seen it before, in some sense. Ah—it was, in essence, the *Portrait of Gertrude Stein* (1906), now in the Metropolitan Museum of Art in New York (Gertrude Stein bequest). Picasso was bearing out Leonardo's dictum in his "Theory of Painting" that if the painter really paints he must paint himself, his hand participating in the body—part of the structure of which is his head, too. It is *original* to paint your own head and say it is Gertrude Stein's or that of a whore in "Avignon."

It is original for a reason which is really very simple, and which touches on the question of art forgery too. The genius of an artist is in his *inflection*. It is a slippery eel, his voice. He cannot himself hear it, really. Repeatedly he tries to; slowly, if he has great courage, he succeeds. My friend the art forger told me of a trouble he had in doing Matisse. Naturally, he could see Matisse better than Matisse could . . . and one day, brought up short, he realized he was no longer correctly forging Matisse. There was no *hesitation*

in his stroke: he had surpassed Matisse, and, in order not to spoil his work, he had to backtrack. This, by analogy, is why so many creators burn out—but certain others don't. (Are they the greatest?) Picasso said, "Whether your work is good or not ["Whatever that means," unspoken interlinea—Picasso] has nothing to do with it; the public will like it *when they get used to it.*" *He* jumped everlastingly on the grid so that he wouldn't get used to it. He said contemptuously: "What good are computers? They can only give you answers." I think it the most significant single thing I ever heard him say. Answer is the dead stop. Probably creation shall prove a manifold instantaneous adjustment to thousandfold things; the "conclusion" but a stop, and all real artworks unfinished.

2.

PICASSO

Memory would have to keep out of it, unless it be primordial. Cocteau is very interesting on that, and in another way, Graves. Cocteau's idea, reached just before his death, is truly mysterious; it would, if you believed it, invert your whole conception of reality. He did believe it, I think; its *pre-curse* (this is no idle pun) is pricked out all through his later work, when, no longer "the balancer on a high wire in a wind" as he sadly, ironically, said of his earlier self, he has become tragic—a honey-sweet *tristesse* that he was too obliging, kind, and anxious to please (in the best sense, to please for *you,* not him) to admit to existence, except sometimes.

But memory, as it is usually understood, is, of course, just the imprint on one of what one has observed, and it will be readily seen that that, if

creation is to keep the creation in it, memory must be held off. The creator is on the Freudian couch in a certain sense; only the agility of his hand lets him, unlike us, dream aloud. He looks on, reverted to spectator—that is, "ordinary man"—at the monsters of dream. And he is appalled. He is, in his early life, thrilled, because he has, half asleep, produced what he has learned. He is struck by this deft beauty, of the "going thing." Later, it is quite terrible. I walked the Via Carducci in Trieste in the rage of the *borra*—a wind of the Adriatic—with James Joyce's younger brother, and he told me of the *horror* with which James regarded the emergence of the first pages of *Ulysses*. To what did *that* correspond? How was he to know that *that* was good, and not grotesque and absolutely awful—which was what it seemed? Where was the *authentification*? And—he had a wife and children—Berlitz teaching was not so royal a road that it permitted divagations like this!

Graves, of creation, says it is immersion. You go down again and again into the spell. It is the manuscript *itself* that contains the spell, like a conjuror's ring. Is this the "picking up the thread," the march of coherent progression—*truum, truum, truum!*—the words like resurrected soldiers all doing their fit work in the ordered line? Graves says not. He says it is an *incantation*—the book itself possesses the spell, and you reenter in. His is a room full of incantations, fetishes, that within which he writes—above Deyá, looking out over the Mediterranean from the blue-peaked side of

Majorca. All the books of T. E. Lawrence, a cola nut that he gives his enamorata (fifty years younger than he)—because it "quenches thirst and helps you cross the desert." Everything in the small room on the back corner of the house is handmade, since "you cannot create in a room that has got anything machine-made in it; machine production is the opposite of the human, of human fashioning, which retains the shape of the hand." And there he sits, a shawl over his shoulders, in front of his "pulpit," a little stand that lets him read manuscript placed upright because years ago he broke his neck on Welsh Snowdon and can't lower his head, a small emberish fire of olive wood going, surrounded by the factors of his inductive magic.

Each has his different explanation—and what you see emerging gradually are not rationales so much as profiles. Faint, dim faces, the outline defined as much by where it is not as by where it is, as though descried by Leonardo, the first to know that objects have no edges, as they had always had in art, because they are not where they are but in the optic—and the edges have been given them by the mind, in defiance of the eye, after the moment of looking, and then transferred back to visual perception. And may they not be grouped, these pale, haunted faces? Or must they forever remain apart, and changing? Is there—if you restore the primitive *look* to the eye, which is what all twentieth-century art is trying to do, the falsity of the Age of Reason being too palpable, the Enlightenment quite evidently a darkness,

where reality is concerned—a Dark Ages of man when he obscured the clarity with his "knowing" and got only faint, luminous, humid stars, a parchment moon, scissored, "understood." The real, clear, instantaneous *looking* having been restored, is there no reality, no mending? Has everything come unstitched?

When you go up to the house of Pablo Picasso, you come along the autoroute from Fréjus in southern France. Old Roman Fréjus no longer exists, except for the conch circle, an arena melting together like a ring of molasses sugar, just where the plain was razored by the flood, unleashed when the dam broke above Fréjus and everything was carried in a tumbled, terrible instant into the sea. You plunge into the brown hills, on a concrete highway, like, as Miró would see it, a worm between a woman's breasts, and when you come out you are at the pay station for Cannes. The freeway swings down to the right now, and almost at once into Cannes. To the left, around a large hill— which sits in front of the hill crowned by Mougins like a terra-cotta hill-village (more frequent in Italy than in France), the hill itself topped by the chapel of Notre-Dame de Vie standing haired in wild grass—skirts a smaller road, which eventually will go up and end in Mougins and bric-a-brac, pastiche art. Look up for a moment: you see the villa of Pablo Picasso. Then the hill is closer and the perspective cut off.

Picasso did not live as he once did—not

even five years ago. As the artworks are enduring, the man who made them is changing—from minute to minute, Picasso would say, who dated his pictures, not to record their moment, but because "it is part of the design." But artists are very unreliable informants on their art, there being concealment, intentional distortion for manifold reasons, the interaction of the artwork and man, and all said about the former by many, including Picasso, when his art has remained unchanged for fifty years and he not. Picasso had his regular patter, as you did the "regular tour," obsessively fixed in routine and never varied, visit after visit. It is said he did this to "conserve his energy for creation"— pretty thought—which might even be true.

And then, too, all artists live in the imagination, seeing the world as conceived, but their power has a sulfur glow, a brimstone of gaiety that carries the perception even farther from what things objectively "are," which is why they charm us. Cocteau submitted to the thousandfold influences of his life; Graves *submits* to the manuscript—but each is a feminine man, the one more overtly than the other. Protean, Picasso simply changes places; what is happening within is nil. He never submits, but, vaulting out, seizing, he converts everything that he becomes into Picasso. Though his hand was slackening, he did not inspire sadness—a mellow regret, yes; you were witnessing the end of an immortality. But Cocteau, before he died, made you unbearably sad. How to explain this? How to put these things into words,

which they were not? Cocteau, many though he was, was always Cocteau and, extinguished, would cease to be.

MOUGINS: EASTER, 1970

The weather had been beautiful for the Saturday bullfight in Arles. It was beautiful for the day following, Easter, on the Riviera. When we left Cavalaire it was still beautiful, frost-clear and very cold, but when we had passed Saint-Tropez it began to rain. Cannes was dark under blue-black cloud, sparked with dashes of rain, and when we had come to Notre-Dame de Vie eight kilometers behind, the rain had ceased but the horizon over the Mediterranean Alps was black, and while we waited under the drooping trees by the moat that surrounded Picasso's house it was exceedingly cold. The moat was in flood from the rains and algae were streaming in it.

A concatenation in space and time, a focal center point, the weight of the sky on the naked brain, not a philosophy: something like this must be the inward reality when the quill is about to erect or the brush sperm its color. "I cannot see myself but I can see my essence by the tracks over the snow"—like those of the Abominable Snowman. The ascending wavers of the carob-treed ridges, going up to the final mountains, at Montroig in Catalonia, tell you the fundamental thing you need to know about Miró, combined with what happened after: the faithlessness, the cracking up of the meticulous depiction of the Catalan

farm-earth as it really is under the mallet of "modern art," and then its reconstruction, the pseudo-"farm" infected with self and "Miró," that you see in his celebrated painting *The Farm*. All this accounts readily (with all the bottomless, unending complexity implicit) for the isolation in the prison-house of Son Abrines, his house from which Miró never goes, except, secretly, sometimes to a movie in Palma. Here at Picasso's is another moat-locked man, in the dank exuberance, the Thor who smote—oblivious.

We got out into the cold, and René Dürrbach, the scroll of the tapestry he had made after Picasso's *Les Trois Danseurs* under his arm like a great medieval parchment, rang and then spoke the magic words into the diaphragm behind the grille. We are expected. The enormous iron gate slowly swung in. There was a quickening, naturally, in the drear landscape, worthy of Poe. The barrier having been passed, a slow, wide curve rounds softly up, under giant fir trees. Below, intentionally, there had been nothing but an unsignifying burned grass slope, parched out because it is never tended, so that those going along toward Mougins beyond would never guess that this was the approach to someone—to Picasso.

He had left La Californie because it had become known; he had painted behind double doors there—both locked, Jacqueline in addition mounting guard beyond—and inside had, in the night, additionally isolated himself in the glare of projectors. But it wasn't enough; apartment buildings had gone up along the fringe of Cannes from

which it was possible *to look at his window*. How certain it is that art is aggression in triumph, now in the age of the homogenization of the human spirit—even for the son of María Picasso (and Ruiz).

The turn straightens; the fir trees weeping their pearls in the shudders of the wind are left; on the right side, a garage; across a large cement turning circle, Picasso's house which he had bought from the Guinness beer people. Inside, all is Picasso—a confusion of things: photos of Picasso and Jacqueline with Picasso often bare chested, a long settee mountained with art editions, a TV (that wouldn't have been there until now; Jacqueline is *chef de la maison* now), the Kivu and Ivory Coast masks, the portraits of Jacqueline splintered and not. Heteroclitic confusion, and the god of this Communist is Heraclitus, whether he knows it or not (and Picasso has a vast amount more formal knowledge than he would admit)—the philosopher who contended against fixity, finding everything in flux.

We look at the tapestry of *Les Trois Danseurs*. Dürrbach has unrolled it on the floor. Present are Jacqueline de la Baume, Dürrbach's wife, who has woven the tapestry on the great loom at Cavalaire, with Dürrbach, Jacqueline, myself, Picasso. Picasso has his clumped fists on his hips and his legs apart as he stares down at it.

PICASSO: They ought to have called it *Les Trois Danseuses*. [The critics called it *Les Trois Danseurs*.] They haven't noticed the evident sexual attributes. They are very abstract people.

JACQUELINE DE LA BAUME (interpolating): From weaving, I get a stiff back.
PP: I, too. I get a stiff back from the way I paint bent over.

Drolly, he mimes this. The way we are all hunched down over *The Three Dancers* has made us think of a crick in the back. Picasso frequently painted with canvas propped in a low chair. Cocteau invariably wrote with a pad on his knees, never at a desk. What efforts to find refreshment, escape formalism, in late-stage art.

DÜRRBACH: Picasso is always cruciform. But in recent years he has surpassed form and surpassed himself. He will go down in history as a poet.

Certainly the "danseur" in rose is centered, her two arms out cruciformly to the giddy, fragmented dancers at either side. There is a teat like the end of a baby's bottle, impudent—this is of the great virile sexual year of 1925. Maurice Raynal—who had known Picasso since the days when its face to the studio wall, unseen save by the few friends for months, had stood the *Bordel d'Avignon* (whorehouse on the Calle Aviñó in Barcelona)—wrote of the original of this (*Les Demoiselles d'Avignon* as originally called) that with it Picasso had arrived at the true shattering of forms, nothing more disconcerting, more Picassan. Scimitar round into the brain of Cubism. The end of Cubism. Yes, the forms are broken into curves and rounds. The angles and cubes are dead, stillborn.

As we sit down to tea, up above us on a wall, over where Jacqueline de la Baume is sitting,

is the first portrait of Jacqueline Roque (now Jacqueline Picasso). Everyone knows the Z-face in profile. It appeared—*Portrait of Madame Z*—at the Musée des Arts Décoratifs Exposition in 1955, and Françoise Gilot ought to have taken notice, as indeed she had served notice as *La Femme-Fleur*—her head a delicate oval and nothing else depicted but her two breasts—on Dora Maar in 1946.

Occasionally, Picasso does not grasp the initiation of a new subject. Jacqueline cues him. Save for that, he is vital.

Picasso's eyes rest, as each speaks, on one after another around the table, which has on it nothing but a volume of reproductions of Rembrandt. You take a black olive between thumb and forefinger of each hand; then you introduce the digits between your own upper and lower eyelashes and hold the olives as close to your eyes as you can. It is the best way of producing Picasso. His eyes are perhaps anatomically unique. I look closely and there is absolutely no differentiation between pupil and iris.

I am beginning to grasp what I had first sensed. It is Jacqueline who looks older, not Picasso. Older? Well, she must have been perhaps forty and looked thirty when last I was here; now she looks the age she is. Difficult, we are to postmortem the following day, to share the bed, under the vicuña cover, of a man about half a century older. Jacqueline's first husband in French West Africa was not merely a satyr who went after every woman he could find, but a sadist who made a point of driving with them in his open convertible

under his and Jacqueline's window. She came back to France in a bad state of nerves. The former husband goes on shaking his head incredulously forever now that Jacqueline is Madame Picasso and the inspiration of the final conflagration: *Women of Mougins*—a misnomer, for they are all one woman, Jacqueline; Jacqueline, the model, recognizable or reduced to nipple points and the slash essential, in every canvas of *The Painter and His Model*, the slot of the 347 sexual drawings into which the piston drives.

Cubes and squares and angles are not real Picasso; *rounds*—it is always woman. I suddenly grasp something. I have misdated Raynal. It was not in the *Demoiselles* that he saw the curves and rounds but in *The Three Dancers* eighteen years later, and what has led me to displace him is, in his presence, the sense of Picasso. In no real sense was this man ever a man of cubes—angles.

Picasso himself has not seemed to age. He is milder. His eyes, which *seized* you once, are still intent; but now they contemplate you. Maybe that is it: they remain intent but they are no longer *intense.*

WF: Evidently your father, Ruiz Blasco, and your mother, Picasso López, were both from Málaga. That is, you were born there—when your father was professor at the Escuela de Artes y Officios in Málaga. But the further origins of your stock—?

PP: My mother was from Córdoba, my father Basque. The double *s*—that is not Spanish.

WF: No.

PP: And the legend is that Italians came to Spain—it is just the reverse. Spaniards went to Italy. There was a General Pi-

casso there, and a painter, Matteo Picasso. His works are still in the museum of Genoa. But the name was "Picazo" and the z was Italianized.

WF: But that's not your line of the family?

PP: No. Pure Spanish.

WF: How is it, then, you have the double s and not the z?

PP: Who knows? The z was probably Arab. Córdoba—seat of the caliphate, and they used the z in their language.

And when I pressed him he said these were things of "long ago" and the tales that had been told in the family. I remembered Cocteau's saying that every research must end in mystery. Cocteau had said too of Picasso: "He hates an objective eye upon him. This can drive him into imbecile frenzies and to simply terrible remarks. Françoise Gilot had that objective eye. His present marriage is infinitely more harmonious. His wives are always servants."

WF: Is it work, then, that keeps you young?

PP: I am exhausted if I don't work. It fills up the void of nothingness. Sometimes it seems as if all the forces in the world are united to prevent me from getting to my work. Then I am like a furious beast. But if I am let work I am humorous— ironically humorous, a little in the sense of what the Spanish mean when they refer to black humor.

WF: But you are often droll. And that phrase occurs perhaps most frequently of all in your conversation. "How droll," you will say. Putting on the crazy hats, as you used to do, for the photographers doesn't seem particularly an expression of black humor.

PP: It is perhaps useful to have these printed cards to hand out.

WF: I wonder if you are carrying around something intact. I wondered when we were at the bullfight in Nîmes a decade ago why you, who have put up so many defenses and made

your gates like moated portcullises, nevertheless walked openly right in the midst of the crowd and, when you were asked for your autograph, actually drew little bulls on scraps of whatever was handed you. The fighters were terrible that day.

PP: No. They did what they could. An enormous wind pulled at their capes.

WF: They were bad in terms of the repertoire of passes that they used.

PP: But if you know about the passes that is suicide. You must not know the names of the passes!

I thought that peculiarly characteristic. Picasso, of all men, would not want to know the names of the passes. His whole life has been spent in flight from the names of the passes, which he knows perfectly well. Most encyclopedic of painters, he is also the most original. "Creation is destruction of the known," he said.

PP: Come downstairs. I have all the statues downstairs.

WF: What would you say is the governing force, really, at the bottom of your art?

PP: The hands. Plastic art is manual work. You do it with your hands. You grub for it with your hands—it is like digging potatoes.

WF: You have said that what you are digging for is already there, an invisible picture in the canvas—or perhaps the subconscious—as Michelangelo said the figure was in the block, and sculpture is merely the removal of the irrelevant parts.

PP: Michelangelo! All the critics since—and no explanation of Michelangelo! The savants will never create one creator!

WF: I will tell you, Picasso, something that may amuse you. My latest novel is about a collector and a creator. I took it that collection is the feminine principle, the receptor-critic-connoisseur who tells over what comes to him from without; but the act of creation—aggressive, male. I had a bit Cocteau in

mind in the one case, and you in the other. I didn't realize it, but I wrote it after having seen and written about Cocteau, you.

The glance flickers upward upon my face and my recollection is startled. It is the glance of *Cocteau.* Unconscious memory? In one of the greatest mimics of history?

The Minotaur of 1934 and Boisgeloup, the time of Marie-Thérèse Walter—Minotaur, violent sexuality, the dominant bull-animal, the primitive savagery, the *con* (translation: the cunt). From the crayons and pencils of the classical 1899–1901 4 Gats period, to the delimiting self-portraiture of the *Demoiselles d'Avignon* time (1906–7), on through Cubism into the great, various, and cuntal art. As Dürrbach says, the older Picasso gets the younger he is—the freer. And once he is free of things and theses, then finally distortion of the form, he paints continually that which is most important to a man—the flute, the owl, the feminine attributes. The style is more, more, and more direct: the line a simple pen arc, the cunt a black stroke, a thick straight line. Or a spiny black *erizo de mar* ("sea urchin") of Dalí, with black humor.

WF: Isn't total liberty saddening?
PP: But freedom is illusory.
WF: You are the freest artist in modern times, perhaps in art history.
PP: You can only not do what is done.

Pablo Diego José Crispín María de los Remedios y Crispiniano de la Santísima Trinidad

Ruiz Picasso was born in Málaga on the twenty-fifth of October 1881, of José Ruiz Blasco, who—perhaps influenced by his brother, who was a canon and held a prebend in the Málaga cathedral—did not want to marry, and María Picasso López, whom the family talked Ruiz into marrying. Said by the midwife to be dead, Picasso was laid aside on a table. But another Ruiz brother, Uncle Salvador, was a doctor, and he said Pablo was not dead and picked him up and saved him from asphyxiation. Picasso has it that Tio Salvador blew cigar smoke into his face and then he started to breathe—"all Andalusians were cigar smokers then." But Picasso, like Cocteau, has a Scheherazadism—a thousand and one tales for a thousand and one nights. They are accused of braggadocio—which it *would* be, such exaggeration, in us—but they are necromancers, men of imagination: their perpetual displacement out of literalness into thrall is a necessity of their being. Their assertions do not read as they sound—a very great problem with Cocteau, who did *not* succeed in conveying the real Cocteau save when he spoke; so that everyone who knew him well said, after he was gone, that he had been greater than his work. This may be a transitory verdict: for example, *Demoiselles d'Avignon,* which Picasso painted in 1907, was not shown for thirty years and is now "the origin of Cubism."

Picasso avoided using words and paint as invented for other uses so far as he could, to try to give back those old whores their virginity. A biography of him following the mere progression of his

meat would seem likely to miss, because—and this is burningly apparent when you are with him—he is where his attention is, and what must be wanted is something like James Joyce's "epiphanies," those crucial moments, those moments of climacteric when the accrual of life has at last altered the recipient, and he is ready for the next spurt.

It is best to look at Picasso laterally, not vertically. The first known Picasso is *The Picador* (1888). *The Old Man,* even an oil of *The Corrida,* painted hardly six years later in La Coruña, create a feeling of awe, not least when laid alongside his first scratchings. When and how did this prodigious talent come to be?

In Málaga he had imbided—and this is enduringly important—his father's love of the bullfight (I have from direct personal observation conceived the idea that he does not really go out of himself except to bulls and the woman—whoever it might be, but only one, save once—all else being merely acquisition, a quick rapine theft by the eyes, addition to the miser's hoard for possible future use, himself untouched). In Málaga he passed the first decade of his life in the flutter-sound of his father's dovecotes, which gave the world an enormous heritage of painted doves finally and the Soviet world its peace emblem. He told me: "They called me 'the Andaluz,' not because of what I was but because I came from there; then, finally, in Barcelona, Ruiz; and finally Picasso, because Ruiz is a common name and Picasso isn't." But Picasso here is somewhat mythomaniac, as practically all creators are because they are in the grip of a tre-

mendous theatrical sense, a violent imagination
that explodes reality and "talks as of itself." Pi-
casso himself, about 1900, grasped the use to him
of being "Picasso." He was nineteen.

It may well have been that his friends
called him Picasso, but it is the *selection*, as always
with Picasso, that matters. He elected to be Pi-
casso and might well not have. [It must have been,
at that time, no small thing to obliterate from his
painter signature his painter origin, the Ruiz, his
father, who had been his art teacher, still alive,
and Picasso himself not yet twenty.] From 1901 he
always signed Picasso. And he made the *way* he
wrote Picasso part of his repertoire, as can be
traced over the years. He has always seemed to
"stand still in the middle of his life," so that he
moves forward and back and has had no real de-
velopment, the threshold once passed, and passed
with shocking celerity. You cannot place him un-
less you realize he is where the flame point of his
attention is, the diamond drill of his eyes, and then
you will grasp why it is that the horse of *Guernica*
(1937), anguish at the ravage of his country, is al-
most identical with the gored picador horse
painted in 1917. And yet Picasso can say, "You
must never repeat yourself. Never." He has simply
sublimated consecutiveness, which is a myth of
convenience, and lives with the more burning and
the truer actuality, the primitive reality of being
where you yourself are in your consciousness.

Just as, approached, the man is "a monu-
ment that suddenly moves," so is it unsettling to
see the real succession of his works in his studio, for

he may paint in two or three of his periods *on a single day* (till he was, say, eighty-five and effectively had commenced to cease to be "Picasso"). Again, it is only necessary to understand that the insane rapidity of his hand permits him to annotate inward instantaneity. Why should he not have flashed back to an earlier period and entered it as one enters a city one formerly inhabited, finding everything familiar and going on just as before? It only requires the simplicity to live with things as they *are*—separate, rocky (or suave), meaningless. But Picasso is not a naïf and, in some part of him, could never have been, even when he was being called "the Andalusian kid," *el chico Andaluz:* end-of-the-century Barcelona, commencement-of-the-century Paris.

Cocteau, when he met him toward 1917, asked him what best he could do to advance himself, and Picasso said: "Improve your signature. Simplify it and make it distinctive." When I asked Cocteau what he thought Radiguet, who had written a French classic, *The Devil in the Flesh,* before he died at twenty, would have done next had he lived, he surprised me by saying, "Oh, seen to his publicity." I had been innocent enough to think he might say, "Try to write even better."

Innocence is not part of the makeup of these men, though simplicity is. A simplicity of very complicated beings, the "Paris crew" such as Cocteau and Picasso—an imposture probably, but art is an imposture, an impersonation. I have had Graves's proof copies in hand, when, in Deyá February, in a climate that ought to have been min-

ing-village Wales, running with damp, gutters of misery between stone Majorcan walls, I read—in bed in an unheated hotel room tucked up to the chin, sole guest in the hotel—the works of Graves I otherwise had not been able to find. He had lent me these—with a very characteristic reluctance and a burn-eyed, severe look upon me as he demanded my absolute assurance that I would return them, and in the condition in which I found them—so I had the chance to see Graves emerge, correction by correction, as when one rubs a page on an intaglio with graphite and that which gradually issues in lead is the edging of the cutting beneath. What emerges with Graves is the authentic voice of Graves. It is not all there at once, in the first go.

But what emerges with Picasso, in the serial revision, is rather different. We call it Picasso, of course. But because the intellect is removed, Picasso's work is far more universal, diverse, heteroclitic. Just as if, as Cocteau says, his hand is a severed hand—"a sacred, severed mummy hand"—and his art stops at the wrist. His work is a report on the interior, but it is not a journey to the end of the night. He has never tried to make a masterpiece, or not since his beginner years; he is not cryptic, viewed laterally. "I have a style," Miró said, implying this was the impetus of his art; and indeed one way of tracing the agony of Miró is to trace his struggle to obtain a style and, once he obtained it, its having become *visible,* his struggle to get out of it. Yet Picasso does not have a style, or even styles, if you look very closely and see how the

works are formed. When he made *Guernica* he did indeed draw a naturalistic bull at first. Finally he made it into a bull that perhaps owed something to African art (for African art always had portrayed the *inside* of a thing, as had complacent Greco-Etruscan art after the age of magic, and so African art naturally had an appeal for decadent Paris).

But it is not this conceptual thing that matters with Picasso; it is the specific way he did it, and he probably wasn't even really thinking of it, for the disturbing evidence is, from those who were actually there at the time, that he was thinking not of Franco or of a Hiroshimized village in the north of Spain, or even apparently of Dora Maar.* The evidence is he was desperately bothered by a red spot he had painted into the picture. Something had impelled him to put it there; the concerted protest of his friends induced him to take it out. But when *Guernica* was already hanging in the Spanish Pavilion, Picasso was going about Paris grumbling that the picture was no good because it lacked that red spot.

He combined the three significant Spanish nationalities: Andalusian, Castilian, Catalan. Though he says he is Basque on his father's side, it would seem the Ruiz actually came from León, which is about one hundred miles south of the

* *The Weeping Woman* (*Femme Qui Pleure*), a distortingly ugly head of Dora Maar, and the nearly identical *Pleureuse* in *Guernica* were painted on the same day, June 22, 1937, and it is easy to conceive that, as much as with Franco he was angry with Maar, least tractable of all his "wives"—and who was so much nearer.

Basque country and in the north of what was New Castile. He displaces facts as he does eyes, to the benefit of the composition. The Catalan element he got by habitation, and it does not seem to have struck deep—as Dalí and Miró are marked inexpungeably Catalan, though in contrary ways. Picasso seems always peculiarly impervious to everything in his environment, except his female. He doesn't seem to have cared.

One impetus I have never seen set down. He realized the aspiration of the family toward painting, in which both his father and his uncle had failed, and he would have had this from the start.

3.

JEAN COCTEAU

Cocteau lived under the tattoo needles of self-scrutiny, pricking an everlasting image of himself on a flinching skin. I told Picasso of having found, in the Etruscan Museum at Ferrara, a pitcher with the two eyes of the face on one side, *à la* Picasso— so that we know that that long ago someone was battling with the problem of what vision is and with the simultaneity of representation. It was an Etruscan "Picasso." I described for him the reclining, pallid, slab-handed, Juno-eyed *Ariadne Dormiente* in the Vatican Museum at Rome, thrown back as she is, swimmingly abandoned—from the Hellenic third century B.C., a neoclassic Picasso. He grimaced with boredom.

I asked Cocteau if it were not true that his existence had been starred principally by three individuals, all very like one another and all exceed-

ingly different from him: the original Dargelos, Radiguet, and Picasso. (The Scotch he always offered others, and himself drank copiously from the time of his first heart attack because he either believed or wanted to believe that Professor Soulier considered it the cardiac's best defense, probably buoyed me to this.)

He was seated on a little settee in front of the cold fireplace wearing a Japanese kimono over his fine shirt, a small-knotted tie, turned-up cuffs. Nearby was a photograph of himself in garb of *honoris causa* receiving a degree at Oxford. His hands closed one over the other in front of him as in the picture; he was a replica of himself, waxen, diminutive, with the steel-wool burst of hair you may read of being cultivated for dramatic effect in his first novel, *Le Grand Écart.* He said: "You ask me the qualities of the genius? They are egotism, cruelty, anguish at human contacts, disinterestedness, amorality, a violent taste for the pleasures of the earth." I said this characterized Picasso more than himself. "Of course!"

It may have been the essential sweetness of the man that emboldened my research into the further chemistries of personality. I had an attentive collaborator—the alert scholar, erect on his bench, hands folded in front of him, helpfully teaching at the school of himself. But the vial in which personality is held in suspension may crack if penetrated, and the complex formula alter.

His lips, at one moment, trembled; his eyes flickered with queer light. I asked him what they possessed in common, these incarnations of the fa-

tally fascinating type. "Egotism that doesn't apologize for itself, indifference. They make you want to open the shell."

"What would you say of Raymond Radiguet?"

"That he was heartless."

"And Picasso?"

Silence.

I met Cocteau on the set of *Le Testament d'Orphée* among the lime rocks, tortured into Cocteauan shapes by the wind, at Les Baux in Provence. It was on the day he filmed the death of the poet, himself. He chatted with eminent grace between takes, then went over to stretch out again upon a tarpaulin laid down out of camera range on the floor of the quarried-out cavern in rock, which was lit up eerily by the floodlights—there to be the transpierced poet, a spear through his breast. The hands gripped the spear; the talc-white face from the age of Diderot became anguished. Picasso, Madame Weisweiller, Dominguin the matador, were standing by to participate in the subsequent scene. Dermit, as in *Orphée,* was the hero. Last of the young friends, he married after Cocteau died. One day, long after Cocteau's death, we were alone in the flat in the Palais Royal in Paris. Dermit was closing it up. It was a rainy night; rain was pouring down on the Jardin du Palais Royal. The blackboard on which Cocteau had noted his many engagements was still on the wall by the phone, everything effaced. "He was such a wonderful man," Dermit said. Tears sud-

denly streamed down his face. I thought then it
was incongruous he had married.

Normally Cocteau was at Madame Weis-
weiller's at Saint Jean Cap Ferrat, where he spent
most of the last eight years of his life. The villa en-
trance was framed by facsimiles of the two great
masks from his staging of his *Oedipus Rex* with
music by Stravinsky. Masks were worked in mo-
saic into the cement walk that winds through gar-
denia bushes and lilies. At table, the poet was
framed by his own tapestry of Judith and Holo-
fernes which covers the whole of one of Madame
Weisweiller's dining-room walls and provokes
strange reminiscences of the slumbering Roman
soldiery in the *Resurrection* of Piero della Francesca.
It is, in fact, an outright theft. I was learning how
often the great borrow.

Cocteau's vivacity of intelligence caused
him to live in a world of accelerated images, as if a
film were run in fast motion. It made one think of
a different time stage as a real possibility: differing
human beings apparently all on the same physical
plane actually living at different accelerations. His
rapidity of intelligence accounted for the prolifera-
tion, juxtaposition, and mixing of experience. His
phrases are not so much thoughts as "touches
upon the long corridor of association." His *bons
mots* often hide a deep sense, a vulnerability, not
immediately apparent. He spoke to me with feel-
ing of the woman who had committed suicide be-
cause suddenly "she had started receiving all the
radio stations of Europe in her head." He knew

time was an illusion, and one day he said: "We speak of premonitory dreams. You dream something; later it happens. How do we know that dream time and wake time are the same? Perhaps in dream time we dream of what has already happened, but not yet occurred."

PROUST AND INVERSION

JC: Proust was a great friend of mine. I went every evening to visit him. He was a compulsive invalid closed up in his hive . . . from which he sallied at night to collect his honey from strange flowers. It was I who forced him to read. As I, he began in the elegant conformism of the salons. Little by little he was saved by taking up problems no one had faced— Balzac a little, because he undertook everything, in *Splendor and Misery* for example. It was not Gide at all—not the confessional of *The Immoralist*. Abruptly, Marcel created his great fresco of vice—but prevaricated, disguised. There is a certain charm in the work of Pierre Loti—''Mon Frère Yves'' is not *that*, eh; Proust's Albertine is not Alber*tine;* it was as though the knights of Cervantes were women disguised as men—it was that that lent the work a certain margin, a mystery, very suspect, which Proust wouldn't have had if he had said, ''I am a man who has vicious habits and I am going to tell you about them.''

It was the portrait—*excessive*—that he made of that whole subterranean world that won him his great reputation as humanist. He took his information underground: he snooped with the servants, sucked out the story of what went on above-stairs. As for the *gens du monde,* he was their enemy despite his transvestite appearance of snob. He pumped them for that of which he made his black honey. But what was admirable was just his horrible mania of jealousy. He wanted to close his beings up in cells in order to have them for himself, and he wouldn't let them venture *anywhere.*

If you want to describe the nature of the madam of a brothel, you describe the fetishes of her clients, eh? Transcend all that, carry it very high, and you have Proust, you have the work of Proust. He had those vices, but in his book he transforms them. That ball during which Madame Verdurin becomes the Princesse de Guermantes . . . it suffices him to paste white false beards on everyone, and everyone plunges into the most unspeakable vice—an orgy, out of fatigue, the fatigue of Proust, that you don't find at the beginning of the book.

WF: And Genet?

JC: Hemingway said to me: "Listen, you've got luck. Even if the French are insupportable egoists, they respect artists to the point that when you, Picasso, and Sartre said Monsieur Genet is a great writer, hands off, he wasn't condemned. The judges got scared. In America we're considered trained seals. Monkeys on sticks."

Hemingway was right. France is an inattentive public, with a curious perpetual interest in artists. Criminals and artists. But Paris has become very, very difficult—an ogre that refuses decentralization, a town like the Minotaur, which needs its meals of young boys and young girls and then quickly enough spits them back out. Paris—1916 to 1919—we never thought of a public. It was among ourselves. That is all gone. And a future time yet unborn. I pity the youth. They commence in a small way—their auto accidents, their drug deaths—to express that sense of the short tenure of life which, in the Middle Ages, was owed to the plague. Why be cautious? Perhaps the termination of the day of avoidance of error is in sight. You feel man stands still while his tools grow terribly.

WF: And Genet?

JC: Both Radiguet and Genet I liked because they were younger men with the effrontery to tell me what to do and not do. I discovered Genet. He sent me the manuscript of *Our Lady of the Flowers*. I read five pages. No. But then I looked again. Sometimes, out of habit or inattention, you may read a manuscript wrongly at first. I had dinner with Paul Valéry and I told him I had been brought the book of a young man of absolute

genius, but that it was a dreadful book. Disgusting. What would you do if you were brought such a book? I asked. Oh, burn it, he said. But that would be a crime. What crime? Abortion.

WF: You've rewritten Greek myths. There's something intangible—you've certainly outdone Sartre's *The Flies* or Camus's *Caligula*. They clump. But what have you been after? The suave, idealized surface, or to disrupt it?

JC: These are deep matters of which the public sees only the surface. Oedipus *thinks* he is safe, but he has been gulled by the gods. Superconfident, he fornicates with his mother. But the gods *gave* him the answer to the riddle of the Sphinx. They could have withheld it from his intelligence. For me, also, Orpheus perhaps seeks his wife out of woman hatred. He has created homosexual rites, has he not? Go into the chapel—Greek, Orphic—in the underground Orphic temple discovered in Rome. You will see that the most massive decoration is on the ceiling. It is Ganymede brought by the eagle. But Ganymede is not a child. They have always portrayed Ganymede as a child out of prudery. The bird brings a very beautiful, very large young man, and that is the Orphic sign of misogyny. It is possible Orpheus turned toward his wife not as it appears, because afterward he is killed by women, by the bacchantes, perhaps to avenge his having created a secret homosexual sect. Art is *mysterious*—a line that does not know where it is going but that does not die. That is why Miró, in total trance, created circles that are beautiful—and that is something that the imbeciles who talk of these things on the television will never understand! There is a strange chemistry which brings it about that only by avoiding the things in vogue do you create the permanent.

PICASSO

WF: Do you think Picasso suffers from lack of limitations?

JC: Picasso is a man whose genius is in the hand, and he concerns himself little with himself. He runs, he runs fast—he runs, as he says, to escape beauty. He's afraid beauty may

master him, oblige conformism. You are moved by the plastic rapport, by the *poetry*.

WF: Hard to say that of his Cubist things.

JC: One revolts against the dogma one has. I am going to explain something absolutely important and quite forgotten. In 1913 there was an exhibition of the Independents—a great romantic movement—*La Tour Eiffel* of Delaunay, *Les Femmes Rouges* of Matisse, Archipenko, Maria Blanchard, Rousseau. The fire of Delacroix vanquished the *simulated* academism of Ingres, which was extremely audacious, as went unseen. And then there was the contrary wave; the great movement of impetuosity was killed, guillotined, by the rules of Cubism. And for a long time Cubism, with its geometric, Aristotelian rules, suffocated the romantic and revolutionary movement. And then, little by little, they took to the wild. Picasso. Klee, who had preferred the cage to the bird. You mustn't forget with Picasso that he is a genius but also a child. His houses are in enormous disorder, a poverty luxurious, gorgeous, as with gypsies. Nobody has ever insulted the human face like Picasso. But he insults the human face as the Spaniards insult the Madonna—with love. However, if the Madonna is not of their quarter, they insult her, eh?

Our day of the magazines, television, the radio, is a splendid school of inattention. It is *vanity* that pushes the artist to create—show himself naked, as he is. I must say it is very gratifying. Do you know the character toward the end of Thomas Mann's *The Magic Mountain?* He is asked to accompany those of the sanatorium on their gay outing, and he says he cannot because he is going to commit suicide that evening. They smile cheerfully and go their way; a waterfall is tumbling and they do not hear. They don't heed you, you see.

Cocteau once said to me that he could not otherwise account for the behavior of human beings than to conclude they were inattentive. It was evident they were not stupid, for when sufficiently spurred, they did intelligent things, but

they were on the whole so unintelligent neverthe-
less in their imperceptive comportment that he
had to conclude they were inattentive. He was, at
the end of his life, inscrutable on the subjects that
deeply concerned him.

WF: What would you say is the nature of Genius?

JC: I used to say the genius is one who tries to do what the others do and cannot. That is the mark of his individuality, eh? No one starts out to do what's never been done before. It is our *errors* that sanctify us. Picasso says if a thing's right it can't be good. He doesn't know what to do; he only knows what to avoid. What he does is what's left. You can only do what is not done, he says, accounting for the privilege his enormous freedom accords him; sadly—the sadness he masks, as he does the hermaphroditism of his spirit, deeply hidden, you know. He's husband and wife both—and to-gether they break all the dishes in the house. Ah, but those are old ideas. I think now genius is some as yet undiscovered form of the memory.

WF: What do you mean?

JC: It could be remembering forward; it could be remem-bering back. Alcohol releases the libido rather than dimin-ishes it. Coffee, amphetamine—all those things.

WF: Would you say the genius is one who has these chemi-cals abundant in the blood?

JC: I used to think so. It may cause the impulse. But the im-pulse isn't the genius. It is easy to be definite if you have a goal, because all steps forward are calculations backward from it. But creation is very different. It appeals to internal truth in a void. The *choice* is the genius. Picasso has a sacred mummy hand; his talent stops at the wrist. But he *chooses*. Why this and not that? Why does the creator say *"C'est ça!"* and stop at some point with an immense sense of relief, really postorgasmic, though the step before may be little differ-ent—perhaps better to objective judgment? He stops where he stops, I have come to think, because that's where he will have stopped. He remembers the ending *beforehand* and is

glad to have reached it. Geniuses may have a little better memory of the future than most.

In my final *Orpheus* the young man, vagarying between present and future, sees the doctor die. And when the doctor apprehensively asks him what he has seen for him, he replies, "I have a very poor memory of the future"—out of politeness, you see.

His wit imprisoned him; his velocity destroyed all the first part of his life. "I was like a chameleon on a Scotch plaid," he said. He did not dare look back because then, like Lot's wife, "I would have been turned into a pillar of sugar"— an aptness he hated, and from which he took self-satisfaction. "Truth is found at the bottom of a well," he said.

JC: After you have written a thing and you reread it, there is always a temptation to fix it up, to improve it, to remove its poison, blunt its sting. A writer prefers, usually, in his work the resemblances—how it accords with what he has read. His originality—himself—is not there.

WF: When I mentioned your resemblance to Voltaire you were highly displeased. But you share Voltaire's rapidity of thought.

JC: I am very French—like him.

WF: I had thought Voltaire isn't as dry-sharp as is supposed, that this is a miscalculation owed to imputing to him what would be a thought-out hypercleverness in a more lethargic mind. But in fact Voltaire wrote very fast—*Candide* in three days.

JC: I am the antipode of Voltaire, his opposite. I am nothing; another speaks in me. This force takes the *form* of intelligence, and that has been my curse since the first days.

WF: It takes us rather far to think you are victimized by intelligence, especially since for half a century you have been thought of as the keenest critical-poetical intelligence in

France; but doesn't this bear on something you told me about yourself and Proust—that you both got started wrong?

JC: We both came out of the dandyism of the end of the nineteenth century. I turned my vest, eventually, toward 1912, but in the proper sense, in the right direction. Yet I am afraid the taint has persisted even to today.

Marcel combated those things in his own way. He would circle among his victims collecting his "black honey." He asked me once: "I beg of you, Jean, since you live in the rue d'Anjou in the same building with Madame de Chevigné, of whom I've made the Duchess de Guermantes—I beg you to get her to read my book. She won't read me. She says she stubs her foot in my sentences. I beg you—" I told him that was as if he asked an ant to read Fabre. You don't ask an insect to read a book on entomology.

WF: Do you think the loss of your father in your first years bears on your accomplishment? There is a whole theory that genius is only-childism.

JC: I have never felt any connection with my family. There is something in me that is not in my family, that was not visible in my father or mother. I do not know its origin.

WF: You were launched pretty young.

JC: I had met Edouard de Max, the theater manager and actor, and Sarah Bernhardt, and others then called the sacred monsters of Paris. And in 1908 de Max hired the Fémina Théâtre in the Champs-Elysées for an evening of reading of my poems.

WF: How old were you?

JC: Seventeen. It was the fourth of April 1908. I became eighteen three months later. I came to know Proust. The Countess de Noailles. The Rostands.

WF: Sarah Bernhardt. Edmond—the Rostand who wrote *Cyrano*. God, it seems like another century.

JC: I was on a slope that led straight toward the French Academy—where, incidentally, I have finally arrived, but for inverse reasons—and then, at about that time, I met Gide. I was pleasing myself by tracing arabesques. I took my youth for audacity and mistook witticism for profundity. But something from Gide, not very clearly then, made me ashamed. I

thought literature gay and amusing. But the Ballet Russe had come to Paris, had had to leave Russia, I believe. There are these strange conjunctures. I often wonder if much would have happened if Diaghilev had not come to Paris. He would say: "I do not like Paris. But if it were not for Paris I believe I would not be staged." Everything began, finally, with Stravinsky's *Sacre*. The *Sacre du Printemps* reversed everything. Suddenly we saw that art was a terrible *sacerdoce*—the Muses could have frightful aspects, as if they were she-devils. One had to enter into art as one went into monastic orders. Little it mattered if one pleased or not. The point wasn't in that.

Nijinsky—he was a simpleton, not in the least intelligent, and rather stupid. His body knew; his limbs had the intelligence. He, too, was infected by something happening then—it must have been in the May or April of 1913. Nijinsky was shorter than the ordinary, with a Mongol monkey face and blunted fingers that looked as if they'd been cut off short. It seemed unbelievable he was the idol of the public. When he invented his famous leap—in *Le Spectre de la Rose*—and sailed off the scene, Dimitri, his valet, would spew water from his lips into his face to revive him, and they would engulf him in hot towels. Poor fellow, he could not comprehend when the public hissed the choreography of *Sacre du Printemps* when he had himself seen they applauded *Le Spectre de la Rose*. Yet he was—manikin of a total professional deformation that he was—caught in the strange thing that was happening. Put the foot *there*; simply because it had always been put somewhere else before. He was *morose*. He walked apart. Alone, ahead. Up the rue Royale. The infernal concentration on his work *dismayed* him. He was always irritable. He would pull a burnoose over his head and write down his choreography. Once he had a stiff neck—he had been practicing for a faun or stag role, in his room, with real horns. I recall the night after the premiere of *Sacre*—Diaghilev, Nijinsky, Stravinsky, and I went for a drive in a fiacre in the Bois de Boulogne, and that was when the first idea of *Parade* was born.

WF: But it wasn't presented then?

JC: A year or two later, while I was listening to music of Satie, it took further form in my mind. Then, in 1917, to Satie's music, Léonide Massine, who did the choreography, I who wrote it, Diaghilev, and Picasso—in Rome—worked it out. I had induced Picasso to try set design. He did the stage settings: the house fronts of Paris, a Sunday. It was put on by the Ballet Russe in Paris, and we were hissed and hooted. Fortunately, Apollinaire was back from the front and in uniform, and it was 1917, and so he saved Picasso and me from the crowd, or I am afraid we might have been hurt. It was new, you see, not what was expected, so the public hated it.

WF: Aren't you really positing a kind of passion of anticonformism in the ferment of those days?

JC: That's right. It is all very new, you see, this revolt against everything you see everywhere now fifty years later.

WF: Do you think this liberty can go too far?

JC: There is a total rupture between the artist and the public. But it will cause its opposite, and there will be a new conformism.

WF: If you had to name the chief architect of the revolt?

JC: For me—Stravinsky. But you see I met Picasso only later, in 1916. And of course he had painted the *Demoiselles d'Avignon* nearly a decade before. I had then known Stravinsky—oh, five years.

WF: You spoke of this "other."

JC: I feel myself inhabited by a force, or being—very little known to me. It gives the orders. I follow. The conception of my novel *Les Enfants Terribles* came to me from a friend, from what he told me of a circle, a family closed from social life. I commenced to write, exactly seventeen pages per day. It went well. I was pleased with it. There was in the original some connection with America, and I had something I wanted to say about America. Poof! The being in me did not want to write that! Dead halt. A month of stupid staring at paper unable to say *anything*. One day it commenced again in its own way.

WF: Do you mean the unconscious creates?

JC: It may be much more complex than that. Dargelos was a real person. He is the one who throws the fatal snowball in

The Blood of a Poet. Again the same, a snowball, in *Les Enfants Terribles,* and that time, also, the black globule of poison, sent Paul to provoke his suicide. I found I had to use the name of the actual person, with whom I was in school. The name is mythical, but somehow it had to remain that of the lad. There are strange things that enter into these origins. Radiguet said to me, "In three days, I am going to be shot by the soldiers of God." And three days later he died. The name of the Angel Heurtebise, in the book of poems *L'Ange Heurtebise,* which was written in an unbroken automatism from start to finish, was taken from the name of an elevator stop where I happened to stop by accident. It wasn't my floor. I once wrote in German. I had a German nurse. It is the only language I know aside from French. But my vocabulary was very limited. From this handicap I extracted obstacle—difficulty which I thought I could use to advantage—and I wrote some poems in German. But that is another matter and touches on the whole question of the necessity of obstacle.

WF: Well, what is this question of the necessity of obstacle?

JC: Without resistance you can do nothing. I write with an apparent simplicity, which is really a ferocious mathematical calculation—the language and not the content, which is to say the after-the-fact work, for, regrettably, our vehicles of communication are conventions. ["Thinking is a convention."—Rossellini] If Picasso displaces an eye to make a portrait jump into life, or provokes collision which gives the sense of multiview, that is one thing; if I displace a word to restore some of its freshness, that is a far, far more difficult thing. But Picasso—in multiple perspective—after all, that was the original way of depiction: the commonplace.

WF: It is possible to think that here is a reaching for more mysterious truths, truths that issue from juxtaposition.

JC: Truly . . . there is something else. Madame Colette once said to me you needn't *read* the great poets, for they give off an atmosphere. It is truly very strange. Rimbaud commences writing real poetry right from the start, and then simply gives it up because it is very evident the audience doesn't care.

WF: Is that really true?

JC: Ours is a dreadful métier! The public is never pleased

with what we do, wanting always a copy of what we have done. Why do we write? Above all, publish? I posed this to Genet. "We do it because some force unknown to the public and also to us pushes us to," he said. And that is very true. When you speak of these things to one who works systematically—such as Mauriac—they think you jest. Or that you are lazy and use this as an excuse. Put yourself at a desk and write! You are a writer, are you not? I have tried this. What comes is no good. *Never any good.* Claudel at his desk from nine to twelve. It is unthinkable to work like that.

WF: I read once from a French critic that Gide's work always tended to keep to the surface, but yours plunged for the depths, with—sometimes—a considerable fracture of the waves.

JC: Gide always wanted to be visible; for me, the poet is invisible. Gide was the architect of his labyrinth, by which he negated the character of poet. The moment one becomes aware of the crowd—performs for the crowd—it is spectacle. It is finished.

WF: You resorted to opium, wrote your book *Opium* about it . . .

JC: It is very useful to have some depressant perhaps. Extreme fatigue can serve. Filming *Beauty and the Beast* on the Loire in 1945 immediately at the end of the war, I was very ill. Everything went wrong: electricity failures nearly every day; planes passing over just at the moment of a scene. Jean Marais's horses made difficulties, and he persisted in vaulting onto them himself out of second-floor windows, refusing a double, and risking his bones. And the sunlight changes every minute on the Loire. All these things contributed to the film. And in *The Blood of a Poet* Man Ray's wife played a role. She had never acted before. Her exhaustion and fear paralyzed her, and she passed before the camera so stunned she remembered nothing afterward. In the rushes we saw she was splendid. With the outer part suppressed, she had been let perform.

The public is lazy! You ask them to enter into habits of thinking other than their own, and they don't want to. And then, what you have written in autograph changes in type-

writing, and again in print. Painting is more satisfying be-
cause it is more direct. You work directly on the surface.
WF: What do you think of the French new novelists?
JC: I must make a disagreeable confession. I read nothing. I
find it very disconcerting. I disorient the other. I have not
looked at a newspaper in twenty years. If one is brought into
the room, I flee. This is not because I am indifferent but be-
cause one cannot follow every road. And nevertheless such a
thing as the tragedy of Algeria undoubtedly enters into one's
work, doubtless plays its role in the fatigued and useless state
in which you find me. Not that—"I do not wish to lose Alge-
ria!" But the useless killing, killing for the sake of killing. In
fear of the police men keep to a certain conduct, but when
they become the police they are terrible. No, one feels shame
at being part of the human race.
WF: You recommend one should read nothing?
JC: I myself do not.

Here Cocteau did something odd. He
stood, rather tiredly (he was very slight, quite
small—his photographs belie and do not really
convey him); he went with slow steps to an end
table. And he took up a tube of silver cardboard or
foil, which made a cylindrical mirror upon its out-
side. And he placed it down carefully in the exact
center of an indecipherable photograph—that I
would learn was Rubens's *Crucifixion,* taken with a
camera that shot in the round—which was spread
flat on the table. Masses of fog blurred out in the
photo, elongations without sense. Upon the tube,
which corresponded in some unseen fashion with
the camera, its maker, the photograph was re-
stored—swirls became men. Nevertheless, the ob-
jective photograph remained insane.
He didn't say anything.

Later on, seated wearily, he did remark: "I feel sorry for the young. It isn't as it was. Paris has become an automobile garage. Neon, jazz, condition everything. And it is not as it was: a young man sitting writing by a candle. A great scientist came here the other day. He said, 'There is nothing left to be discovered.' And we know nothing about the mind! Nothing! Yevtuchenko came to me. We had absolutely nothing to say to each other. Do you know why? There were twenty or thirty photographers and journalists there to snap and misrepresent it all. And the young are in a limbo that hasn't a future. The world is very tired. We go back to the clothes of the twenties. And speleology—that is a rage here—burrowing down to the most primitive caves."

JC: I have no facility. I had written a novel, fallen silent. And the editors at the publishing house of Stock, seeing this, said: "You have too great a fear of not writing a masterpiece. Write something—anything—merely to begin." So I did; I wrote the first lines of *Les Enfants Terribles.* But that is only for beginnings in fiction. I have never written unless deeply moved about something. The one exception is my play *La Machine à Ecrire.* I had written the play *Les Parents Terribles,* and it was very successful, and something was wanted to follow. *La Machine à Ecrire* exists in several versions, which is very telling, and was an *enormous* amount of work. It is no good at all. Of course, it is one of the most popular of my works.

My long poem, *Requiem,* has just been published. I leave repetitions, maladdresses, words badly placed, quite unchanged, and there is no punctuation. I was finishing staging one of my things in Nice. I said to the leading woman, "When the curtain is to come down, fall as if you had lost all your blood." After the premiere the next night, I collapsed. And it was found I had been unknowingly hemorrhaging

within for days and had almost no blood. Hurrah! My conscious self at lowest ebb, the being within me exults. I commence to write, difficultly above my head in bed, with a pen Bic, as a fly walks on the ceiling. Requiem. It took me three years to decipher the script. I finally changed nothing. One must fire on the target, after all, as Stendhal does. What matter how it is said? What is wanted is only what one has already done. Another *Blood of a Poet*. Another *Orpheus*. It is not even possible.

I will recount one thing. Then you must let me rest. You perhaps know the work of the painter Domergue? The long girls? Calendar art, I am afraid. He had a domestic in those days—a "housemaid"—who would make the beds, fill the coal scuttles. We all gathered in those days at the Café Rotonde. And a little man with a bulging forehead and a black goatee would come there sometimes for a glass and to hear us talk. This was the "housemaid" of Domergue, out of funds. We asked him once (he said nothing and merely listened) what he meant to do with himself. He said he meant to overthrow the government of Russia. We all laughed, because of course we did too. That is the kind of time it was. It was Lenin.

It is necessary always to oppose. The avant-garde—if that is enthroned. The public? All they want are names.

WF: Films?

JC: I went with Gide to see a rerun of *The Blood of a Poet*. I did not like it. The rhythm was off. As we walked away, Gide's remark was true. He said the film was right but I had become wrong. I had changed and lost that rhythm.

WF: Why hasn't the industry taken up so obvious a purchase on the public as the creation of unique things you have to go to the movies to see—like some of your films—rather than the banality you can see out your window?

JC: The public loves to recognize, not to learn, not to grasp the new. They go from the theater. They think themselves Ben Hur, or Messalina. Our films oblige the risk of money. Why should a man risk ten thousand dollars on a film like ours

when he knows that if he puts a million into the other kind he is sure to get it back?

WF: But the new film has found its audience.

JC: For the time. It is the rule for a young man without means to make a film, and have his success, but afterward, seated in his armchair, millions flowing in, he finds he knows nothing about it. His *difficulty* made him. I told Alain Resnais—he is one of the best, but he has a great fault: he listens to the people around him—that *Marienbad* should not have been shown in a Champs-Elysées house. You cannot put that on the same screen as Ingrid Bergman as Joan of Arc. It should have been shown in a little theater such as the Pagode, where my *Testament d'Orphée* played to an audience of attentive young people. But the higher criticism had taken him up and terrorized the public into liking him—out of fear of seeming stupid. Do you know to what lengths we are driven? There can't be any surface continuity if you would be *new,* if your work would carry conviction. We made a film to the music of Strauss. That was the continuity. And then suppressed the music. Chaplin was on the same ship with me when we crossed the China Sea on my tour Around the World in Eighty Days. He told me of a film he wanted to make. He is Napoleon, and he escapes from Saint Helena. But now he is a pacifist. He decides to impose peace on the world, by force, because he knows nothing else. But just then, on Saint Helena, his double dies, and it is taken for himself. Without the reputation of Napoleon, Napoleon can do nothing and dies of chagrin.

4.

JEAN GIONO

Genius appears to be bent. Warped. Perhaps you can go no further in defining it: the peculiar way a particular person looks at a particular thing, with all that bears upon the instant. Jean Lurçat said to me in Aix-en-Provence: "Find out how he's getting along with his woman and what the woman *is*, what weather it is, what he had to eat last night, how he slept, what and if he drank, if you want to know why he does what he does, makes what he makes—what his art of the day following is." Marceau said to me, "Genius is silence." At which I smiled slightly. "No—I don't mean mime. I mean the mime is silent because if he spoke, the expression would be so much easier, and so he is *silent*," he said with a whispering sibilancy, "to oblige himself to say more."

Genius is grease in the elbow, refusal to do

less than the best—all the definitions—except that genius is intelligence. You had a feeling that that is rather harmful or, in the highest geniuses, had the use that they should have to overcome it. The classical definitions did not help, however, because it had to be a man of genius who sweated, refused to put up with less than the best, and so on. Picasso said, "Genius is individuality." He had said earlier to Sabartés at Royan during the war, "Genius is individuality plus two sous of talent." Dalí said, "Genius is Dalí."

Giono (I felt absolutely sure of his genius) very heatedly said, "Genius does not exist." It, he said, did not exist. It was the only point that broke the calm of his indifference on which he insisted very much. "I feel nothing. I am indifferent. Do you want to know what creation is? It is *feu continu* [uninterrupted fire]." And he pointed to his pot-bellied stove, twenty-four-hour fire. "You simply keep on going, taking up each day from where you ceased. What you insist on calling genius in me is artisanal. My father was a shoemaker. So am I. To the last. You say my words are sometimes totally fresh and sourceless and so they indicate genius. They are simply the seventh, eighth, or ninth choices. They exist only because I eliminated the others." I said nothing. He had found the unique words. Wasn't that the point? "I must only prevent myself from going too far."

"You don't use the Code Napoléon, I suppose, like Stendhal?" I quipped.

"I use the *Nautical Guide*," he said. He reached into his shelf. "Here it is. The guide to

navigation. How to get in and out of coves, and so on: a quite clear, precise language. It is my Bible, and I consult it every day."

Across from his desk was the cot he lay on and pullulated—the marvelous French word *four-miller*, "to swarm," as with ants, from *fourmi*, "ant"—with the characters of his invention like Gulliver "crawling with Lilliputians." And out through the window I saw the Mountain of Gold where he took his walks and, he solemnly assured me, saw dryads looking out from behind the trunks of the trees.

I asked him if he really believed in the ancient gods. "I cause myself to." I asked him if then he had ever really seen the dryads in the trees. He said no. I thought I had caught him out. He said: "One day I walked up behind the Colline d'Or. I came upon a stud fox suspended upside down from a yew. Do you know the sexual sensuality of skinning an animal with the gliding knife? . . . A hunter had killed the stud fox and left it to blanch. And all around the fox in a circle was the chorus of the widows, howling. That was how the antique gods were hung, at the center of the squatting circle. I do not believe in anything, except the absolute human necessity to believe—in what must of necessity be false."

He was strangely incurious. A stream of visitors still came to seek him out, though the day when he was prophet and guru (a period he quite evidently looked back on as comic aberration) was well in the past. His door is open, and he puts

aside his pen, but when his visitor leaves he imperturbably resumes where he left off. He lived in a three-story house in which he had lived for thirty-five years, in Manosque where he lived his whole life; and the house was commonplace, conventional. This too is statement—you gradually realize. He was neat, clean; he wore a beige sweater and a blue sports shirt, and had close-cropped white hair and robin's-egg-blue eyes. He worked at a table on which was little more than the pad on which he composed his books (he makes much of the personality of longhand, saying it is impossible to write really well by any less intimately personal means) and the rough-hand notebook in which, simultaneous with his finished creation on the pad, he scrawled trial sentences, caught ideas that came before their place in the script. Above him on the wall was a photograph of his mother, which must have been taken not long before she died at eighty-nine. Obviously, she is the model of Pauline de Théus, the heroine of *Le Hussard sur le Toit,* one of the greatest novels of the century but strangely unknown in America. When I ask him, "Certainly Pauline is your mother," he says: "Yes. Pauline, the Duchess Pardi, Carlotta in *Le Bonheur Fou,* and the nurse of Angelo. But don't mistake; Pauline de Théus is not like my mother."

You have been handed a piece of his attitude, with his characteristic indifference as to whether you will get it or not. By 1951 Henry Miller had written that Giono had surpassed in poetic exultation the lyricism of the Song of Solomon. That was the precise year he commenced

publishing as though he were rewriting Ecclesiastes. In the thirties he was universally considered the modern Walt Whitman, even in America; when he died in 1970 he was universally considered the modern Stendhal (he himself said he got it from Machiavelli—"where Stendhal got it").

JG: Fernandel played *Harvest—Regain*. Then Fernandel played, too, another film that had an extraordinary success in America—no, it wasn't Fernandel; it was Raimu. It had a scenario by Pagnol, but I wrote it. It was *The Baker's Wife*. I wasn't very satisfied with Pagnol's script. Oh, I was discontent! I was too young then, too petulant and proud, not to think that what I wrote had final form. Now I think the transformation of my text by Pagnol was perfectly logical and correct. My spirit is larger. If someone asks to retouch my work, I say why not?

WF: I thought having told a tale well, being a great talker, the greatest in France since Cocteau's death, had decided you to write.

JG: Not at all! These things never work out like that. You are asking yourself: How did it happen that an obscure bank teller in this lost village of Manosque, who has lived all his life here, decided to become a novelist? One day I was driving through the Col de la Futa. It struck me that that was precisely the way Machiavelli must have passed, going from Florence to Imola—not absolutely there, because the Futa wasn't opened till 1752. But here he passed, on his horse, asking himself if it is better to control a people by fear or by conciliation. If you want to know what such a man thought, take your walking stick, follow his roads, go at the same time of day he went, in the same season; you will have the same ideas he had. That is how I wrote *La Bataille* of Pavia. I actually went there on the day the battle was fought, early in the morning *when* the battle was fought. Charles the Fifth did so-and-so at that time; and Francis the First did the other. At seven in the morning, Francis was prisoner. What were the conditions on the twenty-fifth of February in 1525? Well, approximately the

conditions on the twenty-fifth of February 1962. And I went there and paced it all out. Of course it couldn't —physically couldn't—have happened as formal history says. You must put yourself back to Manosque in 1910. You must imagine the total, savage isolation of a boy in those days, left to his own devices. There were no distractions at all. We would go up onto Lure, on Saint John's Night, by stagecoach, and then on foot, taking resin brands, slowly up the stone steps cut in the mountain. The peasants clustered in the inn, utterly silent, and smelling of leather and sheep hair. You will see that there was nothing to be said of such a place. But I sat down at a corner of the kitchen table and scribbled my books in school notebooks to divert myself because I hadn't anything to read.

WF: How could the books have been so remarkable?

JG: For a simple reason. They were not written for anybody, and as I had no money I could buy only the classics in Garnier, which then corresponded to the pocket books, and so had never read anything but the best. You express yourself as incredulous when I tell you I need no human contacts, get nothing from people. I can tell you I do not need publication and would go on writing without it. I did not write those first books to be read. I wrote seven novels and put them into a drawer. A friend took them to Grasset. I knew nothing of it. They all came out at set intervals. They didn't want to flood the market. *Colline* was published first, in 1929. No, there was a small magazine put out by James Joyce and Valéry, and *Colline* appeared in that a little before book publication. Gide discovered it and made its reputation in Paris. I have no respect for Hemingway. He was not a novelist; he was a journalist. But Americans cannot appreciate the romanesque as they have no culture. Literature is a cultural expression, which therefore the Americans cannot understand.

WF: People are a raw material for you? You don't care for them as such? Literature is more important to you than life?

JG: Yes. You have said my sentences expand like flowers. They *seem* to expand like flowers. You say that certain of my "inspirations"—of which many, many others have written— *could* not have been thought out. I don't believe in inspiration; I don't believe it exists. I believe in continuous work, contin-

uous every day: ten hours. I rise every morning at eight. It used to be earlier but I am seventy-three. Every morning at nine I am here at this table. I write till midday. I take a walk along the canal before lunch, always over the same route, the same path. At two I am at this table again and I write till seven. I listen to my music—always the same composers. I go to bed at nine and read an hour—always the same authors: Shakespeare, Dostoyevsky. I sleep till morning and I get up and start again. I write steadily without errors or corrections, and that is what is printed. It is the work of a furniture maker.

WF: But you have choices of words that go beyond anything seen in contemporary language, that are born with you, and in *Hussard sur le Toit* you have descriptions of the effects of the cholera or of the birds pecking the eyes from the corpses, and butterflies feasting on the decay, which go beyond the necessities of description, which are almost sadism—a sadism against your reader though I know that conflicts with your principles as novelist.

JG: Don't you think that dissimulation plays a great part in production? When I reflect, yes, certain of the phrases appear to come of themselves. Yet—the rhythms must be adjusted. Too long or too short. The style must be *made*.

WF: Somewhere you write one must dissimulate the infernal need to believe in something.

JG: Well, yes. If you believe in De Gaulle—but you believe in him too openly—then he, himself, falls short of what you believe. You have that need to believe in something; but if you show it, it loses the quality that made you believe. The belief becomes an *object*—and it outgrows its object. If you hide your belief in De Gaulle, you leave him free of what you believe, and yourself too. Tale-telling, it is said, is outgrown because we have outgrown credulity, but the novelist has not found how to surmount this saturation. He lacks talent. Making novels is easy. A door opens. Someone comes in. A novel begins. A noise outside the window . . . All the rest is style, shape. Do you know the *Reader's Digest* series "The Most Interesting Person I Have Ever Met"?

WF: Yes.

JG: They go to everybody and they came to me. I wrote of the shepherd on Lure—Zerboufier. The Most Extraordinary Person I Have Ever Met in My Life. Zerboufier is utterly alone with his flock, fifty years. Lure is a desert, stripped by the winds. What does he do to save his soul? He fills up that half century planting oaks. He has a staff with an iron ferrule and a sack of acorns. And Zerboufier wanders over that desert with his sheep planting oaks. Little by little, the trees come up. The streams revive. Humans return. There is a forest. Zerboufier dies in the hospital of Banon. I sent the pages to the *Reader's Digest*. Eight months pass without a word. And then one day an American comes to me here from the *Reader's Digest*. I have been to Banon, he says. Ah, you have done well—it is a pleasant place. I have looked up the records of Zerboufier in the hospital. Zerboufier? I cannot recall who Zerboufier is. The man who planted the oaks. Oh, the man who planted the oaks. There is no record of his death. But how should there be a record of his death? I invented him. The *Reader's Digest* looks at me with condemnation. But the most extraordinary people I have met in my life I have met in my imagination. If they do not want that, they should not go to a novelist. Look here. You only want to write what occurs to you, and they only want to stuff it back down your throat.

WF: When you translated *Moby Dick*, you suddenly and spontaneously came forward with flashes that so exactly expressed Melville that everyone was astounded.

JG: Do they say that? You asked me which are my best books: the biography of Melville, and *Le Bonheur Fou* which is not so much read as *Hussard* because *Hussard* is about the cholera which has been solved, and *Bonheur* about revolution which hasn't, and so leaves them less comfortable in their armchairs.

WF: When I read *Pour Saluer Melville* I couldn't help thinking you had invented Melville.

JG: I invented Adelina White, the girl cattle runner he seduces in England, pines over, tells Hawthorne about—to the extent that Melville's granddaughter wrote to me about it. I relieved her (Melville was married at the time), but she an-

swered, "Nonetheless, it was very much grandfather." Melville, of necessity, was myself.

WF: And Machiavelli in the psychological-biographical detail in the French standard edition of the works?

JG: Of necessity.

WF: When you were jailed as a collaborator in 1945, why didn't you show them your play *Le Voyage en Calèche*?

JG: That was a time when one said nothing. *Voyage en Calèche* was refused production by the Germans; it came out in 1947, so in fact it didn't exist. I had my house full of Jews, German Communists, pacifists—

WF: Even German deserters, I hear.

JG: I was jailed because I wasn't a Communist. I was never tried. They kept me awhile; then they let me out. The first time, at the beginning of the war, I was in prison with Communists. But that was before the attack on Russia, and after that they were the wildest for the war of all. I was simply against it before, during, and after.

WF: For what were you thrown into jail in 1939?

JG: For refusing the call-up and tearing down posters of mobilization.

WF: But weren't you at the end of mobilizable age?

JG: In December. They could no longer hold me then, and they let me out.

WF: Why did you do it?

JG: To put my acts into accord with what I had said. What else could I do after all I had said?

WF: You wrote at that time—in *Refus d'Obéissance*—that the pacifists were obeying, flocking to war. "No longer does anyone respect man. On every side they talk only of bossing him, forcing him, making use of him. You even hear the crap: the present generation must sacrifice itself for the next. They say it on our side too, which is the worst. If only we knew it to be true! But we know that it isn't. The future generation always has tastes, needs, desires, aims, unimaginable before it. We laugh down the prophets of the grand adventure. We do right to laugh them down, fear the builders of the future. Especially if to build the future of those to be born they must

kill those living. A man is the raw material of his own life. *I re-fuse to obey.''*

JG: Well, that was about it.

WF: You say it was because you weren't a Communist that you were jailed the second time?

JG: Gide got me into that. He had a courage which was largely overlooked. I liked him (though I couldn't read his books—they are unreadable). He wanted me to go with him to Russia in his Communist phase—and I wanted to share his inclination insofar as it was anticapitalist, since capitalism leads plainly and inevitably to war, but I rejected the collectivist part. I didn't go. That got me into trouble with Aragon and the others, and I was always suspect; and when I went on resisting the war, which was now *pro* from their point of view, I was jugged again in the Marseilles prison where I had been with the Communist war resisters. The experience wasn't at all disagreeable.

WF: You have a side I don't understand. You always say you are happy.

JG: Yes. I know it is rare. And among writers and artists rarest. But I am because I am satisfied with little. I trained myself to it: to use what's at hand.

WF: I went up to Mallefougasse. I saw the horse chestnuts around Banon, the yews, green oaks, the Celt and Druid ruins, the smoke-hole beehive-stone Gaulist temple at Ganagobie, and the hill next where Dominici slaughtered the English family—and you followed the trial and psychologies and wrote it up, writing Capote's *In Cold Blood* before he did. And perhaps I didn't waste my time. On the way back I stopped at Contadour.

JG: That was the idiot period! Much has been said of that. I was the guru. They sat at my feet, and my vanity liked that. They flocked to me from all over Europe. We meant to go up onto the mountain of Lure, but I put my foot through the floor in a barn loft and hurt my leg, and we had to hole up there. About two hundred and fifty disciples. Pure sky. Glorious air.

WF: Nonetheless, the things you told them have a curiously modern ring. ''This society built on money sets out to destroy you. They take your patrimony, the streams, the forests, they

give you a money civilization. It is useless to your heart, your limbs, your soul . . . your intelligence can't fight it; it salivates an intelligence that drugs your mind. You owe nothing to its bag of vicious laws."

JG: I thought we could abjure the city. And every aspect of agglomeration. I admit to having had intentions of doing social good. We were to have discussions and discourses, and do the work in turn. And those who came there to live the wholly free individualist life immediately asked me how we were to organize it. I was the prophet of Provence. In 1930 four thousand came to the train station in Berlin and hailed me, singing choruses of the poet Mistral in Provençal. They had it down word-perfect. I don't know Provençal.

WF: You are not Christian?

JG: No. I am guilty of the greatest sin in the world. I am not for, I am not against. I am indifferent. Issues don't exist for me.

WF: What interests you, then?

JG: But all the rest! What's on Venus? What's on the moon? How is a tree made? They can stuff that. I have no need of theoretical explanations. I have no need to be carried on their arms as they carry a corpse to the grave. What I experience. What I remember. What I imagine. How things are. That's enough. But it's the human condition. We are born alone. Admit it.

WF: You are not a joiner.

JG: I am not a joiner. Individualism is never sterile; the mass is always sterile. Humanity has that great weakness of choosing chiefs.

WF: I admit that when I had gone up to Mallefougasse and found that it exactly *wasn't* a place that could accommodate the "two hundred shepherds and two thousand sheep" and in fact had no pasturage at all, and then when you told me that that was precisely why you had picked it, and then told me the whole Dionysian ceremony—flutes and all—at the end of *Serpent d'Etoiles* was invented whole-cloth, I was flabbergasted. It was so circumstantial, and with footnotes!

JG: But that is my trade! And it is a *trade*—quite conscious, cool, controlled, so that you made me laugh the other day

when you seemed to suppose some Pandora's Box of the unconscious where I keep holed up all these Angelos and Panturles. The unconscious. That is a myth.

WF: May I read you something you have written in *Pour Saluer Melville*—ostensibly describing Melville?

JG: Read away!

WF: "Alone, in the room where he wrote, when he was bent over the page, the other often jumped on his back from behind: with that terrible force which twists the neck, that cruelty without pity—yes, without pity—without pity!—which takes nothing into account, not fatigue, not desire, not the right to live like everybody else, lying a little, to right and left, to oneself and others—to live, that is—to abandon big ideas, great resolutions, the appetite of sacrifice, the gift of one's self, things difficult to do, things to which one must be dragged by the scruff of the neck, things that wake you up in the night. To live like everybody with that great egotism taught by all the churches and establishment . . . to do what one knows how to do, everyone wants to do what he knows how to do—but since you insist I am a poet—"

JG: I only want to write the books I don't know how to write. Otherwise I would die of boredom. That accounts for my famous changes of style.

WF: After all, in your early work you portray an age of faith; afterward you turn to the human condition. Does not that in great part explain the difference—the richness of the first part, the aridity of the second?

JG: Yes. You saw the patriarchs; now you see a "people." It is a good deal less poetic. They have been to the university, but you still see the wolf factor of their ancestors look out sometimes in crucial situations. But I am sorry to tell you the main reason of the change is simply the evolution of style, to keep myself interested. To keep myself interested.

WF: But certainly you were influenced by the cynicism of Machiavelli—

JG: He was one of the naivest men of his age! The Signory—the Florentine government—they were the same toads as always; they understood nothing. But Machiavelli was a fine young man who went to look at the lions, but he

wasn't a lion. He went to look at the lions because he wasn't a lion. Besides, he wrote an excellent Italian!

WF: Do you think Daphne du Maurier took the story for Hitchcock's *The Birds* from you?

JG: I don't know. The cinema is an industry; I write for it but I don't view it. In my book *Le Hussard sur le Toit* the birds eat the cadavers and become arrogant. They have lost their fear of man. A crow sings to Pauline; tries to serenade her toward death. It has learned the value of corpses.

WF: Why didn't Angelo profit by his occasions?

JG: But he did! Only according to his nature, not ours. To gallop on horseback across the whole of Provence strewn with corpses like a battlefield; to have Pauline naked in his arms and do nothing about it. He was a hero. What could be more comic?

WF: Why didn't the cholera infect him?

JG: For a clinical reason. It is well documented. You don't get cholera unless you believe in it. It is mathematically proven you don't die of cholera if you don't fear it. It is statistically proven those without imagination don't die. Among the *corbeaux*, the "crows"—the stretcher bearers who collected the dead, bore them away by wagonloads, thrust them into the ground, and went off wearing their rings or clothes, dug the gold out of their teeth, couched on their bodies—there was a mortality of two in a thousand. But among notaries, doctors—eighty percent. The shoemakers were more affected than the carpenters or blacksmiths. The shoemaker works a silent, pliant material and is more poetic; he has time to reflect. The carpenter, the blacksmith, bang and hammer. And don't think about cholera. And don't get it.

The cholera of 1832 infected Algeria as well as Provence. My grandfather went there with Emile Zola's father as a volunteer stretcher bearer. In Provence a doctor had two *corbeaux* in his service. One, he saw, had the cholera. But he didn't tell him. The man was going to die. Why tell him? But the man didn't know he had cholera. The cholera? No. Why me? Anybody else, but not me. And he went on working, hauling the dead. He had the vomiting; the cold started in his legs, mounted to his thighs. But he rubbed his own legs,

thighs, as Angelo rubbed Pauline's. And he went on working, and eating, and drinking. And he didn't die. Doubtless my grandfather's experience is how the idea was planted in my mind. But it would be naive to say I wrote *Hussard sur le Toit* because my grandfather experienced the cholera of 1832. Bayard takes a pose of chivalry—*the knight without fear and without reproach*—but he did a thousand other things. That was a moment in his life. And probably it didn't happen at all.

WF: Still, Angelo missed his chance with Pauline.

JG: No—no. She found herself in Angelo's arms. He rubbed her thighs to where they join so that the friction would arrest the cold of the cholera. Why didn't they make love? The critics have asked that; one of your American critics has asked that. One doesn't make love to a person with cholera; and besides, in that day lovemaking still had a certain tenderness, had not become a brutality as today. And he saved her life. Love had been made.

WF: Now they are going to film *Le Hussard sur le Toit.* Who is going to do it?

JG: Buñuel.

WF: Salvador Dalí told me Buñuel has no ideas, that when he and Buñuel made the first Surrealist film, years ago, that Buñuel came to Cadaqués with a hopeless story, and that then he, Dalí, made up the whole film in two or three days—out of his obsessions.

JG: The difficulty is that you see only the surface in judging art. You can never be right; you must always be wrong. You know my published work—you have done me the honor of reading it all—but what do you know about the unpublished parts? The trial and error? The suppressed things? What do I? What do I remember of all that? You have made much of *Le Hussard sur le Toit* and *Angelo,* which precedes it, which was merely an experiment to see what could be done with Angelo, who is the hero of both books, and of those that came afterward. *Le Hussard sur le Toit* is a fragment . . . chosen at random, simply because it works—does not dissatisfy me too much—from a manuscript of four or five thousand pages, covering the period from the cholera epidemic

of 1832 to the end of the Second World War. *Angelo, Hussard sur le Toit, Le Bonheur Fou,* ''The Death of a Personage,'' ''Tales of the Demi-Brigade''—and more—are *parts* of one long work. And before that was *Angeline*, which I have destroyed, and can't remember. It is all fabrication. *Fabulation* is a better word.

WF: In your first published book, *La Naissance de l'Odyssée,* it seems to me that you were Ulysses nevertheless.

JG: No. In reality no. I simply thought that Ulysses could be a person much less mythical, less heroic, than as seen by the Greeks, like one of those one meets in Marseilles, or Aix, or even Manosque—who lies to explain why he is late, but owing to his genius transposes his lie into a *chef-d'oeuvre* of lying. He was a diplomat who lied all day and was sent on diplomatic missions expressly to lie intelligently.

Do you know what a novelist is? He is one who tells tales. *Romancier*—that is the better word for it, in French. That is why I have said Hemingway is not a novelist. Faulkner is a novelist. Caldwell is half a novelist, half a journalist. I have told you that I know how my novel is going to end before I start, that I write the last paragraph first. But that is not to say that when I leave my table in the evening I know what is going to happen the following morning. I haven't an idea. You invent, or there is no creation. Creation is invention. Invention in the moment. Sublimation, temperament, talent. Balzac is not the reporter of an epoch. Balzac is the reporter of Balzac. Look at his portrait when he was young. He is supple, graceful, elegant. And then find him twenty years later, like a great tobacco pouch, huge, rotting. Why? Because he'd passed twenty years at his writing table. But today it is all reputation. A reputation is fabricated, and it goes around the world like a ball of—gathering in size.

WF: Like a ball of snow?

JG: We won't say of what. That's the whole thing, you see. Everything is misrepresented. Bayard forever dying chivalrously beneath the tree—words of chivalry forever on his tongue. That was just an instant in his life! I am guilty of all the crimes: Not taking time for self-advertisement. Forgetting the

book just finished in concentration upon the next. And so on. But it is humorous. I have a great sense of humor. The epoch may sink—

WF: We suffer a progress more than doubtful.

JG: Oh, progress! That's to die laughing. The most doubtful in the world. But we can do nothing against it. When you see another rocket set off for the moon, that's to laugh yourself sick. Astronauts—that is the ultimate absurdity.

5.

JOAN MIRÓ

"I should be utterly lost if I knew where I were going," Braque said; and Leonardo said, "If you know where you are going you will surely not get there." And Tolstoy said, "What you may not have above all in making a novel is preconception"—in other words, in a novel, which would seem to be a logistical affair, you may have no logistics. And Picasso said, "I find first, seek afterward." Even in science, Koestler writes, concerning its great discoveries, the conclusion has *preceded* the research; the research has merely verified it. It was so with Einstein. You find what you are not looking for, in *big* discoveries, says Koestler, and the process is one of *looking aside.* The genius, in science, heats himself to fusion point working at something, but what he suddenly solves is something *else,* another problem of the universe in the

periphery of his vision, not the dilemma he's riveted on—as though precisely by so intently looking he were freed to see something else.

Braque said, "I am sure that a *thing* is different from its appearance." It, in its *self,* must differ from its appearance in our perceiving apparatus, but when Braque—also Miró—stood in long contemplation of an object "trying to see what it was," wasn't he trying to see deeper into himself seeing the object, "force the door of appearance"? It's so with Miró. He uses the object as a catalyst—as a point of departure, too, as Henry Moore does, each turning to crags, stones, jawbones, for the recognition that will give the knock, the punch on the belly, the spiritual erection, the accordance of which is, Cocteau said, the only proof of art.

Artistic creation arises in a void. The problem is to get there. In 1968 Miró told me, "Oh! The unconscious is the source of it." I was pretty square about this. I wanted to get these things as they *are,* not as they appear. The terms of the art profession, or genius, are pretty much rainsheds, even as used by the geniuses. Besides, these are old men, adept at fending off. I asked Picasso why he posed with the hats for David Douglas Duncan, at variance with the main line of what he is; he said, "Perhaps it is useful to have these calling cards to hand out." I asked Miró if his art of the caverns did not come directly from the paleolithic painted caves of the Pyrenees but little north of where he lives. He said: "No! I saw the caves *after,* and the consonances gave me a shock." I thought it much

more probable that he had sometime, in Cata-
lonia, heard of the cave art, seen postcards, repro-
ductions, and so on. The unconscious memory—or
memory conscious but overlooked (as inconve-
nient), a phenomenon we all know but which is
difficult to put into words, for so soon as looked at
it becomes one thing or the other, remembered or
not—might have functioned in Miró, having had
hint of the caves, but needing the sense of freshness
that drives the enthusiasm of the brush. Geniuses
had, however, a common *breath,* and it is really
that that reaches us and conveys meaning.

Braque said that he thought the "intui-
tive" was simply the absorbed, deep, assimilated,
become-emotional experience—and the known
the business of the mind—and you had more con-
fidence in the latter, the known, than in the for-
mer, the intuitive, until you had gone deep *in,*
when the falseness of all outward knowing is at
once apparent. "Something strikes me . . . I don't
know why . . . and I at once jot it down. Oh, on a
scrap of newspaper perhaps," Miró told me, "and
thrust it into a drawer. Leave it for months. Don't
think about it. But it is working inside me all of
the time." When he stares at an object trying to
see through it to what it is, more exactly in his ex-
pression to get hold of its interior, he is certainly
using the object to extend the frontiers of his very
seeing—what more is there that is Miró than I
have yet seen in the interior of that stone? What
more by its agency can that stone make Miró see?
"Solitude is everything," Miró said. "Creation is
impossible without it." "I must have total silence,"

Braque said. "If I hear the least sound I cannot create."

I went out to Miró's. I lost a good deal of time finding the way. Miró is anonymous. "My wife and I hardly ever go out, and we don't entertain. Sometimes we slip into a movie. I love Chaplin." Further, the place where he lives, out past Terreno in Palma, has vanished as a carrot does overwhelmed in cabbage. It was the one thing that agitated him. We went out and stood under his windmill—and the painter who has kept pure cursed the high rises.

"What can we do? We resist modern life in every way we can. And it surges on us anyhow," he said.

Above us was the Balearic windmill, where, at times, he is not unwilling to pose for a publicity photograph, on the slat gallery before the vanes which, not frequently, he uses to work the mechanism that brings up the water as it had always done, because, of course, with the extension of Palma he is on the mains. Beneath us was the ultramodern studio, seagull-wing louvered vents, waffle walls; past it, the some eight stories of the Impala Apartments, spoiling most of the view of the sea. The gravel of the promenade behind his house was impeccable, like the talc sand of the road leading up to Chagall's house above Saint-Paul-de-Vence; you looked to the right and beyond the modest skyscrapers saw the dun burnt-green loaf hills beyond Génova. Within the studio, small in the vast modernistic barn, Miró, standing

on the tiles, declared you could not paint unless you were footed on dirt. "Earth flooring, on which you are planted as is a plant in the soil," he said, standing on the ultramodern flooring Sert had made.

I noted an odd detail. On a cork baffle he had fixed clippings of nudes or near nudes, but they were not the great busty centerfold girls of a Spaniard's preference. They were fashion mannequins, hay rakes to hang clothes on. And I wondered why Miró had this nudes' gallery. He isn't such a man. Picasso—I saw it in a private collection and it has not been released to the public— painted a nude in the lotus position and said with enormous satisfaction, "Now we will show them the cunt, exactly as it is!" Miró does not go beyond showing the scrotum or mound of Venus as if it were a tuber, a sort of sweet potato, a few black hairs sticking out from it.

The thing you feel most immediately about Miró is his enormous equilibrium. Hearing him speak of the madness of the Catalans and their incorrect sexual attitudes—he has been carried to this by speaking of Dalí, the sexual phrenitis a venereal pathology of the mind—you forget (a certain dry amusement far within Miró?) that what is Catalan is the secret, the hidden, the suppressed, the constriction of a strangulated sexual contradiction that coitus cannot spring. A vent can be exhibitionism, which conceals the reality from itself, as we are finding out now. Refusal to give way, refusal to vent, refusal to spurt, could finally be the intensest thing—as the picture *frame,*

which Miró too has lost, has, holding at the exact point between absolutely having to break and being unable to, the formal virtue that it is the line of tension. Still waters ran queer, you came finally to feel of Miró. In a world of the programming of the obscene, the coprophiliac, step by step with the blatant, Miró gorges his pudenda more and more out of recognition.

JM: My hand, with a will of its own, has imparted the peculiar mirth called Mironian. To me, the inspirations are tragic. I relieve this by reference to materials.
WF: What do you mean?
JM: If I paint on burlap, I derive the feeling from burlap. You don't feel the same in front of a piece of burlap as in front of a copper engraving plate.
WF: What is the source?
JM: Everything significant in contemporary art is rooted in the primitive, has relevancy to the primitive—long before Christ. I feel my work going back even further as I grow; I feel I am at the beginning, only now. No, I never work immersed in night like Picasso—I cannot work at night. I rise every morning at eight, dash water on my face, and run to my work. In the afternoon I prepare. I sometimes recommence, and yet, even if the canvas is again completely blank, something nonetheless remains from the first time. I have many paintings in work at once. Each takes three or four years altogether. Occasionally I dash one off like Picasso. "That's all I can do," I say. It has to stay like that.
WF: Dalí?
JM: He started well. But now—now it is too bad.
WF: Do you think Gala, his wife, is responsible?
JM: She could be. She is very strong.
WF: Neither of her husbands has been especially masculine: neither Dalí nor Eluard. But she influenced Max Ernst too, even before that. He is strong, I think?
JM: He is. Well, I have not seen Dalí for a long time.

WF: He is very strong, very forceful, quiet, when one is alone with him; then when the crowd comes in he becomes rather hectic, very brilliant.

JM: Yes—that is it! He is calm and strong when the public is not there.

WF: I saw him a few weeks ago alone. He sat like John Barrymore or a Renaissance prince.

JM: I am said to have a pixie sense of humor. It does not seem so to me. *Will* is the force of creation, but it is faceless. Whatever will open up the vein is good, or shut the artery of doubt. But I do not believe in drugs.

He didn't elaborate, but I thought that no matter what he said it would be because he would not do what is being done. He sat among the Surrealists in Paris in the twenties and said nothing; none divined why. But it was because he was in disaccord. Sagacious peasant, he was garnering a harvest.

His "Rashomon" gate at Saint-Paul-de-Vence, aspiration gigantesque, but ultimately unavailing, expresses something in the human condition humans don't face. He has found out what truncation means for us: the feeling of being cut off. "I like the purge of fire," he said. He likes the Vulcan flame. He is probably the greatest ceramist alive. The stunted, mute beings of his sculpture—when they do not show influences of another sort, evidence of the personal equation and conundrum, not ever to be charted—his sculptures, when great, have a stump potato plaintiveness, a hopeless mass.

I had gone out unannounced. I was told that I could not see him, that he wasn't there. And I could see him, small, back in the hallway that

leads off to the kitchen, beyond the Douanier Rousseau, wiping his face on a towel.

"What do you want? And why have you come?" the maid asked.

"Picasso told me to."

This caused an odd pause.

Miró came forward. Still wiping, he looked up at me.

"Picasso told you to come here?"

"He did."

"Listen, I work hard. I'm exhausted when I finish working. Could you come back at five?"

JM: And why did Picasso ask you to come here?
WF: He said that—I will tell you exactly, because I wrote it down after—"If you want to talk to geniuses, why don't you go see Miró? He lives in Majorca."

"But I don't know his work well enough."

"He'd only say yes, yes, yes, or no, no, no—agreeing with you. He never says anything about his art. *Tiene razón. No vale la pena. Casi siempre no vale la pena.*"
[Translation: You're right. It's not worth the trouble. Almost always it's not worth the trouble.]
JM: I need a departure point. If you don't have that you feel a great nausea. But don't you think everything proceeds by opposites? We always search for freedom—freedom from romanticism. That was essential in Catalonia when I was a youth . . . turn from Wagner to Bach. And then the fight against Cubism—freedom from rigor.
WF: You wanted to "break their guitars" . . .
JM: Yes, I wanted to murder them. But the formalisms of painting, whatever they were. And as they always change, it is only the revolt that is constant.
WF: Do you think the public understands your art?

JM: No. The understanding of art is a consequence of culture and training, and spiritual laziness is the rule. But understanding isn't so necessary. You must get to Point Zero. No, I have never liked my work. It inspires a sense of nausea. I couldn't have it around. I couldn't hang it in my house.

WF: Which of the old painters is the most important to you?

JM: Zurbarán.

WF: Cézanne?

JM: Cézanne was very important to me, I confess, because I felt he trenched deeper—"We must groove deeper, cut through to essentials, like Cézanne," I'd say—but now I feel different. The great reputation of Cézanne is entirely a myth. I admired Manet once too, when—it must have been in the World War One years—his works were brought to Barcelona and were among the first we saw in Catalonia of the new art . . . or the first I saw. It was Picabia who brought them. No, that was later. But Manet is Parisian in spirit, as must be detestable to a Catalan. I like nothing worldly—*mondain*. The canvas must find its own way. If you try to formalize your thoughts, you will never get anywhere. The painting rises from the brushstrokes as a poem rises from the words. The meaning comes later.

WF: Who would you say is the greatest living painter?

JM: Picasso.

WF: What would you say is so great in Picasso?

JM: He is immense, absolute, unlimitable. He has ended a phase of art—totally, irrevocably. It is his great service.

WF: You are not a joiner.

JM: I sweat. You saw me when I came out of the studio. Well, I believe that painting must give birth to things. There must be a *chispa*—a spark. I never start from nothing, never seek the point of departure; I go to the canvas naked, without preconceptions, but nevertheless it is not abstract, as some accuse me—there is always that link, the departure point, a stone, an *O*. The battle is to defend it. A tree or a bird is also human. In art they are. That is, they are made by a human. The transformation is an assertion. Or a confession.

WF: How long have you been married?

JM: Thirty-nine years.

WF: Why did you associate so exclusively with poets in the early years?

JM: Well, really, I had poetic ambitions myself.

WF: Do you write poetry?

JM: Yes.

WF: What you seek is direct expression.

JM: Immediate! Born in hallucination. I reproduce sensations with the greatest precision possible, without second thoughts. Direct forces from nature—semicomprehensible, beyond criticism and analysis. Comprehension can *kill*. Will is vital . . . not understanding.

WF: When did it all go wrong?

JM: Oh—

WF: You see I have found out that every artist, if he is at all major, feels that it has gone wrong—and a long time ago. Graves says with the end of the Pelasgian Greeks—he means with Plato. Picasso said art is finished, that he has been only an experimenter, that he only prays that a painter will come along someday who will revive art. Giono is, the best of Marceau is, rooted in Panic Greece.

JM: The Stone Age.

WF: The Stone Age?

JM: You asked me when I thought it had gone wrong. In the Stone Age. You see, you must keep in contact with nature, because it is indifferent to you. Regain the feeling of the primitive peoples, the last magicians. We cannot reproduce a *thing*. We reproduce what it says to us. All men are alike, and they differ only in their habits, their customs. The rupestrian painter of the cave of Lascaux was like you, like me. I sincerely believe if you get to the bottom of one man you get to the bottom of every man.

WF: Did you meet Picasso in Barcelona?

JM: Jaime Sabartés was a cousin of mine. At his mother's house I saw a portrait Picasso had made of him, and that was the first time I saw a Picasso. But I didn't meet him in Barcelona. The Ballet Russe came to Barcelona in 1917 and played at the Liceo on the Ramblas, and as Picasso was just

then courting Olga, whom he soon married, who was a dancer in the company, he came too, to introduce her to his family. And I went to the theater and I saw him, but of course I didn't dare speak to him. But his mother and my mother were friends, and when I went to Paris two years later, in 1919, I asked his mother if I could take anything for her to her son— and she gave me an *ensaimada* and I took it to Picasso, and so we met. He was one of my first buyers. His genius struck me from the first.

WF: And your opinion of him hasn't diminished?

JM: No.

To Miró, to Dalí, to Lurçat, Picasso seems the one sure incarnation of genius in the twentieth century. Even Dalí has rated Picasso higher than himself on the scale of genius (he says he, Dalí, paints better), giving him an equivalent rating with those he, Dalí, considers the greatest of all: Raphael, Velázquez, Leonardo—Raphael 10 (on a scale of 10), Velázquez 10, Picasso 10, Dalí 9. Slamming his fist on the table at Aix-en-Provence, Lurçat said, "He will have the same reputation a thousand years hence that he has today! . . . if humanity lasts." (Picasso, alas, referred to Lurçat as "the Turkish carpetmaker. So you have been talking to the Turkish carpetmaker. . . .") But the greatest tapestry artist since the fourteenth century said of Picasso: "He should do as he wants. I keep my prices down because of my Socialist inclinations, and because a group depends on me: my assistants, the weavers. I am a whole industry, and I must not price the others out of work. Besides, I prefer it so. Picasso is a proletarian too. But he is simply the exception to everything. He should do as he likes, ask what prices he likes." I asked him

how he created. "I lie in the total dark and think and think. I get a feeling of what the shape of the tapestry will be—and then, *Bon Dieu!* I *fonce* ["charge"]." We were taping and, saying this, he swung a hand, knocked the microphone from the bed table there in the hotel room in Aix-en-Provence, short-circuited the equipment, and, as though to illustrate his statement, plunged a whole wing of the hotel into darkness.

JUNE 1, 1979

Three of us are in the Hotel Colon, Barcelona—Miró, his wife, myself—two days after the opening of Miró's "Homage to Gaudí"* exhibition.

One must sit on his right side, but this done, his hearing seems as good as ever. His eyes are bright and full of intelligence; he has to put on spectacles to read.

JM: Art is in an enormous decadence. You have to get back before, to origins. Art has been declining ever since the age of the caverns.

WF: Frankly, I found your three new sculptures of 1979 the most primitive of any of your sculptural work—the meeting with your ceramics. Which is to say the best. (I have long thought you are the greatest ceramist of the century. *Mute Longing. Pajaro Lunar.*) And this growth is exceptional in a man eighty-six—I am tempted to say miraculous.

JM: I too believe they are the best. So many complications have been left behind.

WF: It is as if human stones mutely speak . . . one hundred

* Antonio Gaudí, Catalan architect. Born Reus (Catalonia), 1852; died Barcelona, 1926.

paintings and lithographs and four sculptures in 1978–1979! You are eighty-six!

JM: I work every day in the week. It is not so much.

WF: But you travel too.

JM: When I must. Only on business. I am not a tourist and I have never been a tourist.

WF: Does age make any difference in your work?

JM: I feel I work better than ever.

WF: Why do you feel so?

JM: I have lost no force, and technique is natural to me now and causes me no thought; and I am rid of many things . . . things learned. I work as before. More drive, more purity. Somewhat less stamina. An animal impulsation begins each work—and later the realization in a cooler mood.

WF: What would you say about genius?

JM: A genius is born. He is or he isn't. He is one with his special way of doing things. Social life brings in nothing. Conversation with sympathetic fellow souls, yes. I have few friends in Palma. Friends come to see me—from Barcelona, for instance. Two or three hours of fruitful conversation.

WF: What is your method?

JM: You mustn't interrupt the flow of work. Even a short interruption can cause weeks getting back into it. I awake and "think" paintings from four to six in the morning. I sleep again briefly—and to work. I work best when I am angry, or annoyed. And then I have a look at it again in the afternoon after lunch, when I have cooled down. I make my works with my whole being, not just my head. [Dalí the contrary.—WF] Dalí fascinated me with his intelligence, but he lacks human qualities. His lack of human dignity is the cause of his abrupt decline. No—I would decline to see him.

WF: Why did you return to Spain in 1940?

JM: I wanted to go to America with Sert. But there were no places on the boats. My daughter, Dolores, was a little girl, and I felt a great responsibility for her. When the Nazis invaded, I went back to Spain.

WF: I don't like to use the word *fear*, but considering what you had done against Franco, didn't you feel fear at going back to Spain?

JM: I felt an immense fear. But I felt I had no choice.

WF: What happened?

JM: Nothing. I was treated to forty years of silence.

WF: It is different now since the death of Franco.

JM: Yes. I am received by Don Juan Carlos the First and Doña Sofia, the king and queen.

WF: What happened to your painting Le Faucheur—The Reaper—that was the chief exhibit alongside the Guernica of Picasso at the Republican Pavilion in Paris in 1937, as assistance for Republican Spain against Franco?

JM: It vanished. It is perhaps in a warehouse somewhere and nobody knows what it is, as Picasso drawings are sometimes turned up.

WF: Tell me about the influences on you . . . Gaudí, of course . . . and the members of the School of Paris, when you associated with Breton, Aragon, Masson, Artaud.

JM: Antonin Artaud was perhaps the brightest of all. We all sat at his feet. He wrote Van Gogh, the Suicide of Society and ended in a madhouse.

WF: What really was the influence on you of Gaudí? He was not primitive.

JM: Colors. Innovations. In the facade of the Teatro Romano he actually worked in real children's dolls and all kinds of such objects. And all this before the beginning of the century, decades before collage, found objects, Picasso, Marcel Duchamp. His work didn't appeal much to artists (Dalí and I were the great exceptions), but he did appeal to the maecenas Güell, who backed so much of his work. It was Gothic and mudejar [medieval and Arab]—skipped the Renaissance.

WF: What about his nonmarriage and consequent freedom for total dedication to work?

JM: Yes, this was very important.

WF: Did he carry it too far? He was after all a very solitary man.

JM: I too am a very solitary man.

WF: What is the advantage?

JM: It allows me to concentrate inward. Gaudí was a very modest man. When I was twenty-two, and he must have been

in his early sixties and was famous, in 1915, at the Academy of Sant Lluch, in the same building which used to be the 4 Gats in the time of Picasso, he would come and sit modestly among us and draw from the nude.

WF: As you at the Grande-Chaumière in Paris when you went back to life class with the students at forty-four when you already had a European reputation.

JM: Gaudí's preoccupation was such that he walked in front of a tram. He carried no papers and his indifference to dress was such that he was taken for a tramp. The injured old man lay unconscious and a number of pedestrians passed him by. Finally one stopped and examined him. He was not in the habit of carrying money. Two cabs refused to pick him up. A third took him to the hospital. The first two cabbies were eventually located and fined by the City of Barcelona for their neglect of a great man. The taxi had been directed to the clinic but went to the hospital because it was nearer; strangely enough, this fulfilled a wish of Gaudí, who had always said he wanted to die in that hospital. His habit was to sleep in his studio at the Sagrada Familia.* When he did not come back, his fellow workers felt alarm and began a search. They soon learned that an indigent old man had been struck by a tram in what is now the Avenida José Antonio. Having learned his whereabouts, a friend went to the hospital. The director, a friend, said: ''Of course we do not have Antonio Gaudí here. If he were here, all of Barcelona would be here.'' When the inquirer learned that they had a penniless old man whose underwear was found held together by safety pins, he said, ''Yes, you have Gaudí here.'' He had been put in a common ward for the poor and received no medical attention. On the order of the mayor of Barcelona he was put into the best room in the hospital and was attended by the three best doctors of the city. He had a severe brain contusion and it was believed there was no hope. Nevertheless, his three broken ribs were set. He apparently was conscious much of the time, but looked at all who flocked to see him with an as-

* Unfinished church by Gaudí whose "corncob" spires are today the chief landmark of Barcelona.

pect of reproach and seemed to recognize no one. He repeatedly said in Catalan, "Jesus, oh, my God," but spoke no other word. On the third day he died. He was buried in the crypt of the Sagrada Familia. All Catalonia followed him to his grave.

JM: Yes, I was involved in the Madame Cuttoli tapestry experiments. I think that was in 1930. Yes, Picasso, Braque, Léger, and I—but they were copies, three of mine. Copies woven after paintings. But now I do *creations*.

WF: Last year I saw a huge tapestry, *Mujeres, Pajaros, y Estrellas—Women, Birds, and Stars,* very characteristic—at the Miró Foundation* here in Barcelona. It was immensely tall. I would say ten meters.

JM: Not quite that much.

WF: Where is it now?

JM: In America. But I have just completed a new one. I am giving it next week to the Miró Foundation. It is slightly smaller, however. It weighs two tons.

DIGRESSION ON GENIUS

The genius is the man of the caverns—what he evokes is essentially *in*human: the contrariety of a woman, the insouciance and spontaneity of a child. When a man does something we cannot explain, but which touches us, what do we say of it? We say it was "very human of him." Thus describing that which is essentially human as that which falls outside the range of being human as we understand it: that elementally logical behavior which is so characteristic of the species.

 Genius is therefore, thus seen, caprice; it is

* A building by Josep Lluís Sert, who built Miró's studio in Majorca (classified in 1979, by U.S. architects, as one of the fifteen best examples of new architecture in the world, and the only one such outside the United States).

the Abominable Snowman inexistent yet know-
able by its massive tracks, which, indicating the
pad of a foot that never fell, strike our imagina-
tion. The necessity is to get it down in something
like its original state. "A lifetime of preparation is
not enough," Giono said—and that was the whole
justification of the work and "talent." You had to
be very agile to follow the bent, weave, and crook
of "inspiration," the breakthrough of the natively
human through the human structure of logical
language, the cogent, the relevant—in short the
limiting and calculated, by which we commu-
nicate, because we must. In the hard mirrors of
logical language we straighten the image of
the quirked human impulse—what it is "to be
human"—so that "by its distortion we may know
it" and see as in a glass, much too brightly. Not
being a logical structure, the human impulse can
be neither logically approached nor logically
judged, which puts the genius to no end of trouble
both before and especially after the act. Unless he
is protected by the new skin of an impermeable
egotism, he too judges after the fact by how the
thing relates to the known. Victor Hugo probably
did well to carve *V/H* all over his house in Guern-
sey, and to write *Victor Hugo* almost larger than the
paintings, signing the quite excellent paintings
you may see displayed in the Place des Vosges—
Hugo was, as André Gide said, France's greatest
poet, alas. The ego (Hugo must have thought: the
French language, *c'est moi*) does not make the ge-
nius, but it is an enablement. The genius must
cultivate the acrobat ability ("I walked a tightwire

in a high wind"—Cocteau) to meet Genius when it comes, and the impenetrable self-assurance is a shortcut, while at the same time preventing the possibility of the highest genius.

Genius is something that happens in the dark of the moon, and necessarily, if we recollect that human truth is simply the adjustment, by head-shrinking, of "the great globe itself" to what we need of it—an accommodation to utility of what is finally very mysterious and vast. Like sexual love, genius strikes the greater awe the less you know about it, so that all art movements have their springtime just as human love does. The genius has the half-mocking capacity to feel real love. At first, normally, he simulates it; then, carried away, he genuinely feels it.

The genius closely relates to the tread of man, not so very long ago, on the clay floor of the caves. He negates the whole human progress by swallowing it with a heady draft of "work-passion" and, even if it is transient, self-esteem. Digesting it, in its naked state "as it was in the beginning," and regurgitating, he makes complicated things directly, immediately, without reflection, though this sainted state is not likely to last—so that the right thing, the indubitable right thing, will be there under his hand when he *feels* the need for it.

Chagall, when he *feels* the color green, finds it; as happened, for the first time spreads the color beyond the form "conceived green" so that the green Russian beggar [*The Jew in Green*] exceeds the confines of his figure, and by no process

of calculation, so that it seems an aspect of Fauvism is caught in this moment in its motile state of "being invented." Chagall sees or feels him so, and "the green feeling about him" invades the atmosphere. The splendid risk! What does a thing resemble in order that it may be understood why it should be? We slide sideways across the hot brainpan of our indwellingness, and our business is to put the chaos right. He will be a very enormous genius, or else a bungler, if he achieves genius this way. (The genius is one who by missing the target hits it.) At Picasso's you are with an equivalent Michelangelo; if you can face this—that the little man is really a man for all time exactly as though you were with Michelangelo—you are "in touch." Evade this, and you are likely to be thunderstruck, but perhaps your greatest amazement could come from something you can never see but can only imagine, yet you brood upon it: the moment he let *Les Demoiselles d'Avignon* stand. It is said to be the beginning of contemporary fragmented art. Who could have known better than the delicate painter of the blue, the fragile, lovely rose, its uncouth *ugliness*? An act of arrogance; or humility—truly titanic! The genius does not permit himself any rallying point and departs into the blue.

Machiavelli had ever present the conception that he was imparting instructions to princes. The genius provides princely instructions, inapplicable, but limited to the size of no prince.

The paleolithic painter supposed his painted magic really did kill, or render a cow gravid. He who, denuded of all faith as we must

all be now, can revert to the tremendous impella-
tion, the modern utensils in his hand, dominated,
not scorned, performs an act of such antagonistic
dimension that he galvanizes us all. And no more
than the paintings of Leonardo can his work ever
die, owing to the inner contradictions that forever
oscillate, the tremor that never ceases, so that you
do not ever "get to the bottom of it" and can have
done with it.

Usefulness is a rat in the corner, on which
the genius persistently seeks to tramp; he does not
try to express what he means, knowing that he
knows more than he conceives he means—he
knows that a man is larger than the physical uni-
verse so far as man shall ever know it. He is sad-
dened by the limitation of the great loveliness of
expression, but by this he is saved from being
amused, and this is one of the marks on him—his
nonobjectivity. He lays the coins of whatever may
be his medium of expression precisely on the pulse
points as in the moment they seem to him, and
sometimes he is lucky. For the rest, he fabricates.
Dostoyevsky wrote: "Occasionally you hit a pas-
sage and that alone you let stand. For the rest, it is
just grinding work. I revise every chapter over and
again." Counterfeiting—falsifying Dostoyevsky.

6.

PABLO PICASSO

APRIL 1962

Georges Ramié, master potter at Vallauris, the center of ceramics in France. He is a large man in shirt-sleeves like Fernand Léger. In town they say, "He loves to amuse himself better than work." Surroundings of the Picasso copies, owls, impudent fauns, bullfighting, the dance, all the iconography of Picasso.

GEORGES RAMIÉ: He came here in 1946 simply as a visitor. He asked to fashion a few pottery pieces and leave them with me for baking.
WF: Was Vallauris pottery still in the old-fashioned mustache-cup tradition?
GR: The war had broken things up. We were experimenting. I think Picasso sensed this and saw further into the possibilities of innovation than the rest of us.

WF: What happened?

GR: He went away. Silence for a year. In 1947 he came back, and when he had looked at his pieces left here he seemed to *see* them—as though they were discoveries his hands had arrived at almost by accident—but guided accident if unconscious—and he sat down right then and commenced.

WF: You mean literally made pieces then and there?

GR: In back—there, by the wheel. He became a Vallauris potter at once, made thousands of pieces now in the museums of the whole world, still goes on with it but sends in models from Mougins now, worked harder than any laborer—a real artisan. You got the impression his hands had printed what to do, in those 'forty-six pieces, and he had to wait a year to see.

WF: You'd say it all commences with the hands?

GR: You have only to watch him.

WF: A little like Nijinsky dancing? I mean, something that can't go wrong?

GR: He is an empiricist. That is why he has no school— though there are some imitators here in the town—goes from one thing to the next, creating while the theorists are arguing the sex of angels. It's a constant evasion of theory toward some eventual syntax entirely unforeseen.

WF: I'd like to get this straight from the *toro*'s mouth, not to be disrespectful. I know him a little—have gone to bullfights with him—only—

GR: *Toro.* Bull. He has that in him. Not in the sense of angry charge—that is his myth. But something solid and terrestrial and close to nature in him. I know what you mean by "only."

WF: You agree his art is like dancing?

GR: Like talking, more. You don't reflect in the doing.

WF: It's right you don't reflect in talking as you talk.

GR: You see him feeling the form. It's art in motion.

Chemin des Potiers, Vallauris. Portanier's penlike brush has everything of Picasso's, save the

originality. Lean, soft-spoken young man in blue jeans and sandals, fine-threaded brown hair, round as if cut with a bowl, naive blue eyes, but startlingly harsh with his child, gypsy-camp atmosphere.

PORTANIER: Radio Télévision Française interviewed crowds in the street. Practically everyone said defensively, "Well, we like his early things."

WF: They were the rose and blue periods. He was twenty-five when that ended. Fame is a peculiar thing because this town was jammed with those who came from everywhere for Picasso and only an infinite minority liking his art. I came on a proud old Frenchman a mile away above Cannes. He said: "I wouldn't go as far as Vallauris for him. These painters amuse themselves. It's the decadence of art." It makes me think celebrity may be some kind of universalized telepathy unisolated yet—akin to the peasant crusades of the Middle Ages.

P: Why should he see people? Besides, he's past eighty.

WF: Are you influenced by Picasso of Antibes?

P: If you like.

WF: I am very hesitant to attempt to sum Picasso up because I think that would be peculiarly likely to falsify him. If I am to be true to him I have to work out some principle of eliminating selectivity, as he has. Probably most of us work out some sort of theory almost as a sales approach to life and conform ourselves to it—then call it our "belief." Picasso flees static formulation, which if I am not mistaken he calls "beauty." You're really more a painter than a potter, using pottery as a vehicle because of Picasso-created demand. What do you think of his *Guerre et Paix* mural in the chapel here?

P: Badly painted and a work of genius.

WF: What do you mean by that?

P: Picasso is a bad painter in the sense that he has no feel for colors but he is a genius of form. The chapel is bad but great.

WF: Why great?

P: It moves you.

WF: Not me. It repels me. I have gone in twelve times. Tried. But it's like the Clouzot film—you see Picasso reach something, and then he deforms it.

P: It's the rejection of beauty.

WF: That seems mad in an artist.

P: Listen. When you try to learn the piano you employ a lot of effort—but a concert pianist has achieved a second nature where he lives within such skills. Picasso could design kilometers of "beauty."

LUCIEN CLERGUE (photographer launched by Picasso and Cocteau): Yes, he wants to be admired. Yes, he likes to form a coterie. Perhaps if my photos had been from other sources than his pictures . . . On the other hand, he has a real affection for *workers*—for those who work, who make an effort. One day I arrived at La Californie and there were still parts of a manifesto stuck on his portal. He greeted me—"*Ça va, Lucien?*"

"*Et toi? Ça va bien, Pablo?*"

He said, "*Tu sais comment ça va.*"

"Yes. We won't talk about it if you like."

"Yes. That would be better."

But he went on: "They asked a sketch of me. Why should I give it? They offer nothing—no work. You come here with work to show me. For you, I am at your orders. Whatever you want, I will do what you like. But I gave them nothing. Then they paste up a manifesto saying I am not generous. That is bad—eh?"

If your purpose is to grasp Picasso, an interesting method would be to study the pictures he's kept for himself. Why has he retained them? Because they are the best in his judgment, or failures he doesn't want to release?

WF: I am greatly mistaken if the Picasso method isn't to release everything. We argued yesterday over the undeniable crude infantilism of one of the sketches among the *Déjeuner sur l'Herbe* variations on Manet—from the octogenarian (extremely mature) hand of the world's greatest living artist! But the propulsion to non-self-criticism is profound.

LC: He won't hear talk of death or growing old.

ROBERTO OTERO (son-in-law of Rafael Alberti, the Communist poet and intimate of Picasso): When Breton died, I was there. He talked about him as if he were living. After Sabartés's death, his secretary, Pilar Solano Treviño, came to Mougins. Naturally she wanted to talk about the loss of Sabartés, which grieved her. Unload herself. Picasso made jokes at the expense of Sabartés, as though he were alive, and she was mortally hurt at the irreverence—and couldn't understand. But I am Spanish by extraction and can tell you that is simply Andalusian; all Andalusians do the same. It is a primitive way of shunting off death, like the Irish wake. The Evil Eye is a real thing to them—and in Spain and Italy they genuinely fear it. Talking about death brings it on, they think.

Did he really "marry" Jacqueline? Well—of course he did. But I don't think marriage, the legal state, makes any difference to him one way or the other. One day he said to Jacqueline, "Why don't you put on some nice clothes this afternoon and we'll go out?" He took her to the city hall and married her. She hadn't even known where they were going. He hadn't told her.

WF: But surely he did that because of the inheritance?

RO: Believe me, when Picasso dies it will be a real *pagaille*! He hasn't made any provision about the inheritance at all. He won't sign *any* document—he's superstitious about it. I think he marries a woman because he thinks she'll like it—a sort of gift to her.

COCTEAU ON PICASSO

WF: You are the greatest expositor of Picasso, I should think very likely including Picasso. Your testimony is invaluable because you have been with him side by side through the whole art revolution from 1916 onward and because you have said his principle of permanent revolution and refreshment in art is the chief single influence in your own creative work. Thus you know from both outside and inside. When the barbarism—African art—and then two-plane instead of three-plane surface appear with the arrival of Cubism and rejection of

perspective, and Picasso quits his early work—the Tou-
louse-Lautrec influence and then the *"pathétiques"* of
clowns and paupers in rose and blue—what theory does he
form?

JEAN COCTEAU: He has no theory. His creation ends here.
[He shows two beautiful thin-coupled wrists, exposed by the
retroussé cuffs. "If Cocteau is so sincere, why does he turn
his cuffs back all the time like that?"—Picasso]

WF: This quest after the reality of Pablo Picasso is condi-
tioned by exteriority of Picasso when he has become ob-
server of his own art, by the observers questioned, by this
writer who cannot avoid principles of selection in which the
clever could easily read his autograph.

JC (wearily smiling): These are things exceedingly difficult to
define. Were one to go into their true intricacies, his reward
would be that the auditor would turn away—because he is
lazy. An essential problem is that one cannot know, ques-
tions of formulation and art are too complicated for it to be
possible for one to foresee, and one simply does not know.
Perhaps Picasso says of painting that it is the art of the blind
for this reason. He never reflects, never halts, makes no at-
tempt to concentrate his expression in a given work . . . to
produce a *chef-d'oeuvre.* With him, nothing is superfluous
and nothing is of capital importance. He finds first, and after-
ward researches. Not, as is sometimes said, surfacing that
given by intuition—but rather accommodating to the discov-
eries of his hand. Like Orpheus, Picasso pipes and the ob-
jects fall in line after him, the most diverse, and submit to his
will. But what that will is . . . In 1917 I induced him to attempt
stage design, the settings for *Parade.* One day the company
was on stage rehearsing when we noticed a void—a
space—in the stage design. Picasso caught up a pot of ink
and, with a few strokes, instantly, caused lines to explode
into Grecian columns—so spontaneously, abruptly, and as-
tonishingly that everyone applauded. I asked him after, "Did
you know beforehand what you were going to do?" He said:
"Yes and no. The unconscious must work without our know-
ing it." When the first satellite passed over, *"Ça m'em-*

merde," he said—"That bugs me. What has it to do with me?" He is wholly concentrated on his work—more than any other man I know—inhumanly. He needs nothing outside his own closed universe. He rebuffs his friends—but sees non-entities. Why? Because, he says, he does not want to nurture feelings of resentment against those few he loves, who, alone, can disorient him. He does not want to resent their intrusion. Yet—how strange it is—that this art—so completely "closed" . . . that is, personal and isolate—has the great popular success. It entirely contradicts the shibboleth of the artist's contact with his audience.

WF: Do you think I can penetrate this closed universe and get his (undoubtedly partial and biased) opinion on him?

JC: He would tell you nothing. He *never* discusses the rationale. How can he, for it is a process of the hands—manual, plastic. He would reply with *boutades*—jokes and absurdities; he lives behind them, in the protection of them, as if they were quills of the hedgehog. His tremendous work—he works more than any other man alive—is flight from the emptiness of life, and from any kind of formalism of anything. Believe me, he does not know what to *do*, but he knows unerringly what not to do. His hand knows where not to go, to avoid the stroke of the least banality, the least academic—a *constant* renewal. But where it does go, where the line does go, is merely the only place left.

WF: Why does he deify the ugly? The effect on his psyche of the Spanish War?

JC: Goya. The real inspiration of *Guernica* was Goya. The author of *Guernica* was Goya. When he had been particularly heartless in a human situation I confronted him with it. "I am as I paint," he said. Look, friend, it takes great courage to be original. The *first* time a thing appears it disconcerts everyone, the artist too. But you have to leave it. Not retouch. Of *course* you must then canonize the "bad." For the good is the familiar. The new arrives only by mischance. It is a *fault.*

WF: You told me how pleasant the original sketches for his chapel of *La Guerre et la Paix* were, and how he progressively deformed them until we have the final work—which is

pretty frightening—and which you tell me made Matisse so terrified of being caught at producing conventional beauty that he deformed *his* chapel at Vence . . .

JC: He thinks of neither pleasing nor displeasing. He doesn't think of that at all.

WF: On the sound track of *Le Mystère Picasso* Clouzot suddenly asks him what the audience will think. He answers spontaneously, "I haven't given a thought to the public in years." That is a damn chilly moment. That and the scene when he draws magnificently—with one of the greatest hands in the history of art—effaces, obliterates, finally says: "Now I see where I am. Now I begin."

JC: You know he has said, "Reality is found at the bottom of the well."

A lean-faced, very masculine man, with gray-blue level eyes, a resonant French *r*, so resonant in the bass-nasal register as to be exceptionally difficult to comprehend, of the masculine world of Gary Cooper / Hemingway / Yves Montand / Picasso.

Nine-thirty at night and he had had a long day's physical work, but he ate very lightly and sparingly of white asparagus tips, veal, and berries, and he drank beer. Formless corduroys, workman's shoes, and loose brown sweater over his naked chest, the sleeves pulled up.

RENÉ DÜRRBACH (weaver, sculptor, friend of Picasso): Agriculture will support art. Otherwise you are in the hands of the art dealers and your integrity melts like *this*. A man has to be his own. I asked permission of certain painters—only the masters—at different times to weave tapestries of their paintings. I did it for money but also to learn by transposition, not copying, entering within their art processes. I did *Guernica* about 1955. Légers. Picassos. Delaunays. Picasso is the most modest of them all. He is a *monsieur*. He has a marvel-

ous sense of "things." He talks very little. I don't believe he has a gift of expression in words. He is a great plastician. He is an intuitive, yes. But spontaneous after years of inner reflection. Talk of art? Well—he talks of the canvases in work, showing them, but doesn't comment on them. I've a channel to talk, because he commences to discuss, compare my tapestries versus his originals.

"They don't like you, eh?" he said to me once.

"Who?"

"The others. Because this is good."

That gives you a glimpse within—if that's what you're looking for. Areas of his canvas are not even painted. You see this if you have to weave the space. The greater master a painter becomes, the thinner his paint. You see the stuff right through often enough. Cézanne's first things are thick-paint; he was searching, experimenting, didn't know what he was doing with surety—late, very thin. Picasso is extremely sure and rapid. He went at *Guernica*—oh, I think five times. You see the overlays. Tapestry isn't a copy of painting, because the materials differ. So *Guernica* in tapestry isn't, can't be—shouldn't be—"Guernica." Picasso alone knew this. He said: "Go ahead. Exact copies are impossible. Nothing can ever be done twice. Start new each time. Never copy!"

PICASSO: Too many things! Too many things! Too many things! There isn't any room for so many things! [Forty or fifty canvases, linoleum cuts, materials. He starts to elucidate several works—including the portrait of Jacqueline at present on his easel. Breaks off.] It's difficult to explain these things.
WF: Who can explain Picasso?
PP: It's necessary to understand . . .
WF: Can you?
PP: Sometimes.

When we had entered the heteroclitic room, Picasso sprang up, naked to the waist, wearing narrow-legged elegant slacks and loafers. His

black eyes a-twinkle, he greeted us gaily. "An American author," Dürrbach, the weaver and sculptor, said. "Very well. How are you?" Picasso answered—with an expansive let-come-who-may shrug—in English. (He spoke some English. Jacqueline, who learned it all in school, is fluent.) I reminded him we'd met before, at bullfights. In French, which he used thereafter: "I remember you. *Tiens!* Because of the beard." Immediately infectiously cordial: "I am very glad to see you again." Jacqueline came in. She offered her hand and said shyly—as if it were possible one couldn't know—"Jacqueline Picasso."

Masons were building nearby, adding on another wing to the great house to accommodate the ever-swelling welter of "things," and one glimpsed their plaster-dusted bodies, naked to the waist. Picasso thrives in such atmosphere, which seems to reproduce him in images outward. The "butler" at the door, which opened without ostentation under shaggy great firs, was a stooped, thin man with a creased, concerned face, rivered with character, and in ordinary brown pants and a tieless shirt, the opposite of jacket or livery. There was a desire to be the naked camera lens, simply inert, to record everything . . . for was not all germane to Picasso, and what assorting principle could there be? Two dogs: the one an elegant Russian wolfhound, the other a mongrel. ("Each man has in him a 'night' which is unknown to him and is *unknown,* and expressing it is . . . what art has become" were the sad words of Cocteau.) A powerful impulse not to *compose* . . . "I should think I have to

do the anti-Picasso," I think wryly, "and damn
well keep out of it—and be as neuter as a lens." A
regal disorder. Toys (a little wheel that rolled and
returned on a looped track which made a kind of
cage); packets of photographs from David Douglas
Duncan in New York as yet unopened; I recall
Cocteau telling me of a parcel of a Christ or cruci-
fix which he saw waiting to be unwrapped amid
the Picasso clutter for *years;* kaleidoscopes (four)—
they were the new types that do not pattern with
bits of glass but rearrange the outward world like
little distorting telescopes—and Picasso demon-
strated them delightedly (in sequence, to everyone
who came in later). In kaleidoscope one saw some
van Gogh sunflowers in a tall vase and Jacqueline
Picasso from four or five portraits on the wall frag-
mented and recomposed (but in one or two of the
portraits she was fragmented and recomposed al-
ready). Polish discussions of his work, French art
newspapers, a U.S. monster-size art edition about
him. Handsome Louis XV–looking furniture, also
a tubular steel blue-canvas garden chair, a tat-
tered chair, silk split and stuffing coming out; it
takes an effort of perspective to realize the incon-
gruity and recognize one is not accustomed to see-
ing tattered furniture in a millionaire's house.
Photos of Picasso everywhere in every pose—in his
rocker reading *Los Picassos de Picasso;* with Domin-
guin and Bosè. Little probability there isn't a mes-
sage here: at the bullfight in Arles he was in a
Spanish cloak closed by gold frogs and lined in
scarlet; he came into the enormous jamboree in his
honor in the Palais des Expositions of Nice, many

of the greatest Soviet musicians in the world there to salute him. Picasso was wearing a jacket of black horsehide—that at a little distance glistened like a dinner jacket. The following day he wore a corduroy worker's coat, but with gold buttons. One doesn't forget that naked chest exposed in the Clouzot film—same chest, monstrously healthy in a man his age, exposed before us now. (Dürrbach is to whisper to me later, *"Everything* is dramatic." I: "But one gets lost.")

There are rooms in the house in which there is nothing whatever, perhaps a telephone standing on the bare floor. It gives the note of a place into which the inhabitants haven't yet moved. The large front rooms are after all (*define* in the Picasso world at your peril) in a rough way classified. Room 1, where we are now and Picasso is joggling Balthazar, the son of René Dürrbach and his wife, Jacqueline de la Baume, in his arms, is the reception room. Room 2 has the paintings. Next room beyond, Room 3, making a corner of the California-style house, a long, narrow room with wrought-iron balconies looking, at a distance, to where the Esterel autoroute departs from Cannes to shoot toward Fréjus and the truer Provence, holds ceramics, Jacqueline repeated over and again in tiles. (Downstairs, a double room and veranda house sculpture.) Jacqueline repeated over and over by the hand undoubtedly guided by . . . I sense a distinct instinct not to sum up, which prevents me from ending a sentence.

Hold on—humanly, there is no Mystère Picasso. He is undoubtedly enchanted with

Balthazar, this infant of six months much the most important personage among us. He is without question a bright-eyed, inquisitive, small man, startlingly small, without pretension of any sort— in fact, as slowly dawns, miraculously *not present* to himself; that is, un-self-conscious in a way that urges reminting of the word. Have you *ever* been listened to with such attention by any human over the age of twenty, not to speak of the great? Why, human conversation is a matter of waiting turn— of giving the pale courtesy of apparent "listening" during the intervals—two rather ill-mated monologues. Pablo Picasso is a wholly different affair; listens, is alive with curiosity at what you are saying—it is true that the next moment his attention has gone somewhere else and you have evaporated (but he returns). Jacqueline comes up to him when he has for a moment been willing to define a splinter of his art reference and touchingly and humorously it is as if some earnest other person had sought to do this when she beams with a radiant, surprised approval and says, *"Je vous adore,* Pablo"—rewarding him by kissing the side of his neck. Picasso, who calls her *"tu,"* thinks this over. *"Ça c'est bien. Ça c'est très bien,"* he says.

What is it about Picasso that makes him different from everyone else? He is never bored. I check this against bullfights—yes. Jacqueline is the one who is different. She has something orderly, neat, about her when she appears with him abroad—here, barefooted, in slacks, she is terribly sensual.

I meet Paloma, Claude. Paloma does not

remain very clearly in my mind, but three are burned in my recollection from that afternoon— Picasso, Jacqueline, Claude. With time I find out why.

In the room of the ceramics is a space of floor large enough for the laying out of Dürrbach's and Jacqueline de la Baume's tapestry—actually she sits at the loom, in a large Provençal house which still belongs to the dead Albert Gleizes, rationalist of Analytical Cubism, and Dürrbach does the plans.

DÜRRBACH: What do you think?
PICASSO: Hmm. It's good. Jacqueline, don't we have the original of this one around the house somewhere?
RD: The client is here. He won't buy it. He doesn't like this gray border because he thinks it won't suit the wall he's prepared for it in his New York apartment.
PP: Cut it off. Fold it under.
RD: Look. The pagination. The organization is centrifugal from the nose here at the center of the body parts, but this yellow shovel . . . look, it's balanced by this extra breadth of gray border on the right. And has to be.
PP: You did it on purpose? Then all right. Weave another one for him. Somebody will buy this one.

His eye fell on a painting of his on the side wall, one of the few in this room mostly filled with the plaques of Jacqueline. He said: "Dürrbach, this would make a tapestry. It's good, no? but the date would have to be left in. You must weave the date in."

"Picasso, look here, my blue is exactly your blue from the point of view of color analysis . . . but look, it's different. It's mine—that's yours."

Nobody had seemed to know where the original of the tapestry was, but a blue was seized in another canvas. (Gleizes writes somewhere: how can critics who are not painters write about art, because in fact they know nothing about it? Later during this afternoon at Notre-Dame de Vie, Picasso interrupts an art discussion: "But talking about painting is like talking about music apart from the violin, and it is something that happens between the man and the violin when they are together.") I have the strong feeling that that "centrifugal nose" stems from Gleizes, who was Dürrbach's mentor, and not from Picasso ... all honor to Dürrbach. Yet it is true that the nose is centered, and once this has been pointed out to you, you reread the work thus (probably forever). As I am wrestling with these imponderables, the artists have gone to talking of materials.

Picasso roughly chafes the face of one of the new tiles which he has made of Jacqueline's dark head and had baked in the Ramié furnace. And what interests him is neither brushstrokes nor the head of his wife, seemingly, but process—that new process by which this surface becomes impermeable and, scrub as you wish, Jacqueline cannot be rubbed off. And when later on I gaze with astonishment at a squat, phallic little man in the garden studded all over with tiny grotesque humans bursting out of the flesh and say, "How did it ever come to you to imagine a thing like this!"—he is utterly delighted to be able to tell me he did not imagine it at all, but it is a copy of a piece from the "Breeteesh Museum" and imagined

by someone a very long time ago. Yet what really intrigues him is the way it was gotten out of the material of the original into this different material here, and he turns from me to Dürrbach, despite a human generosity that expresses itself in courtesy, in his occupation with this *process,* for of course I am carried out of my depth.

There is a constant play, a constant effusion, in the Picasso world—I remind myself of the danger, then the courage, very probably finally the real arrogance, involved in forever seeing everything fresh; the refusal of codification ever of anything. Sterility is after all "knowing"; stasis (very comfortable, as Cocteau points out) comes at the end—the conclusion—of a search. I suddenly overhear—as there has been a commotion in the outer rooms and we are leaving that of the ceramics—Picasso explode with contempt saying to Dürrbach and Jacqueline de la Baume (both technicians who must in the final count deal with materials, concretes, as he does himself): "They will never produce anything good there at Sèvres—because they work serially! What can that lead to? Pof! Pof! Pof!" He is saying scornfully a moment later as we leave the room, ". . . They fill in the spaces now, trowel in the cement between the stones. But the ancient Peruvians fitted the stones together. The earthquakes came, but the walls are still there. What worth has what is done now? As soon as you learn how to machine-cut stones . . . everything is finished." These men have a syntax. They are speaking a language that is not ours. Not merely the artisanal language, or that of doing-

in-the-moment-of-doing, which is Picasso's "violin participating in the music" and which every creator knows carries his act, by its infinite intricacy and simultaneity, out of the world of static analysis. From Cocteau, one has learned that these men are speaking not in paradoxes and clevernesses (Cocteau appears to do so in cold print; one must modify him in setting him down in text to prevent the abstraction of his human tone entirely misrepresenting his questing and perplexed spirit) but are talking a language sprung out of Montparnasse and used by them, within what was at first a closed circle, over more than fifty years. By the suppression of "subject," the refusal of summation, they have overturned the sense of things. I feel I am nibbling on the edges of this when I am capable of getting what Picasso means when he says to me—with a perfectly straight face—of computers: "But they are useless. They can only give you answers." How easy and comforting to take these things for jokes!

Cocteau relates somewhere that when Picasso quits being "Picasso"—for he must rest too—and, for example, paints a head of Paul (almost as if he were Renoir), then everyone feels the relaxation and is happy, Picasso, very probably, too. For *he* is more like that. Only—it isn't "Picasso." Then soon enough the ferocity returns. "He is the most modest of them all," Dürrbach had said. "But he absolutely hates mediocrity, of course," he then had added thoughtfully. I realize I am seeing a sunny Impressionist's afternoon Picasso . . . There is too much evidence of the feroc-

ity, the cruelty, of this sprightly little man here—
the tragic and inhuman termination of his first
marriage, for instance, so far as the story is
known—for me to think "my" Picasso is entire.
The Impressionists said to the earlier painters who
thought themselves literal realists: "A haystack?
But it doesn't exist. A haystack when? Is it the
same at midnight as at noon? You, dear old anti-
quaries, are painting the *idea* of a haystack." Much
more than this, Picasso strewed through my whole
afternoon the tacks of a far deeper frustration.
Shall I strew them for you? "It is an 'other' who
does the painting," he said. "Rimbaud talks of
creation as the work of the 'other' . . . and this is
true." Seated in his famous rocker in front of his
easel with his current work of Jacqueline unfin-
ished before him: "Look, the other goes there to
the canvas and does my work for me, and I could
just as well stay here and read a newspaper. When
'he' returns I am refreshed, and not tired." Touch-
ing his bald forehead: "It's not here. It has nothing
to do with this."

The commotion in the outer room, that of
the heteroclitic array of things, had been occa-
sioned by the arrival of a whole small horde of
people—about half a dozen Americans, two of the
owners of one of the seven art galleries in New
York at that moment showing simultaneously (a
fragment of) the perspective of Picasso, and their
passe-partout and translator, a European woman
"of a certain age" but with good solid Picassan
bread under her deceitfully simple-looking *haute-
couture* frock. At the thought one recalls the Pi-

casso paganism, the kind of woman-forms he has chosen to depict through his whole career; his is probably a different Mediterranean from the "Riviera" of these who have just arrived. The Mediterranean is inextricable from his work—the sunburnished half-naked potters of pre-Christian (and pre-Platonic Greek) Vallauris. And with these visitors are Claude, Paloma, and Jacqueline's fourteen-year-old daughter, with a dachshund; the animation becomes at once that of a "cocktail party" and Picasso takes it well: gnomishly smiling and making his eyes wide in astonishment, then wriggling into a fawn-colored sports shirt to hide the chest, but getting it on backward, and it has to be turned around with everybody's help. It is very much the reprieve and diversion of a "Renoir" Picasso of Paul, and—fortuitously—after Picasso has made everyone look through the kaleidoscope, greeted everyone with a strangely sincere directness and interest in them, looking up straight into their faces from his small stature, there is the "affair of the *culotte*." This piece of nether underwear is turned up mysteriously in Picasso's atelier. Very much confusion and merriment. Whose can it be? Two Manhattan women arrive at—separately—the same retort. "Can't be mine! I don't wear them!" they explode. (I doubt this.) Balthazar has vanished somewhere to sleep, but now someone cries that they must have been left behind by Balthazar. Jacqueline Picasso: But, no, they cannot be his! Why? But they are too white!

The tour commences. We are led by a

bright-eyed, lively little cicerone, who happens to be Pablo Picasso. He is intently interested in our reactions—to the materials, techniques, even sometimes occasions of these Picassos. A tableau is fetched out from the back of a stack, and the linoleum cut with a shiny patent-leather black has also a scarlet that might be blood run fresh from the goring of a matador—much exclaiming over this! How red the red is! The *glaze* on the tile of Jacqueline's head plays its role a second time, incites enthusiasm. Picasso is fascinated by our responses, as he had been when offering the kaleidoscopes, watching intently, arms crossed over chest and hands tucked into armpits, as is characteristic. What do we see?

There are several variations on a coach dog, a white animal with black spots and a wistful expression, simply titled in Spanish *Perro*—this is Picasso's Dalmatian—but the serial subject infesting the house is of course Jacqueline. I have by now afforded her a good deal of amusement by my "quest." She has taken to looking all about her in merry mock search at moments: Where is this thing Genius?

It takes a good deal of nerve, I can tell you, to call a man a genius to his face, though he may well be, and I have preferred to talk with Picasso of bulls and such matters. Nor, looking at the paintings, does anybody, including the professionals from New York, including Picasso himself, think to say more than "It's good, no?" or "That scarlet is tremendously scarlet." Picasso's interest, after all, is in *us*; I had noticed that whether it is a

trinket, a child, an artwork, myself, wherever he ventures he is not in Picasso—yet one feels Picasso never ceases to be Picasso ever, a *toro* of a man. I remember Cocteau's saying how on strolls in Montparnasse years ago Picasso made his real harvests, collecting the seemingly least-related objects. What is this house where we are now but the silo of a harvest? "The king of junkmen and a junk dealer king!" Cocteau had exclaimed lyrically, with a kind of ironic admiration.

Downstairs, the New York art dealer says, "They're going to institute an educational television chain in America, and I've been deputized to ask if we can have a Picasso owl for the emblem or symbol—you know, to open the programs—you know, the sign of wisdom . . ." A lank Bar Harbor sort of man with a Saint-Tropez tan, he puts the question diffidently. "Why not?" Picasso explodes. "That is very easy. Jacqueline, where are all those owls we have around here?" Massive owls on the fireplace mantel, beaked owls in tin, a strange small hump which in some mysterious manner *suggests* an owl—and Picasso loses himself in comparison and examination of owls.

Since I have confessed myself to Jacqueline, I finally broach it with Picasso. After all, doesn't he specialize in the *in*appropriate? So I throw off the social shackles and say—what is simply the honest truth—"I suppose I'm trying to catch creative genius on the wing." Instead of smiling he replies with another meaning: "That is the only way *to* catch it." He veers, as with the owls, to something else. Easy to say Picasso is not

"serious," but it was serious to make *Les Demoiselles d'Avignon* in 1906. This braving the horns of the question of art, face to face with the man in a social situation, is (in minuscule) a *Demoiselles d'Avignon*—certainly unsuitable. For reward, however, I have the witness that genius is fugitive— from one obliged to spend a good deal of time attempting to catch it, though his hand may arabesque more than suits our sense of appropriate solemnity. "Contrariety is the spur—eh? *Peut-être?*"

Picasso goes on conducting the show. He is the "animator," as the French say, and to suppose that he doesn't know it would be naive. Yet he isn't really self-conscious. He has a natural and instinctive dramatic sense, as common to his unexpected torso as are his always startling clothes. He is detached from his artifacts, in a most curious way, yet, after all, hasn't Picasso center stage? What human asks more? And I catch myself asking what would happen if, drawn on by his open generosity, anyone should contest him this? And indeed I have heard what happens when, as is naturally so rare, he is opposed—to any degree at all—or if anyone fixes him, or even worse his art, with the cold eye of objective scrutiny. (After all, he does not permit this even to himself. "How can the critics criticize my work?" he said to me. "I don't permit that to myself.") And I follow with the crowd through this "Picasso Museum," trailing a little bit behind like a shoplifter and filching points on Picasso and on art, and not always lis-

tening to the lecture. Picasso says—when we all react to his model of the *L'Homme au Mouton*—which stands in the marketplace square of Vallauris and with the chapel facing it is the center of Vallauris, but which in its moulding here serves as a clothes rack for his children and is hung and strewn all over with his children's clothes—laughs: "Art requires disrespect!" And when I say, "Yes, you can't afford to make a cathedral of it or people won't go in," he offers me a sudden flash of shrewd smile. Nor does this collector fail to know the money value of his Picassos. "Be careful. Nothing divine keeps it upright. It is on this base—look. And if you knock it over it will smash. Then what?" he says when one of the children has darted too close to a crazy zigzag of statuary that is ballet-pointed on what may be one toe. Unconsciously he says this with the suggestion of illimitable possibility of disaster as if you or I might say, "And if you smashed my Picasso, then what?" A queer, weird woman in dead-white plaster is evidently a child's nurse—and, yes, when the identity of this Dickens personage has been confirmed by the actual baby carriage, which is a small, real pram that has been dipped in plaster, Picasso stands back and looks interestedly into our faces: Now what are we going to make of this? The infant who is going to go into this piece of art turns up on the other side of the alcove, which gives out to the veranda where stand the famous iron pregnant Picasso goat and other of the heterology. Physically this plaster child is the replica of one of

those at Pompeii, cinderized in this rigid agony, but—but this child is dead white—and in time I grasp the image, one of the frozen children I had seen turned up out of the avalanche slope in the Walsertal, in Austria. Now Picasso was not there; where *do* these hands get their materials? One *hopes* out of intuition or physical skill.

I am "touched," of course. Suppress these thoughts, as one might well have suppressed *Demoiselles d'Avignon* in 1907. Even though I know what has pushed me to this—*my* incursion of the barbarities of African art. On the real plane of life, Picasso says with great delight: "Look! This is a piece of pipe from a ceramic furnace at Vallauris. And it is all of things like that." And he raps a lady made of welded junk. Someone spots a round object once a boiler joint and exclaims, "She has an African drum!" Picasso gazes, mystified, squat and stocky, hands under his armpits and arms crossed over his barrel chest. "Yes!" he decides suddenly with enthusiasm. "She has." He puts his cigarette into her iron flat-lipped mouth. He does this in such a manner, at such an angle, that the character of the being is changed; and he recognizes this, for he glances very briefly and then says, "And now she looks entirely different." We go back upstairs. I think—strangely—we are all quite tired out. In a moment the Americans are to collect in the reception room and talk in English, as if in release from a great strain.

Probably Picasso was the least tired of us all. But he is an assimilator, a reactor, in a constant state of interest in things, like a child, in a

world in which—save when "the other" is paint-
ing, and this the Rimbaudan other does blindly—
value judgment and the very possibility of value
judgment have been suspended. For the rest of us,
there is perhaps a sense of collision, as we follow
Picasso about through this heterogeneous maze of
the Minotaur. If his heterogeneity were at least
single-stranded in a phase of time . . . but it is not,
and schools, epochs, and strata of art and of the
art of Picasso lie juxtaposed in his house, bearing
the date of the same week and even the same day
of composition. One thing I glean. At one mo-
ment, just when we are by the object teetered on
its "toe," he suddenly says of Claude, fifteen, how
much Claude, with his straight lock of hair over
one eye, his sullen gypsy look, his square head, is
himself when he came to Paris. And at this a
whole album of photographs vaults into the mind,
and one knows, reviewing Picasso through those
years, what secret it is Claude brings to the com-
plex.

Picasso sinks into his rocker. "*Je travaille.
C'est tout,*" he mutters, almost to himself. "I work.
That's all." And somehow I do not tell him I have
come to him fractured, like a Cubist schema, by
four years of intense study of the art which frag-
mented. Leonardo had, as Picasso, one of the most
consummate hands in the entire history of art; and
by breaking up the "unities" of life by suppressing
the links, smashing the idea world to its concrete
fragments of disparate things, Leonardo had
opened the way to the illimitable possibilities of fi-
nite inventions and—

* * *

PP: Painting is manual; it is physical. You find in the materials with your hands. You have a blank piece of canvas. The picture is already there. You scrape for it.

WF: Then is the genius in the hand . . . ?

PP: Ah, maybe not even there.

WF: Then . . . elsewhere? [A sketching gesture of my hand as if to indicate heaven or far corners.]

PP: No! A man is here—where he is.

WF: But it is the hand?

PP: Yes. Nijinsky—ah! He would make a gesture like this— same as anybody else—but longer, longer. I don't mean in length. The difference between the good and bad is not the breadth of a hair. A friend of mine copied a Cézanne—exact copy; you could not tell the difference. But the one was good and his was bad. Why? An orchestra plays pure notes—''no good.'' Science. Man goes to the moon, and then? Man does not change, always the same, always the same, always the same amount of the good and the bad, like a horse or a bull in the field—and that is why there is no progress, and can't be. I hate to end things, you know, when I paint. How can anyone end anything?

WF: I share that.

PP: A hundred painters are better than one—than any *one*, given that they are units in themselves. But there is no multi- plication in human beings . . .

WF: Maybe genius is who-knows-where? Your hand, for in- stance. What authorizes us, aside from the mere stage of our present psychological knowledge now, to say its propulsion is your ''subconscious''—your—another culture would have said it is a somewhat puckish God, or Pan—

PP (abrupt grunt, but with a flick of smile; these are plainly pastures where the Minotaur will not venture): Those in there—they are on vacation, so they think I am too. I am never on vacation. I work. *Je travaille. C'est tout.* [He is wait- ing—with really an enormous patience, considering—for us all to clear out. And shortly we go.]

Why is Picasso called protean, to the ex- tent that his creativity has been likened to that of

God himself? Because he has protean goals? Or rather because he has no goals? Upon reflection, it is clear the result would be the same: an unlimiting intention, or no intention whatever.

On the main square of Mougins, Jacqueline de la Baume tells me: "He was very chic with us. It seems everything passes by, and his attention flits off to other things. But he took the trouble to sell the tapestry, to one of those Americans there, and he waived his share."

Picasso is loquacious but not theoretical. He does not skirt theory as a mystic might who is afraid to know, theory is overtaken by all the concrete elements that make it up. He either hasn't time to get to summations, or else he is too *here* to take the savant's-eye view. Sometimes he is pensively silent—crinkling his forehead, squinting his eyes—uttering a *oui*—a *oui* . . . he absorbs, ingurgitates. Humble interrogator, I do not serve him as a mere springboard—he offers me no royal consideration, which would have a grain of condescension in it very un-Picassan; I fascinate him (transiently), happening to be human. And yet I would insist I am probably a human "object" for him—and that he participates in me, which he remarkably does, without leaving himself. This is, finally, the complaint of his friends. One has tended to think him capricious—an Orpheus-piper marshaling behind him the data and minutiae, arrogant. *Capra:* goat, bounding, virile, inquisitive. It is true he has been freed by a gift divine or material (we

do not know) as is the lightning, and by that extraordinary Montparnasse revolution in contemporary art, by these combined conditions liberated to do just as he wants. Had he not been Andalusian, he might have perished of ennui and frustration—the Doris Duke syndrome. I had gone to him expecting to find him suffering from lack of limitations. Art lost in the void. Too much freedom. The *nothing*ness of everything. No. He retains the vivid interestedness of a child.

Finally I had tried to draw him out on Leonardo, the linkages and similarities binding these two men closer, it might be claimed, than either is bound to any other artist. ("If you follow rules you will never get to the beginning of anything."—Leonardo da Vinci) But one draws a blank just where the average practitioner would probably be self-intrigued; that is all distant for Picasso, who is in the immediacies.

You cannot see Claude Picasso in a blue cotton shirt with cuffs too long, carelessly open, barefoot, with his great black smoldering eyes, and never once smiling, without knowing that here you have—far more than in the little old man—Pablo Picasso of the 1900–1910 period. Picasso may have invented Jacqueline—or chosen her; she is in his work long before he knew her. All the same, the enormous sensuality and young force in the "late Picasso" stem from her, from Jacqueline; at the scene of the origination of these works, this is undeniable. A triumvirate: Jacqueline, Claude, Pablo—together being "Picasso."

* * *

ROBERTO ROSSELLINI: The main thing is the very existence of Picasso. That dizzying change! That dizzying search! How many turns you can do with your brain, like an acrobat. Then it is perfectly normal to put the ear in the place of the nose, or the nose on the forehead. I am not against it if it is a complete, sincere, urgent need of a person in a certain moment. But I am against it if it is rule.

WF: Aren't you speaking of yourself?

7.

PICASSO: WRITER

In *The Four Little Girls* Picasso expresses the confusion of ambiance—the raining in on one of the surrounding atmosphere, a variant rain compounded of illogical particles selected not because they suit but because they are there, and the four little girls, naked, usually, are subjected to this. He is not "analyzing the universe of a kitchen garden," with four little naked nymphets in it. (He said: "How do you establish yourself in art? You paint nudes. They come to look at the nudes—and get the art without wanting it. But don't ever start with the art.") He is showing life as it is, for him, in its simultaneity.

His writing is an excellent entry to his painting—perhaps more accessible. It is literal, at the same time illogical, because it scamps usage.

He said to Sabartés: "You say I should correct my French to rules of grammar? What have rules that did not take me into account to do with me? No, it is the crook in your hand that matters, not your 'intelligibility.' "

He is a voluminous writer. He said: "I have written far more than I have painted. I will be remembered—if I am—as a Spanish poet who produced a few paintings that may last." He is not wholly joking; he has written some of the best poetry of the age, and the children's notebooks in which he wrote number up to unexpected totals—if their existence is undisclosed to the public: as that of *hoards* of his paintings, of which glimpse was given from time to time, with elfish humor in which there was something almost malicious. In his secret room at Mougins, the only one to which he carried the key himself, he had uncatalogued Douanier Rousseaus. "How should they be catalogued?" he asked with innocence. "The douanier gave them to me. Who ever saw them?"

His plays, his many poems, are replete with imagery very *his*. Uniquely. And the ordering and tumble of it too. Sometimes Picasso's images are terribly expressive. The third little girl in the second act of *The Four Little Girls*, naked, enters with her doll larger than herself and chained with flowers, finds a goat, lies under it, sucks its tits, and caresses it—*Handsome young man, my lover, my sun, my centurion, my furious goat, my hands in butter, my lie* . . .—looses it, cuts its throat, takes it dead in her arms, and dances with it.

* * *

Here is an example of the fluid and subter-
ranean, but not external, sense of Picasso's poetry.

DREAM AND LIE OF FRANCO
(My translation from the Spanish; alineation, punctuation,
Picasso's)

dance of owls marinade of swords of octopi of evil augury
mop of skullcrown hairs of foot in fear of frying pan clodded
into club placed over the cornucopia of sherbet of fried cod in
the mange of his heart of castrated one—mouth full of the
louse jelly of his words—rattle of plate of snails tangling
guts—pinkie finger in erection neither grape nor young fig—
commedia dell'arte of snarling and of befouling sky-
clouds—beauty products of the garbage wagon—theft of
the Meninas in tears and in TEARS—on shoulder coffin full
of pork sausages and mouths—rage contorting the sketch of
the shade [darkness, shade section in bullring] flagellation of
teeth nailed in the ring sand and the horse open from flank to
flank to the sun which reads it with the flies that hasten to
nodes of the webgut squirming with sprat skyrocket of
lilies—beacon lamp of lice where are the naked rat-dog and
the hiding place of the palace of old rags—the flags that fry
in the pan flop in the black of the sauce of the ink profuse with
gouts of blood that submachinegun it—street rises to the
clouds bound by the feet to the sea of wax that rots its viscera
and the candle over it dances and sings mad with fear—the
flight of fishing rods and first of all the scree-scree of the bur-
ial of the removal van—broken wings rotating over the cloth
of spider of the dry bread and clear water of the ragout of
sugar and velvet that paints the whipcut in its cheeks—the
light covers its eyes before the mirror that monkeys it and the
slice of marzipan of the yolks bites the lips of the wound—
screams of children screams of women screams of birds
screams of flowers screams of wood and stone screams of
brick screams of beds of chairs of curtains of cat dishes and
of paper screams of smells that tear themselves apart
screams of smoke thrusting into the fighting bull neck hump
of the screams that cook in the cauldron and of the rain of

birds that inundates the sea which wears away its bones and breaks its teeth biting the cotton that the sun sweeps onto the plate and that the money market and purse hide in the groove the foot has left in the rock

He writes in the *Entierro del Conde de Orgaz* (untranslated)—"the light that dungs the white of velvet that makes gallop the clasp knife blade aspen and sunfish the call of the candle over half the hand lain feet in the air on the scrap of table-cover of the silk of the arm flung over the gape of the gulf of the pen drawing the color of his memories and his voice of rainbow of the perfume of fried sole and of the smell of fish and watermelon and the air of cigar smoke and clams and basil later at two-thirty or three in the morning beside the beach in Barcelona in Barceloneta a Saint John's Eve wrapped in strips of silk paper"—writing then at seventy-seven.

MOUGINS, 1968

WF: I am disappointed by your biographers. Brassaï. Vallentin.

PP: They have not really got me, have they?

WF: There is one writer who has got you.

PP: Who?

WF: You. In *Désir*.

PP: Ah, *oui*! There is something in it perhaps. But there are thousands of things. Thousands. [His gesture means to include the million artifacts in his house.] But that play was a pastime. A piece of nonsense.

WF: You have been reading your commentators. Brassaï. You are Big Foot, aren't you?

PP: Yes, I am Big Foot. At that time. One isn't the same half an hour before or half an hour after. If you put a bird on a blue

background it won't be the same as a bird you put on a red background. It can't be, *can* it? [Something wistful in him—a quality seldom recorded, but very much part of him. The Picasso world is so enormously contradictory.]

WF: *Desire Caught by the Tail* is a great play, independent of the fact you wrote it. It doesn't have to rely on that. It is the key to you, a means of approaching your painting up another channel, perhaps more accessible to many. A door to one of the great spirits of our age and your real inner view on painting, sex, and the world. It is a very great deal better *as play* than Genet's *The Blacks,* for instance.

PP: You are making me blush. [Textual: *Vous me faites rougir.*]

WF: It need not ride on your name. It was written in 1941?

PP: Yes. It was played at Leris's [Michel Leris, a French writer and critic] place during the war. Camus staged it. And Jean-Paul Sartre was Roundbottom. Raymond Queneau played Onion. Dora Maar was in it. And Simone de Beauvoir was Imbecile Girlie.

WF: Has it ever been staged?

PP: No.

This wasn't true. It was put on in 1967 just outside Saint-Tropez, the mayor of the town having refused a permit when he heard La Tarte was going to piss on stage. The stage direction states: *"She squats in front of the prompter's box facing the audience and pisses and gonorrheas"—pisse et chaudepisse,* untranslatable joke, but you can see what he meant—*"for a good ten minutes:* Ouf! That's better!" La Tarte is written to play "nude except for wearing stockings," and Marnie Carbonetos, the Paris stripper, wore leotards, but she was breast-bare. After the war, there was a reading in London in which Dylan Thomas took part.

* * *

WF: But the English translation is inadequate.
PP: Why don't you translate it then?
WF: Do you have the rights?
PP: Gallimard and I.

Big Foot is in the corridor of Sordid's Hotel. Picasso wrote the play in four days—from Tuesday, January 14, to Friday, January 17, 1941—in Paris in French. I asked him why he worked so fast. "To keep myself from getting between myself and it," he said. "You can never work fast enough. Never! You must always work faster!" This applied to his painting as well.

He said: "My favorite painter is van Gogh."

"Because he is best?"

"No. Because he is van Gogh. He is not always good but he is always van Gogh."

He told me his *Burial of Count Orgaz* had nothing to do with Greco's painting *The Burial of Count Orgaz*. But this was not even true. "In the sky of the burial of Count Orgaz, Pepillo, Gallito, and Manolete"—and the bullfighters repeat the trinity of the Greco picture. He wrote *Dream and Lie of Franco* at a single go, in 1937, in a calligraphy somehow weirdly calling up the Rosetta Stone, as though the script were not of our age, and he made only one deletion in the original manuscript.

BIG FOOT

Onion, enough chatter—here we are Christmas-benighted and ready to tell the four fundamental truths to our cousin. It's time to explain once and for all the causes or consequences

of our adulterous marriage—you shouldn't hide its shitty shoe bottoms and its ruts from the gentleman rider, respectful of the seemly though he may be.

BIG FOOT

Thinking it over, nothing is worth sheep stew. But I like better hash or burgundy beef well cooked, a happy day of snow, by the meticulous, jealous care of my slave cook Slav Spanish-Moor albumen-in-urine servant and mistress—thinned out in the odoriferous architecture of the kitchen. The pitch and glue of her ideas apart, nothing beats her stare and her hamburgered flesh on the calm stretch of her queenly movements. Her changes of humor, her hate stuffed hot and cold, are nothing, right in the middle of the meal, but the little needle of desire cut with meekness. The ice of her nails turned against her and the firepoints of her chilled lips on the prison straw brought to day alleviate nothing of the scar of the wound. Lifted chemise of beauty, her allure, allegro, allayed to her breast, and the depth of the tides of her grace scattering the gold dust of her look in the corners and recesses of the kitchen sink stinking with drying laundry at the window of her whetted look whetted on the whetstone of her snarled hair. And if the aeolian harp of her crappy, common obscenities and gross hoots scratches the shining surface of her portrait, it's to her unheard-of proportions and touching propositions she owes the avalanche of homage she gets. Hurl of bouquet of flowers that she nets in the air, within her hands sobs out the royal adoration of the victim. Clear in thought, love at rampage, the painting born at morning in the fresh egg of her nakedness leaps the hurdle and falls panting on the bed. I carry the scars on my body; they're still throbbing, they cry and sing and prevent me from catching the 8:45. The roses of her fingers smell of turpentine. When I listen in the ear of silence and I see her eyes close and breathe everywhere the perfume of her caresses, I light the candle of a sinner with the matches of her wants. The electric cooker's got a broad back.

BIG FOOT (to Imbecile Girlie)
You've got a well-made leg and a well-turned navel, bitty waist and hallmark tits, maddening eyebrow arch, and your mouth is a nest of flowers, your hips a sofa, and the jump-seat of your belly a *barrera* for the bullfights in the bullring of Nîmes, your buttocks a plate of pork and beans, and your arms a soup of shark fins, and you and your swallow nest again the fire of a soup of swallow nests. But my cabbage, my duck and my wolf, I am going mad, I am going mad, I am going mad.

The Burial Of Count Orgaz (Gustavo Gili, Barcelona, 1970—untranslated from Spanish), written in 1957 when he was seventy-six. Of the banquet after the postman has "made plentiful harvest" with his sister-in-law while his wife is with her cousin at the bullfight, Picasso writes: "The daughter of Perdaguino farted, pulled out her tits, flung up her skirt, and showed us the rabbit [low Spanish for *vulva*]. Imagine the face of the priest the antics of the nephew the daughters of the goatherd the whorelettes and the nuns crossing themselves and dying of laughter at so much lightning and thunder."

PICASSO AND SABARTÉS . . .

They are with friends in Barcelona. Picasso suddenly gets into a bad humor. "Come on," he says. He and Sabartés troop out.

At home, which was in Calle del Comercio in Barcelona then, Picasso says, "Come up to the studio."

"You want to work? You'd be better alone," says Sabartés.

"I don't want to work. I want to talk. What else have you got to do?"

In the studio he commences to study Sabartés from every angle.

"I am going to paint your portrait. You want that?"

"Certainly, *amic.*" They spoke Catalan, which Picasso had learned during 1896–98.

"What imbeciles!" Picasso says of their friends.

"Listen, why are you so silent?" asks Sabartés. "You seem to be in a temper."

At this, he put his brushes aside, listening to me for once, and putting me behind him, showed me what he had done, writes Sabartés. [But now he was in excellent humor—everything seemed good to him. "Not enough. Have to work more." Next day, he resumed the portrait by coloring the lips, etc.] *He stopped brusquely* [and left it as it was] *because it was evident his vision was different and if he'd kept on he'd have redone everything.*

In 1935 Picasso told Sabartés he had been writing—quite probably to annoy Sabartés, who was a poet *manqué.* That summer of 1935 he was shipping his writing to Sabartés, who had gone to Spain, in every letter. And the following year he was reading whatever he wrote to Sabartés aloud, and a year after, to circles of friends. He wrote anywhere at all—often in the dining room on the dining table. If anyone came to the apartment, he would get into a rage at the "alien presence." Down with an illness in bed (as he was more often

than he would admit), he pushed on like a hero of the pen. And to Sabartés's knowledge—Sabartés was living with him at the time—Picasso didn't paint. One day when Picasso had commenced to write in French, Sabartés nerved himself to point out his faults in grammar and spelling.

"Well? It's by errors you recognize the personality, my friend. If I set out to correct myself by rules that have nothing to do with me, I'd lose my note. Better I remain me than bend my words to rules that don't concern themselves with me."

On December 12, 1935, he shut himself into the dining room. Sabartés occupied himself elsewhere by setting the kitchen table (earlier, Picasso had abruptly decided they'd eat henceforth in the kitchen). In his *Portraits et Souvenirs* (Louis Carré and Maximilien Vox, Paris), Sabartés writes, "I spread the cloth on the marble, and smoothed it carefully to use up more time. I took trouble to see that the plates were as he wished, and that nothing would be missing nor shock him when he came in, that he'd find everything as the evening before and could have the sense that no thing moved in his absence: the rusks in reach of his hand, his napkin in place, the knife here, the spoon there, that he shouldn't lack cheese, that the fruit bowl be well in sight, his Evian water near him, the glass. . . .

"Picasso came in. 'Here. Take this. I've written your portrait in words.' " The portrait doesn't lack observation—cruelty typical of Picasso: for halfway through its elegiac sweep it

abruptly says (and, remember, he handed it to the model and knew he would):

> Table laid with such grace
> By a beggar's hand
> (Author's translation)

But Sabartés seems to have been very proud of it, nonetheless. When later it appeared in *Cahiers d'Art,* here's how it commenced:

LIVECOALOFFRIENDSHIPCLOCKW
HICHINFALLIBLYGIVESTHEHOUR

The whole thing was printed in one block of capitals without separation of words. He shrugged when it was suggested that this might hamper the reader in reading it.

When he writes in French, Picasso is *pervasive and impenetrable* says Christian Zervos, the French critic. In the writing to which Zervos refers, Picasso is hardly more inscrutable than many another poet, once you have solved his peculiar technique of disjuncture (which is doubtless intended to wake you with a shock). And you must cease referring what commences to what is antecedent, to which (though seldom has there been a division) it relates exactly as do pieces of his canvas—that is to say, not directly except they are there. And when you realize that the words are colorist, and Picasso savors them as does a child lime candy ... Dating his poetry as he does his

pictures, he writes: *16-5-43. The flute the grape the umbrella the girdure of the tree and the accordion the butterfly's wings of the sugar of fantail lake blue waves blue of silk cords pendant rosebouquet from the ladders one and beyond measure measureless measure of doves loosed drunk on the prink garlands of prisms adherent to the melting bells of a thousand lit candles*—written in French. But it is in the Spanish that Picasso is most self-revealingly himself.

The Burial of Count Orgaz (untranslated):

1 Here, nothing better than oil and old clothes.
2 Son of a whore, whore, cuckold and double cuckold rheumatic wolf-snatch and limping owl.

Stop! what has to be done is rip apart and tie up the packet and pull the feathers from the wind of the vigil Itch and longing to break doors and windows open to the cold and heat and deal out slaps and lions and partridges

2 I don't say that that which I don't say I don't say to say I don't say it. [*Yo no digo que lo que no digo no lo digo por decir que no lo digo.*]

1 A mountain of I say a mountain of tell me a mountain of not say like a mountain of castanets ultimately slowly flaring their torches and fried eggs.
2 Clearly these things aren't for nudes and show windows neither in museums or the warehouses of high fashion. Because that's how it is.
0 No more than a little worm adhered to the chandelier lights the dance with spiderweb.

Don't dress in gold or lentil beans if you're cold put on a suit of nakedness with vine leaves and dance because today is Sunday.

Here, suddenly, Picasso begins to write in French, in the middle of the Spanish of fifty pages:

Total emptiness January 12, '57
people o-oo-
The essential completely beyond the
reach of acceptable symbols *pic pic
and peashooter* [the italicized words in Spanish].

January 27, '57 Appearance of the old cunt
and search through the garbage cans of not
enough and too much reality.

The person in the door is Goya painted painting a portrait in
cook's hat and his pants striped like Courbet and me—using
a coffin for palette

above the painting an owl that comes at night
to kill doves in the room where I paint

Picasso writes in *The Four Little Girls,* 1947:

> *We shall not go again to the wood,*
> *the laurels are felled.*
> *Let us dance,*
> *thus we dance,*
> *dance, sing, embrace whom you will.*

We dance, sing, embrace whom we will, because the laurels are felled. And we shall not, therefore, go again to the wood.

8.

ROBERT GRAVES

Robert Graves's study, Deyá, Majorca:

RG: No, it is impossible to sustain love. It's impossible to sustain the marriage relation, which will have disappeared within thirty years—except for one couple in ten which will be venerated as doing something rare. After all, it's unanthropological. Understanding of the poet's ordeal? Love poems must be bounced back off a moon. Love a different woman and you get a different poem.

WF: Your love poems become more and more ardent. That's strange as you're in your late seventies.

RG: Don't forget I began in the Victorian Era. I had a lot to throw off. My poetic system accords with the Irish of the eighth century, untinctured by Rome. Besides, you gradually cease to take critics into account. When I was writing *The White Goddess*—wrote it in six weeks, took me ten years to revise it, and I tripled its length—suddenly I was answering ancient Welsh and Irish questions that had never been answered and I didn't know how or why. It terrified me. I thought I was going mad. But those solutions haven't been disproved.

177

I believe in the inheritance of memory. If a snail eats another snail, it gets that second snail's memory. When you've worked through to the real poetic level, the connections webbing together every single word are quite beyond intellectual arrangement; a computer couldn't do it. You've got not merely sound and sense to deal with but the histories of the words, cross-rhythms, the interrelation of all the meanings of the words. Essentially, I raise dogs because I like cats—that is, I write prose to afford poetry. Prose, now, goes through five revisions. Then it stands. That's not to say it'll hold up ten years afterward.

WF: Does the Muse-woman give happiness?

RG: What does? Felicity and pain always alternate. She serves as a focus and challenge. In looking at the beloved you see yourself most clearly, as distinct from looking at yourself. Otherwise it's not you. She gives hapness. Here I use the English language precisely. *Hap:* "happening." She provides happening. Tranquillity is of no use to the poet. The first use of White Goddess in the sense of Muse was in the Elizabethan Age, Jonson; but then it dropped down into meaning "self-inspiration of young men." After experience of the untranquil Muse it's possible you may move on to a Black Goddess—black positive, standing for wisdom. Can a white Muse become a black one, or must it be another woman? That's a question. Normally the Muse is one whose father deserted her mother when she was young and for whom therefore the patriarchal charm is broken, and who hates patriarchy. She may grow up to be very intelligent, but emotionally she is arrested at about fourteen or fifteen. I once lived here for six years with Laura Riding [poet and co-author with Graves of several books] without moving, but you've got to go out, because you can't live wholly in yourself or the traditional past. You've got to be aware of how really nasty urban life is.

WF: Who sent you here?

RG: Gertrude Stein. She'd been here with Alice B. Toklas twenty years before. She used to say she had been the only woman in Picasso's life, that she had formed him. Maybe this was true. The other females were only round and about.

My writing of prose was always thematically in line with my thought. Always myself, I never left that. *They Hanged My Saintly Billy* was to show how Victorian England really was, how rotten, criminal in contrast to the received version. My granduncle was Leopold von Ranke, the father of modern history. He was always held up to me by my mother as the first modern historian who decided to tell the truth in history. *Wife to Mr. Milton* I consider my best novel. My wife, Beryl, and I were making a bed in England—I suddenly said, "He must have been crazy for her hair." A hair fetishist. Marie Powell, Milton's wife, had long hair with which he couldn't compete. It all came to me more or less at once, and I wrote *Wife to Mr. Milton.* I found out a lot of things about him, heaven knows how, which have never been disproved. I'd always disliked him, from the very beginning. Milton's poetry is constipated.

WF: What would you say about making the real stuff?

RG: The words are already there in the memory. The poem is there at the origin, but at the seventh level of consciousness. It rises up gradually through each repeated revision. The reading touches off the original hypnotic state, but expression is amplified—for example, by the dreams of the night, which are the real interpretations in the primitive mind of the events of the previous day. A poem is present from the conception, from the first germ of it crossing the mind—it must be scratched for and exhumed. The leading atomic scientist in Australia agreed with me the other day that time does not really exist. The finished poem is present before it is written and you correct it. It is the final poem that dictates what is right, what is wrong. There are fifteen English poets—I am speaking precisely—in history who were real poets and not playing at it. What they have in common is a source in the primitive. In the prerational. Before the Greeks went wrong. That takes you back to the Pelasgian. The important thing is that it be preclassical. The Greeks were all right until about the sixth century B.C., but then they went wrong, because they tried to decry myth. They tried to put in its place what we would now call scientific concepts. They tried to give it literal explanation. Socrates makes jokes about myths and Horace

mocks them. Socrates could clarify a myth in a way that deprived it of all sense. They simply had no use for poetic thought. Logic works at a very high level in consciousness. The academic never goes to sleep logically; he always stays awake. By doing so, he deprives himself of sleep. And he misses the whole thing.

Sleep has seven levels, topmost of which is the poetic trance—in it you still have access to conscious thought while keeping in touch with dream, with the topmost fragments of dream . . . your own memory . . . pictorial imagery as children know it and as it was known to primitive man. What happens is this—if a hypnotist says, "Look at this ring" and you are hypnotized by looking at the ring, then if he produces that ring again any time afterward you go down. So also if you're writing a poem and you come back to it next day, you're immediately rehypnotized and at it again at that level. It's the actual draft, which is yourself, that's the hypnotic ring.

Then of course there's the problem of revision. Even in *The Thing to Be Said*, which I am working on now, which is about the necessity of first statement and treats obsessive revision as a disease of age, there are ten successive versions to date. The thing to be said, *say* it. I knew Hardy, you know. There's a continuity. I knew Hardy and Hardy knew . . . Do you see this dial of wood? It came from a tree cut in Shakespeare's yard. Hardy was terrified of revising beyond the fourth time, fearful of killing the poem. Maybe that's why he was more interesting than his poems are. I, on occasion, have touched thirty-five goes. I told you I spent ten years revising *The White Goddess*.

WF: How did you sum up such vast detail into your conclusions?

RG: I didn't. I knew at the outset, then checked.

WF: *I, Claudius?*

RG: I didn't think I was writing a novel. I was trying to find out the truth of Claudius. There was some strange confluent feeling between Claudius and me. I found out that I was able to know a lot of things that had happened without having any basis except that I knew they were true. The whole scene is

so solid, really; you felt you knew him personally, if you were in sympathy with him. The poor man—only now, at last, people have begun to forget the bad press he was given by contemporary historians. And now he's regarded as one of the few good emperors—oh, between Caesar and Vespasian. He grew disenchanted; he could do nothing; he gave up. Well, now, Caligula was born bad, but Tiberius was a marvelous man. But too much pressure was put on him and he warned the Senate of what was going to happen. He foresaw a severe psychological breakdown. If you've always been extremely clean—always brushed your teeth and made your bed—and you get to the point of intolerable stress, you break down and display what is called paradoxical behavior. You mess your bed, you do the most disgusting things. Tiberius had been noted for his chastity and manly virtues, and then he broke down. I now feel the greatest possible sympathy for Tiberius.

There was something kindly and peculiarly young about his eyes. He seemed alive within tiredness, as though the tiredness were on him like a cloak or around him like ash around a live coal. His study—the sources or consequences of his books—expressed him: Milton, *Oxford English Dictionary, English Dialect Dictionary,* dictionaries of Greece and Rome.

He told me he is not erudite, in the normal way not even well read, but simply well informed in his areas of interest. The information "just comes." And then, of course, there are all the books for the detail. "One has the whole vision of the thing—and then one just checks. Cause may not necessarily ordain effect; it may be that effect ordains cause—once you have got the whole time thing worked out."

Deyá can be quite beautiful, or singularly gloomy and desolate, like a town in Wales. You rode up the enormous curve, all the time seeing the terra-cotta roofs of Valldemosa, and then were shooting along through olive trees with the Mediterranean far below on your left. But when I was there in February, Deyá was locked in under its cliff of stone which catches every cloud, mossed, cobbled lanes running with damp.

I asked him why he had gone to Deyá, after Gertrude Stein had put him onto Majorca. "A fellow who fights with the Devil every night told me about it." "Fights the Devil every night?" "Literally." I didn't always know how to take him. He has written some pretty odd things. A short story of the man who dissolves all peripheral waste—including the neighbors—in his compost heap.

Involve yourself with genius, and you get tangled in disheveled syntax and displaced eyes, men whose charm is not surprising if you reflect that fantasy stems from *us* and is human, whereas rationality stems from outside us, from the things we are rational about. We are imprisoned in our rationality.

René Dürrbach told me that that consummate master, Picasso, has hypnotized space: "He has hypnotized us into seeing his concept." But Dürrbach must draw a plan for weaving in actual space. (" 'There's a hole here, Picasso,' I'd say. 'Oh—what does it matter?' The magnificent Picassan shrug. 'It may not matter to *you*, but it mat-

ters to me. What am I to do about it?' ") Picasso has caused that it is not there because we do not see it, but for Dürrbach, who must rehandle it, the space is there.

Miró is driven by a physical impulsion toward work, feels ill when it is not good, is relieved of a nausea only when it succeeds. And then, at once, "it ceases to matter." "The only time I feel physically well is when I have worked hard." His nausea with his own painting comes from this: "I think it comes from the fact that for me they are never really finished."

French painter Bernard Buffet is ready to depart from zero. Room nude. Paint on bedsheet and sleep without the sheet. Giono sheltered him; for a time he lived in the pagoda in Giono's garden. The autoportrait figure so often crucified, flagellated, sometimes flagellated, flagellator, and witnesses the same autoportraited figure. "Why does Buffet paint himself all the time as the flagellated figure?" I asked Giono. "Is he a masochist?"

"Simple incapacity and inability to render faces."

"A woman is the balance of a man," Miró had said. "The family is the absolute necessity, and the absolute curse. The family can provide equilibrium, or chaos." And Giono said, "The infant Eros runs between the legs of one who would walk in a straight line."

Art was ascendant in the caverns of the Stone Age and has been falling ever since. There were no backgrounds in cave art, and except for a sorcerer or two, no men. Art then was neither dec-

orative nor narrative, but was the seizing of the prey in the concentrated arrow sight of magic. I put the beginning of the decadence back to that place in the past (Miró); Dalí, merely to the end of the Renaissance.

The subjective, the self, is constantly at war with the mollifying exterior environment—"truth." The "looking aside" in enormous concentration not on the subject but on something *else* (or D. H. Lawrence's use of daily event) provide caloric heat. The bolt forward exemplifies the value of distraction, the value no doubt of the *re*pressants such as drugs, the alcohol that suppresses inhibition whereupon the prick stands up (*not* stiffened by chemical increase of libido)—the sedatives and the stimulants, both of which shut the eye of the mind. The latter introduces rapidity so that the aging Genius, the only one with the experience to provide a genuine battleground, has the quickness of youth. These *shutters* blind the outward eye and what is within speaks.

Art must be effective, not "true"—because it is the statement of *one* man, in *one* moment, unqualified, synthesized where the contradictions of reality seen by one whose eye is not naive can alone be fused, in the rapidity of the unconscious a thousand times faster than "thought." ("A computer couldn't do it."—Graves) Incompatibles marry, somehow. Because they become one thing while remaining several, they strike us, and the creator too, as authentic—a far better word than *true*. 2 and 1 make 3; or, as Cocteau said, 21. And

Giono said: "If you believe two and two make four you will be castrated by it as surely as by the scissors of the Pasha."

Robert Graves's study, Deyá, later:

RG: Do you notice anything strange about this room?
WF: No.
RG: Well, everything is made by hand, with one exception: this nasty plastic triple file which was given me as a present. I've put it here out of politeness for two or three weeks; then it will disappear. Almost everything else is made by hand. Oh, yes, the books have been printed, but many have been printed by hand—in fact I printed some myself. Apart from the electric light fixtures, everything else is handmade; nowadays very few people live in houses where anything at all is made by hand.
WF: Does this bear directly on your creative work?
RG: One secret of being able to think is to have as little as possible around you that is not made by hand.
WF: Has it some kind of aura?
RG: The artisan, if he is any good, has imparted something of himself to it. In fact he can't help it. Try to draw a circle without a compass. You may be as good as Picasso, but you'll never be able to do it. You may try it a thousand times but it will always list to the side, and it will always list to the same side. A machine couldn't do that.
WF: You served in the First World War.
RG: Indeed I did.
WF: Not served as Giono did, and Lurçat too, with mud-stopped rifle. What happened to your World War One poems? Why didn't you write poems of your trench experiences like your friend Siegfried Sassoon and Wilfred Owen?
RG: I did. But I destroyed them. They were journalistic. Sassoon and Wilfred Owen were homosexuals, though Sassoon tried to think he wasn't. To them, seeing men killed was as horrible as if you or I had to see a field of corpses of women.

Think what it would be to look out each morning and see the field strewn with dead young women.

WF: Tell me about the first Mrs. Graves.

RG: There wasn't any first Mrs. Graves. She was what today would be called a women's liberationist—she wouldn't hear of being called Mrs. Graves.

WF: When you wrote *Goodbye to All That* in 1929, you report a formation similar to Sassoon's. It is surprising how the book has remained fresh—

RG: It hasn't remained fresh at all. It was entirely rewritten thirty years later.

WF: You grew up in the amatory forcing school of English public education, as you put it, where young boys are frequented and girls are despised; married a feminist and man hater as your first wife; quit your country not without suspicion of attempted murder; and at last realized greatness in love poetry under the heel of man-devouring White Goddesses fifty years your junior.

RG: I'll tell you about one of them. You say you know Marceau. Well, I sent one of the White Goddesses up to Paris to study mime with him. She took the money and went to live with a man in France.

WF: But what do they contribute?

RG: They keep you from being dead while you're still alive.

WF: A kind of psychic—

RG: I don't like that word *psychic*. I like the word *balica,* which is Arabic for "blessedness," as you know. It means "struck by lightning"—it comes from the Arabic for lightning. You are struck by lightning and thereafter are blessed. Lightning strikes a place and afterward it is a holy place.

WF: You said there were fifteen English poets in the history of literature who were real poets and not playing at it. Would you care to name them?

RG: That wouldn't be polite.

WF: Do they have anything in common?

RG: Indeed they do! A source in the primitive, in the prerational. My poetic method stems from the Irish of the eighth century A.D., which passed over eventually into Wales. Where

did it come from? From the East. That accounts for my great interest in Omar Khayyám—a very noble poet, as we must come to. It was Sufi.

WF: Originally it was Sufi?

RG: *Originally* it was Pelasgian Greek. Now that takes you back a long time . . . takes you back to the passage builders, 1500 B.C. or thereabouts. The Milesians came to Ireland via Spain and brought with them the ogham alphabet—a very early form of alphabet taking us back toward the time when letters originated in the observation of flights of cranes. Cranes fly in *V*-formation; thus the letter *V*.

WF: Isn't the point that it was preclassic?

RG: That's the whole thing. It wasn't contaminated, because the Irish circumvented the whole classical business. Their touch-point was always Antioch, never Rome. The limitation of life began with the Greeks, the fencing-in of everything within ''rationality,'' the making it scan. After all, it's a power system, useful to those who would rule because it defines things—by omitting the individual differences. The crushing out of the individual. The poetic faculty—which is the instantaneous combining on several different levels—atrophied. What do you have there?

WF: Do you think it remarkable that artists, who work so much harder than anybody else, last so long? That is, if they don't drink themselves to death or get killed in café brawls? This is a little list I've compiled on the death of artists. Picasso—ninety-one years, five months, fourteen days. Van Dongen—ninety-one years, four months, one day. Braque—eighty-one. Brancusi—eighty-one. Miró is in his eighties, and Chagall apparently is immortal. Michelangelo missed becoming ninety by sixteen days. And Titian died at either ninety-nine or eighty-nine.

RG: I've written a poem on that. It's about Finn. Finn comes back from fairyland. Now he's been away a hundred years but he doesn't know it. He sees some fellows struggling to right a fallen ogham stone and he decides to help them. Oh, not big fellows, as in *his* day. But as he leans from the saddle to right the stone with one hand, his saddle girth breaks and

he is thrown to the ground, and the minute he touches down he finds himself suddenly old. And he experiences all the infirmities and uncertainties of old age.

WF: I tried to chart the coordinates of genius. Wouldn't "genius" be the sum of what none lacked and all had? No, not really. It's too individual for that. Cocteau, precocious. Picasso, Dalí, exceedingly precocious. But Rossellini, Marceau, late to develop; Jean Lurçat, very late to develop. Durability, yes. The one thing they all shared (except Dalí) was rootedness in the primitive, in the prerational.

RG: Agedness is an illusion. The age to die used to be forty-six. It still is in East Africa. Among the Eskimos they had to die at forty-six, be killed if they didn't die properly on schedule because otherwise they'd be too old to fend for themselves in the Happy Hunting Ground when they got there. The inherited memory of the death age of forty-six impresses people so much that they give out. A man is likely to have a breakdown at forty-six, about a year of it, that costs him all sorts of inconvenience: loses his job, and so on, as being superannuated. A man is retired at sixty-five. He feels his life is over and so he becomes old. He gives way.

WF: The creator has a better chance, then.

RG: A poet's theme is love. Love and honor. The playwright and painter can cheat because they reproduce. They do not need honor. Picasso tricked from the beginning: he was too greedy; he grabbed up everything. If he had kept purely Spanish he would have been as great as Goya. He *is* great when he is Spanish.

WF: You surprise me. You have said that the supreme genius is one who supremely expresses his own age, all the aspects of his historical period. It would seem hardly possible to find a better description of Picasso; it would seem that that accounts for his immense popularity, the way he expresses the age. Most feel he is the prototypal artist of the twentieth century.

RG: I did once feel somewhat as you describe. True. But there is too much artifice in it all. A poet has no need to heed a world permanently in flux. The direction civilization is going is too patent: the extirpation of natural man, of all that is natu-

ral in man. I admit that Picasso revolts against it, but to revolt is not enough. Revolt becomes the convention. You must have a focal point. And that focal point is the telepathic connection with the person with whom you happen to be in rapport at the time. You function under the direction of the more-than-you formed by your relation with the person to whom you address yourself—obviously, a woman. She needn't be present, but you can't do without her.

WF: And thus you insulate yourself?

RG: Yes.

WF: Isn't there the danger, in such insulation, of enhancing the autobiographic tendency? For example, Claudius was a historian. So are you. Little remains of Claudius's writing. Are you not in danger of writing yourself as Claudius?

RG: I don't have Little's disease—which is what he had, as we know now. No, there's his speech to the Aeduans, his letter to the Alexandrians, and a number of records of what he said in Suetonius and elsewhere. But, really, that has nothing to do with it. You just go back. You have analeptic thought and proleptic thought. Memory, actually. Proleptic is anticipating the future; analeptic is going back into the past. And of course you have inherited memory.

WF: But aren't you threatened by the disintegration that marks our time? The negation? The constant quest for the new? Miró said that not everything new is good, but everything to succeed must be new.

RG: You must put an end to innovation. You need a lodestar. The end point of constant negation is sterility. You direct yourself to that Moon Goddess who is reigning for you at the moment. And there is nothing else in the world.

WF: And thus you write poems?

RG: Most. You establish that poetic trance which is formed by the telepathic communication between you and your beloved. No poem that is worth anything does not start in poetic trance.

WF: Do they all?

RG: No. No. You feel, however, that there are a certain number of poems that you have got to write. One comes along and "This is one," you think. And another comes along and

you think, "This is one." You know. There are poems that are matrix, and there are poems that are jewel. Let me explain. The matrix is the base material from which jewels spring—part gem and part crude. There are poems that are jewel, and there are poems that are matrix. The public prefers the latter, of course. At the time.

9.

ROBERTO ROSSELLINI

ROSSELLINI: What is this neorealism? I don't like that word. What does it mean?

The exchanges with the father of contemporary cinema took place over a long period of time, thread dropped, and again taken up, always at Rossellini's villa off the Via Appia Antica outside Rome. Whenever I was in Rome I would go there almost every night to dine with him and Sonali. There was no formal purpose at all at first—simply that I was intensely interested in him, and so was he. We explored together.

Often I found myself with Sonali and from her learned much about the Rossellinis' life, and once I had her all to myself with her two children, one wholly Indian, the other half Rossellini, in Provence when she was hiding from the press,

Rossellini saying he was going to turn up but, being Rossellini, not doing so. I met none of the other "wives." (Rossellini and Sonali were not married.) Ingrid Bergman was married to him in Italy but outside Italy to another man, and, this being an inconvenience, she wasn't around, but I learned a lot about her ("Do not quote thees"). Their children were present. "I tell you something—there is this public picture of Ingrid but she consented to the divorce if I would keep the children. And not tell nobody of it. These children have one father and two mother and the second mother is me." "Three," said Sonali quietly of the mothers, passing through the room just then.

She is a caste Hindu. When she quit Das Gupta, a Hindi movie producer, for Rossellini, she did something as outrageous as if she had been Sicilian. But she is a woman of delicacy, elegance, grace, purity. However, people aren't syllogisms. One time, again, she passed through the room as Rossellini was talking with great heat—"abstract" ideas ignited his mind far more than cinema did, or when he was in the midst of it ever did. He had just said: "A young man he has everything ahead of him—life, career. And what does he do?" he demanded of me angrily. "He get married! And then it is all over for him. Finished! And for why does he do this? Just one thing—the cunt!" It was just then, on "cunt," that Sonali passed through. I glanced at her nervously. She smiled. Almost imperceptibly, but she smiled.

I didn't meet another of the "wives." This was a dozen times promised, even programmed.

And Anna Magnani had the only complete file of
Rossellini pictures (on 16mm) known to be in ex-
istence—Rossellini hadn't one of his films—and
was in Rome. But as they were both Italian, of
course it never came off.

He is said by the French cinema-journal-
ists such as François Truffaut and Jean-Luc Go-
dard, who later became, under his tutelage, the
nouvelle vague that changed cinema, to be, in his
realism, the only global filmmaker, with global
outlook. But I thought this came from his method,
and I asked him. It is true, as Truffaut described,*
that he lived under a mountain of books, techni-
cal, geographical—political and economic nearly
exclusively the last years. But he said to my ques-
tion: "I take the film from the personage. That is,
the subject decrees the method. I have no precon-
ceived approach. The 'neorealism,' it is just the
tone of whatever is in the objective—Saint Francis
or Anna Magnani. Don't forget that the French
word for the camera lens, *objectif,* that that is a very
good one. This is not to say the camera can 'look
for itself' as many say of me. The tree must say
'tree,' show itself as what it is as a tree, without ar-
tifice and intervention. At the same time, it is
wholly impossible to be objective. You have to
choose. I *never* complete a script before we go,
Amidei† and me, to where we will shoot. I select

* *Cinema d'Aujourd'hui* 15 (Paris: Seghers), an account of his three
apprentice years with Rossellini.
† Sergio Amidei, scenarist with and for Rossellini on many pic-
tures, from *Rome, Open City* (1945) through *Stromboli* (Ingrid Berg-
man) and *La Paura* (Ingrid Bergman), to *General della Rovere*
(1959) and *Era Notte a Roma* (1960).

my actors from the people who crowd around us—out of curiosity—for their *physical* appearance. They are freezed—*congelato*—by the camera, and I teach them back to themselves. I dominate them—or, the personage dominates me, like Anna or Bondartchouk. He is such a marvelous man! He is so great a piece of human out of the steppes of Russia—not 'Sovietic,' which is an *idea* of things, for good or for bad, but Russian. So I let him speak. And that whole wonderful speech of reconciliation and the Russian heart—spoke by Bondartchouk in *Era Notte a Roma*—it is simply Bondartchouk speaking, improvised on the spot, as we shoot! You could not preconceive such a thing, then 'repeat' it. That is why I repeat so little, don't take *prises de vue*—so very careful!—no, *prise à vue: coup*—smack on the eye. Once you have turned the first scene the picture is finished, because that first scene has all the music in it. What matters it is a rhythm, and this rhythm I have inside of me. What difference if it is beautiful or not? If it is *true*? But not true, necessarily, in the Zola sense, because that is a point of view too, as rigid as Mallarmé. It is all of it mixing up together and boiling inside, but under the lid, that makes the picture. But it has no law. It can be disgraceful, it can be noble. But it must be human, a piece of that *enormous* complex which is 'the human.' It can only not be accommodated. That is why I shoot so fast. And then they attack me for it because it makes them afraid. How is it going to turn out? They want to know *before*, because it costs them so

much money. Well, they found out what it is to
make a petrified wood—and the cinema is dead.
All that is left is a little curious man going around
with a hand camera, just like me, except his means
are better. Only I don't like that they always shoot
with that camera between girls' legs—not that I
am not sexual!"

I had been with him when he was "formu-
lating" *Era Notte a Roma:* theorist, pedagogue, mor-
alist, lover of the "next one to me." His departure
point was not the idea of reconciliation of the na-
tions, showing their sameness under stress, nor
Bondartchouk, Leo Genn, and so on—who came
later and then *were* let determine Russianism, Brit-
ishism: didn't they know better than Rossellini?—
but was a little square off the Tiber near where
Lucrezia Borgia's mother had once had a tavern.
"Thees!" he said. *"Thees* square is worth a film!"
And there he filmed.

He gave me, later, the script of a film. I
read it in my hotel by the Tiber. It was fantastic,
wonderful. Later, Fellini made a film such that I
was sure he had copped the essence from the Ros-
sellini script; Rossellini assured me he could not
have, and that he had not. Rossellini's film was
never made. But *Juliet of the Spirits* was. (It is sur-
prising, perhaps, that the neorealist Rossellini
might be as baroque as Fellini, the *carnevale,* the
commedia of the flesh—spiritual, too, in the early
Christian sense of the word, in *The Little Flowers of
Saint Francis.*)

* * *

RR: Follow the individual always, the camera a kind of microscope on the face, as with Anna [Magnani] when I made Cocteau's *La Voix Humaine*. I was very concerned with Anna at that time. I wanted the camera to look in even behind the mask of what she thought she was, as I did too, a kind of a microscope. To see farther.

WF: You saw pretty far into de Sica in *Il Generale della Rovere*. I thought the somewhat bendable general was pretty like de Sica. It's hard for some of us to countenance the maker of *Bicycle Thief* cavorting—

But Rossellini cannot be drawn along such lines.

RR: That picture was no good. Too objective. Of course it won the Lion d'Or.

He did not drink alcohol or coffee. For stimulant, he had only, and copiously, mineral water. He slept three hours in twenty-four. I found this so incredible that I took Sonali aside and asked her. "Yes," she said, "it is literally true."

In his sitting room were many Etruscan relics, exhumed by himself and his children at Santa Marinella on the Tyrrhenian coast. He was an Etruscologue of importance. A hundred ways you were made to see that his true bent was pedagogy.

He went into the movies because a girl friend of his was asked to audition and he was too jealous to let her go to the studios alone. Then he commenced driving actors to and from work. A single photograph stood in his living room, which in the other direction gave into the dining room

through an arch lined with theater dolls, puppets such as infest Marceau's home at Berchères—a photograph of Chaplin: "He is my God." Sonali said aside, "Frankly, I would never say it to Roberto, but Chaplin was here—and I did not think he was bright. But Roberto sees with his eyes, and he is very modest while not being modest at all, of course."

Sees with his eyes. He said to me, "There is no such thing as objectivity." And why does the subjective encounter such resistance? Because of the commercialization of the medium, with resultant conservatism, Rossellini said. (Because of human laziness, said Cocteau.) And why, if the subjective breaks through—through barriers of "professionals": the producers, entrepreneurs, "judges at second guess without souls"—does it mean most of all to that "leetle" man who is the public? Because it is human. And so is he.

It may *be,* said Rossellini, that my films do not appeal to critics, experts, owing to a certain indifference to techniques, the fact that I do not care how I say it but only what thing it is that I say, but I do not think it matters. Him, that one in the movie seat, he does not concern himself with that—unless he has been bludgeoned by that great, conscious machine—and it is a *very conscious* machine, I am witness to that—the propaganda that surrounds *the film.* The powers are absolutely scientific in that. When we talk about brainwashing, it is done all over the world. You can kill them, as the Communists do. Or put them to

sleep. The purpose is to have the society that you need for your consumer economy. There is that certain kind of an elite; they have to build *a certain kind* of world. Why do we have to reduce our product to a level of idiocy, so that father and child can enjoy the same, which is a scandal? Well, there is a certain kind of man who has to have a balance in the bank, but behind that man there is another man. I tell you, very concretely. In 1933 all the big movie companies bankrupted, except Warner Brothers. Fox Films became Twentieth Century–Fox after the reorganization. Who gave the money to reorganize? The electric companies. Then there was a duty to educate the public to use a certain kind of thing—to consume electricity. How many love scenes do you see around a refrigerator? How many electric toasters open and close an American film? How many waffle irons are *absolutely necessary*?

This was done with calculated purpose. Absolutely calculated purpose. I am a witness to that. And if you opposed—if you raised your head—they killed you with scandal. You divorce. But thousands of people divorce. They do not attack you for that. They do not like the way you stand in the way of the convenient infantilization of society. In 1950 Senator Johnson—in Rome—said Rossellini wanted to go to Hollywood to smuggle cocaine from Red China in order to kill the brains of the cinema people. That would have been redundant! Besides, I did not want to go to Hollywood. What is acceptable today is that

man—confused—is living in a world where things are not clear, and this is told vaguely. You see, it is not a danger. Or sex and the homosexual. I do not think that is *so* important. A world is coming into being; and we know nothing of it, say nothing about it. We do not even have the language. They want only your name, then a stereotype. They don't want the film the man with that name could make.

For me, actually, our world is becoming hieratic. Like the ancient Egyptian. You have the ersatz of a thing. Then symbolic replacement. Love is not love. You have the ersatz of it. Death is not death. In our films nobody *dies*. They don't look at this closely.

WF: And Fellini?

It was difficult to get him to talk of Fellini. He was generous in spirit, had a large heart. Finally:

RR: You must remember that Federico has a tremendous graphic sense. You must remember that he was first a caricaturist. He thinks in series of graphic images which even finally may not have special purposeful direction.
WF: He started with you in film on *Open City,* didn't he?
RR: Yes.
WF: Which was your first film.
RR: It wasn't, you know. That was *The White Ship.* It was before the war, in the Fascist era. I'd done some odd jobs, scripting, and shorts. *Nave Bianca* was supposed to be a short subject, but I made a full-length film without telling anybody. And it was a success. It's a battle seen from inside a

ship, wholly inside a ship. I had trouble with the Fascists. Oh,
not political! I wanted more money.
WF: You made it with de Robertis?
RR: Yes.

Francesco de Robertis is said to be Rossel-
lini's master. He was thus the true inventor of
neorealism—if neorealism is shooting reality. But
if it is improvisation; shooting in the streets not the
studio; telling it the way it is, with real people for
actors often; the camera following the protagonist
always, not setting scene, panning in, artifice; if it
is discontinuity, rupture—modern film and, unfor-
tunately, modern art—Rossellini invented it.

Fellini collaborated on scripting four pic-
tures for him between 1944 and 1949: costarred in
one, *The Miracle,* opposite Anna Magnani. The
Fellini-Rossellini methods are identical; they do
not differ, except tonally.

Rossellini, having a bigger heart, being in
earnest, fails. Fellini, whose method is an exact
photographic copy, accords better with public
taste as decadence progresses. And hopelessness—
so that we do not want to see the striving, as after
the war, when we thought the problems were
soluble.

I saw *Joan at the Stake* starring Ingrid Berg-
man at an art cinema in Paris; strictly art, but half
the audience walked out before the end. Had Fel-
lini made it, would they have?

*　*　*

RR: The best one? It is the one on Saint Francis of Assisi.

I saw it in an unheated art cinema in Bordeaux; it never attained general distribution.

RR: I want to do *The Death of Socrates.** He saw the nature of things, which is mystery, and took the hemlock out of obedience to law, because it was the law that existed, though it was a bad law.

RR: But don't you think the director should be like a trumpet—to convey? My film on Garibaldi was hated in Italy, because he is the trumped-up national hero, but I only tried to let the real Garibaldi pass through me, like wind through a trumpet. Yes, *Pulcinèlla* starts from those grotesque stone masks at Bomarzo. Have you seen them? And maybe from ideas in Molière's *The Imaginary Cuckold*. It *had* to be crazy. Yes, there is perhaps a rule of contradiction. You are going to be able to say no more emphatically than yes. Where is the man who can say—passionately and forcefully—"I agree with you"? And you are going to end up saying no to yourself. That is probably a law. Then everybody's going to go against you. That's the law of entrenched society. Its self-defense. That's what obliges some—who have the conscience of these things—to continue to struggle, to continue to fight, to continue to be disobedient, to continue to be beaten, to continue to have all sorts of boring adventures. For me, the real need is to get closer to the human being. It could be fantasy; or—it could be brutality. Because I am convinced that every man is good. Within himself. If you fix on everything a sleeve, then you end up in sterility—or mad excess, which we have now. Don't you think it is so strange . . . in this century of so many wonderful technical advances we have the most profound pessimism about humans?

* Rossellini did it on Italian television not long before his death.

WF: Isn't that what the revolt's about?

RR: Is it? Where is the *parturition* that is necessary in order to comprehend? Who can *imagine* a way of thinking different from ours? Really different? Well, it existed in the past. Maybe it is coming back.

WF: Making your last films—animated in the planning stage—there was on the set the pall of death. Perhaps you were no longer interested.

RR: Now is the time to stop making that kind of film! Unless you are a parrot. It is your intuition tells you what to do. The brain follows. In my early films I used real people as actors. They had stage fright, tried to act, but then gradually I could make them be themselves. And what they were was inimitable! Each! Each man has a truth inside him, only a little bit covered up as he lies to himself in his social life. You create an individual in a film, just as he is, complex and crazy—and maybe he touches moods and feelings in other people, who are individuals too. You work toward that general, loose purpose that you are trying to realize. You cannot foresee what you will do. When we shot *Rome, Open City,* everything was in chaos. We got enough film to shoot two, three days, maybe four. Then we stop till we can get film again. And from that came the good! For me, the great tragedy is that film has become so organized.

WF: In *Vanina Vanini*—

RR: You remember the priest scene? The priest he is trying to get her to abandon her love, and all the time he paces and paces, but she doesn't see him because he is behind her—*burned up* by passion. The priest is *full* of passion for her. So what happens? Nothing. In *my* film he flagellates himself after, with one of those little whips like some priests have in Italy. No—they don't want to say that about priests in Italy. I brought a process—what good did it? One day I went into the production room in Milan and they were cutting and changing the film behind my back. Nevertheless it goes out as *a film of Roberto Rossellini.* I am against these deadening samenesses of conformity. It used to be useful that people did not have sexual intercourse. Now they must do it; it is a convention. With the same prurient compulsive force.

* * *

RR: For instance, Monday I am starting a film. I have an Italian leading man, a German leading woman who does not speak Italian, and in the second female role a Danish. And I am to obtain intimacy and subtlety of playing. Well, it is possible. Because these things are mysterious. When I made Jean Cocteau's *La Voix Humaine* in 1947 I got what Cocteau *had intended,* not what he wrote. He told me after he had wanted to call that play *The Woman Eaten by a Snake* but didn't because he thought it wouldn't go down. Integrity? I myself commence a film by seeking compromise, or at least to adjust—and cannot, as if I touch a snake; it is an involuntary revulsion. I staged my own version of *Joan at the Stake* of Claudel at Naples. Then they wanted it for Paris because it was a success, but they said it had to be changed completely and follow Claudel's literal text, or else there would be a scandal because that text was known in Paris. I refused. Finally, we may do the Naples version in a rehearsal and Claudel will decide. He was an old man. He came from the country and sat there, all alone in those seats—and everybody, scared. "It is amazing and strange," he said. "An artist does not know really what he does. The inspiration for that came to me in a flash on a train from Brussels. You have done not what I wrote but what I meant."

First of all, who is the author of a film? I talk about film which is art; I don't talk about the other thing. A piece of art comes out from only one person, of that there is no doubt. So the author is the film writer, and the film director just stages what the writer has done—or, is the film director, and he makes his film from himself. The writer gives him a kind of notation—memorandum—and from then starts his creative work. So film is adaptation of the script, or is film.

When I made *Generale della Revere* I made a more objective film, but when I made *Era Notte a Roma* I made a more symbolical film. The objective film is easier. You plan more. But you go less deep. In *Era Notte a Roma* I show the nature of the Russian people, the nature of the English people, the nature of the American people—a certain kind of mystery, too, in the feeling of those people. Bondartchouk—

he was my model. I re-created that model in the dress of a Russian soldier, and Bondartchouk played him. You tell me Cocteau told you he couldn't film anymore because there weren't enough people who wanted to see the kind of films he wanted to make. Well, it is true also for me. If you do it so-o-o carefully, calculating everything, you don't do anything. My greatest dream is to stop making films as my principal activity. Films may be a business; that is one thing. What is done today, which touches great masses, and is without cultural purpose, is criminal. That is my deep, deep belief. Because I think it is a complicity with those who want the public really like idiots. If one has something to say—however unpretentiously—it can be useful. When a thing is truly, deeply sincere it is always useful. When a thing is a formula it may serve this or that purpose, but it is never, never useful.

Each of us is a social being. We are tied with society by things that are so powerful. The first link is your children. So I think it is an absolutely primitive feeling to defend your puppies. One way to defend them is to do something you think is absolutely useful. First of all, I am like a tiger defending my puppies—from everything, with or without reason, I think a danger. What is the real object of each one of us, if he is not a brute? It is to try to live in a society which can improve. Because I have deeply the faith that men are good—if they know what they do. Really one of the things I don't accept, which I can't accept, that it is impossible for me to consider, is that anybody can be bad on purpose. Surely every man has a justification within himself for what he has done and feels he has done it for the good. To try to illuminate them, in good faith, is always good. I don't think that is presumptuous. In a society so conformist, it is humbly useful to say even a stupidity if it is sincere.

In making a film, you feel a compulsion to drive back toward the basic and primal emotions. What makes film in America is fear. Do what you like and conform. Probably the irruption of the irrational—which is the key movement of our time—seemed more logical in wartime. Or was more acceptable! Less disturbing. And that is why *Rome, Open City* suc-

ceeded. When I went to school it was written in all books: "Idleness is the father of vice. Labor ennobles man." That is not written in the books of my children. If one makes a film which discusses *seriously* a problem, the public won't go to see it because that is "work."

We have a vertical invasion of barbarism: the specialists, ignorant of all else. The Romans had one hundred eighty days of obligatory holidays per year, you know. That way, the society could withstand the profits of the conquest. In Rome the *gioco* [the game] reached to the level of throwing the Christians to the lions. It was only *gioco*. Today what is our civilization? It is just the same. The grand masses have found their use: it is to be *consumers*. The famous mental age thirteen—it is absolutely an illusion. They are *not* producing what masses want but the idea of good of the producer class. Some men are creators, lawbreakers. Most are followers. Why do they obey? Is it a question of the amount of expendable energy? It seems that the world must always go by rule; the artist, against the rules. But today is no longer the fight of the artist against his obstacles for his own expression. Today is the fight of the masses of people, to which we belong, to participate in the new civilization, in the new fact of life. When I was young, here in the country around Rome, the shepherds knew the *Divine Comedy* by heart, and—I was with them by their fires at night—they recited Dante to each other. And in India, in the poorest villages, where the people are absolutely illiterate, they recite the great poem of the *Ramayana*. Now those are the ones who are brought all at once to the television, or the consumption and television. When you train the man only to the *fa solletico sotto piedi*—tickle under the feet—then, after, he can't understand anything. So you try something; then you are attacked, you are killed. The whole thing is extinguished. But after some years it comes out, a little different. The public figure is an invention to violate the privacy, and anyone can guess what he wants about you. The power to impose beliefs on people is so great—to make them not understand the problem, to create confusion, is so easy. Isn't it enough if a man does something absolutely

good in his life? And to do such a thing you have to try a thousand times. Impossible to do *the* thing a thousand times. I made a film, a certain critic said horrible things. I made a second film. He said horrible things. I made a third film. He said horrible things, reproaching me that I am not the same wonderful man who made the wonderful first film. You see?

10.

SALVADOR DALÍ

The legitimate ring of real creative awareness is different from calculated effect. Creative awareness rings *true*—which is far different from that which scans. In fact, except at the most exterior levels (where, for example, you find mathematics), it cannot scan *and* ring true. Because the two things are incompatible. That which scans is logically consistent, can never be authentic—because the universe we apprehend in our depths, and rationalize for our use, is not consistent; and only by overlooking aspects of it can it be made to scan.

The genius harmonizes the universe at a different level; it may be that he synthesizes the dream state of humanity. He speaks of one thing, which he therefore can afford to organize, and says something else within and the fabric aside. Which is perhaps why he can neither preconceive nor, except in heat, review. The "genius" is in the brush-

stroke, the chosen word that opens onto plains of limitless extension out of its few right syllables, not because it is correct or "admirable" but because it is *right*. There are paintings you can look at every day and seeing them means little, said Miró, and there are paintings you can see once and never forget.

Salvador Dalí equates creative drive with impotence: he cites Michelangelo, Leonardo, Napoleon, Hitler, as men propelled to genius—to frenetic activity—by near impotence. In his *Fifty Magic Secrets of Painting* he lists continence as one of the four necessities for the artist in a creative rut. You have to have enormously overmuch, or to have blocked and frustrated such as you have.

He is intentionally scatological. He is savage—and perhaps desperate. He has rendered a naked man and a naked woman fettered to two trees, facing each other, *almost* within touching distance. This, he says, is sexual stimulation. This *"clédalism"* (as he dubs it in his novel *Hidden Faces*), this love position of sexual withholding, shares the apex of sexual incitement with sadism and masochism, and he finds it the theme of Millet's *Angelus,* the humble pair listening to the bells being the epitomy of sexual tension, according to Dalí. Because they do not touch. He says no man in love is a good lover—*can* be a good lover. He says eroticism must be sublimated in art, and, he adds, "it inspires me to paint chandeliers." He says he is stimulated to erotic feeling if a woman he desires is taken by *someone else.* He is utterly put off, on the other hand, if a woman shows motherly instincts,

and he told me, "I detest children." But he himself had to be sat up with all night by saintly mama if he whimpered at all when he was a child, according to his sister Ana María Dalí.

Not to be touched is a key phrase with Dalí. He told Alain Bosquet: "As for me, I never touch anyone. That is proverbial. When I arrived in Paris [at twenty-three and had the taxi driver at Austerlitz Station take him directly to the nearest whorehouse] I kept a distance of six feet from the girls, because I thought that gonorrhea could be transmitted through air. To look is another matter. The day before yesterday I saw a film in which a young Spanish girl is made love to by a large dog. It was as admirable as a painting by Dalí."*

You hear mad tales—told with solemnity—in the modeling world of Barcelona of girls hired to go to Cadaqués and sit "discovered," nude on a sheet of elevated plate glass, while Dalí beneath, etc., etc. Indeed he has always taken care to cite *Le Grand Masturbateur* among his best pictures, along with the melting watches, the innumerable tributes to Gala, his wife, the crustacea ("which wear their skeletons outside and keep the soft parts of their madness inside"). His girl in his late teens was a torture victim. Her breasts were "discovered" for hours on end as they sat beside each other, but *he never touched her*, he tells in *The Secret Life of Salvador Dalí*, his autobiography. In the same book he describes his first hours with Gala when they were left alone together at Cada-

* *Conversation with Dalí* by Alain Bosquet, 1966 (Paris: Pierre Belfond).

qués; he twenty-four, she then in her middle thirties and in her eleventh year as the wife of Paul Eluard. They paced the empty beaches and endlessly slavered on each other in the soul kiss (what Robert Graves calls "the mandalot, from the Greek word *mandalós*, the bolt you put in the socket," and indulges in with his White Goddesses). "But I thought she wanted something more," Dalí writes.

Luis Buñuel writes: "Dalí and I chose a suite of gags when we made the film *Un Chien Andalou,* anything that came into our heads, with the one condition that nothing signify anything." But Dalí is demonstration of the fact that the created work is never without significance, for the content of the first Surrealist film (1929) is his. He said: "Buñuel came one day to Cadaqués with the script of a moving picture he intended to make. It was a puerile affair. A newspaper comes to life, and after various adventures ends its life in a sewer and vanishes with the offal of the city. What could be more sentimental? I scribbled a script in two days and gave it to him, saying, 'Here is a work with the imprint of genius, and entirely opposed to anything seen on film.' That was the genesis of *The Andalusian Dog.*" The film is rife with the obsessions of Dalí: *The Lacemaker* of Vermeer, under-armpit hair, ants, disintegration of the flesh, severed hands.

Dalí inverts the sense of things, for it is axiomatic that the creator cannot say what he means, if he would mean what he says. Dalí intrudes the metaphor of the crustacean: it has its skeleton out-

side and its soft parts within. He believes in the fixity, the limpidity, of the surface, permitting chaos within, a limpid exterior that conveys the content. But, then, the interior must be mad. And he told me, "What Surrealism meant to me—what I liked Surrealism for—was that its madness allowed me to paint well." The obsessions were real, nevertheless.

SD: The great artist is Raphael—is Velázquez—Vermeer. Raphael was just like Perugino. He paints exactly the same. He only adds little touches. But it is that—the touch—that is the genius. The originality comes when your freedom is restricted, when you are only allowed to add a little something. You put on tight shoes—it squee-e-zes you. But if you break with the form you become a plagiarist—you steal from yourself, you plagiarize van Gogh, you plagiarize African art. Picasso was a genius; I think he was the greatest genius of the century, but he was less of a painter than Dalí.

He believes you must always oppose, free yourself of the current. But contemporary art in flux is the academism of today, and it is that therefore which you must oppose. "The canon for the eccentric painter was fixed once and forever in the Renaissance," he said.

He has overturned the sense of things, overturned it once again by restoring subject. By having righted the apple cart, he has thrown himself into the maw of the irrational and, perhaps inescapably, into facetiousness. He has paid highly for his reverence of Vermeer, Velázquez; for daring to be the first since Ingres ("the last painter who knew how to paint"—Dalí) to paint well. Or paint clearly. Lucidly. Which is what "well"

means to Dalí. "I never sought to master anything but the rendering of photographic likeness."

But for this luxury he has had to become mad, to conciliate the age. "Were it not for my tricks, my painting would interest little. That is why I say painting is an infinitely small part of my activity." You know he would not have had it so, but so it is. "My genius," he says, "is in all I do." He means his unending effervescence of activity: he hands himself the consolation prize of genius, for to have been a genial painter merely, on the road of return to order out of frenzy, would have been a very small thing, a pill that wouldn't have gone down.

WF: But how do you paint?
SD: Just the opposite of the way I write. With great care. My writings are jotted down pell-mell, thrust into a drawer. Gala takes them out and deciphers them.
WF: Then really she is the author of your written works.
SD: She is the author of all my works.

Look at *The Inventions of the Monsters* (1937) and see a very normal, youthful, and romantic Dalí and Gala (the clear-eyed eponym of the woman in her eighties)* fashioning the bust of the twisted, satirical, contemptuous Dalí, and examine the furtive complicity, disdain, and wistfulness on the real Dalí's face.

His adulation of Gala is real. In numerous paintings he is a small boy in sailor collar with a hoop looking up at Gala, a crumbling grotesque

* Gala died on June 10, 1982.

sex symbol in antique statuary. Is it paradox and newsprint seeking for Dalí to say he has succeeded in sex with one woman, with a woman a decade older than he, he who had previously only loved (and he must have a little hated) his mother, who made everything too easy?

SD: She took my virginity. Till she came along I thought I was hopelessly impotent.
WF: Then the impotence is real?
SD: I exaggerate it. It increases with age.
WF: Is it true you kept clear of sex until Gala?
SD: Yes. Dalí is the model husband.
WF: Because of a kind of *noli me tangere*?
SD: No—I was afraid I wouldn't be up to the sexual act.

"What I provide," said Dalí, "is magic." He means he has found a way of liberating the magic power, which he considers to be residual within him, and conveying it to others. He considers himself a thaumaturge, a purveyor of magic, who makes a pact with apparent reality and by virtue of clear painting conveys the delirium of the interior world. He will have nothing to do with spontaneous method ("Genius in art is in the moment of doing"—Picasso) but he says, "I did not know what my pictures were about; I did not know what they meant. They were the obsessions and delusions of the irrational, and they had to be analyzed afterward. *Ex post facto.* By me too."

I went to see him at Port Lligat, "which is the only serious place"—"which is the only place where I am serious," he said.

"What do you want here?" he asked.

"I am on a kind of search for the genius process. I have already been to Picasso, Cocteau . . ."

"Oh, but I am more important than they are!"

"That is why I am here."

His languages are French, Spanish, Catalan, and a sort of Franglish. Actually I suppose he could speak English very well if he would. He began in French, which is the language he habitually uses and in which he writes, and we continued in French.

It is easy to think Dalí is not sincere, a kind of twisted Hamlet soliloquizing with himself and particularly with his earlier self as though he were the skull of Yorick—"A fellow of infinite jest, of most excellent fancy; he hath borne me on his back a thousand times and now how abhorred in my imagination"—a brilliant joke that has gotten out of control. But this is to overlook that a great part of Dalí makes excellent sense, and—this is damnable—whatever exhibitionism there may be in displaying his obsessions, they would have to be his real obsessions nonetheless. He wouldn't have any others. When he told me that, in fact, he really didn't give a shit for Freud and all the rest and that he only used the psychoanalytical nonsense because its lunacy made the sensation that gave him the pass with the public whereby he could "paint well" (with intelligible photographic realism), I thought that that meant the obsessions were inventions. No.

WF: Who would you say is the best living painter?
SD: Dalí.
WF: What would you say about Picasso?
SD: Picasso destroyed ugliness in painting, rampant since Cézanne, by painting such ugliness that it is bound to provoke a reaction back toward classical beauty.
WF: Miró?
SD: He is a folklorist, but you have to like him because he is Catalan.
WF: Yet you have often said you are not a good painter.
SD: I have said the divine Dalí is the best. But in a century of such mediocrity that is not to say much. The future will think that painting reached its lowest ebb in this century. And everything else of the spirit. And technology its highest point. Naturally the artistic collapsed.
WF: What do you seek?

He didn't answer, but the answer would have to be restraint. "Is there *no* limit to what they will accept?" Picasso asked Cocteau once in the deep of night at Saint-Jean Cap Ferrat. From the previously mentioned Cocteau Secret Archive: "Picasso said to me," said Cocteau, "let us make the worst art possible to see if there is anything the fools won't swallow."*

* In the 1950s there was the "Papini scandal." Giovanni Papini, an Italian author, had written an imaginary interview with Picasso, "Conversation with Picasso (or the End of Art)," and it had been circulated around the world as legitimate. Picasso: ". . . people no longer care about art; it is finished. The young are only interested in electronics . . . sport. . . . Happily there are still the snobs, the sophisticates, the rich [Picasso had a habit of speaking of "a rich"; "He is a rich," he would say] who look for novelty, the bizarre . . . scandal. . . . As for me, I have satisfied these *messieurs* and critics with any bizarrity you can name, with anything that came into my head. Less they understand you, the more they admire you. I quickly became celebrated. Celebrity, for the

SD: I have ample reason to suspect the virtues of freedom! Look at the chaos of Modern Art. Do I associate myself with the manifestations of Modern Art? It is because these extremities will cause a revival of sane art, by reaction. I am interested in freedom from choice. The freest place in the world is a prison cell. I used to be tortured by having to make up my mind. What did I want to do? Write a poem? Paint? If paint, paint what? Or simply go to the movies. I was put into jail during the dictatorship of Primo de Rivera, really because of the freethinking and atheistic opinions of my father. I could not go anywhere. I did not have to ask myself where I wanted to go—I was free! I ate with relish food I would have pushed aside with disgust, because it was all I could get.

He spent approximately half the year at the Saint Regis Hotel in New York, and approximately half the year at the Hôtel Meurice in Paris ("because these are the places where there is gold, much gold"), salvaging such time as he could for his Port Lligat house, around the headland from Cadaqués on the small bay which Francisco Franco made a national monument in 1953, for service rendered. It is a pathetic thing, for the whole purpose at the outset was simply to earn enough money to buy that little fisherman's house, renovate it, and live in it in "monastic, masochistic" isolation with Gala, and paint each day "until I dropped of exhaustion." And nowadays, if asked, "What do you really want to paint?" he will

painter, means sales, fortune, riches. . . . I understood the century and exploited the imbecility, vanity, and greed of my contemporaries. . . ." Et cetera. The article was repudiated and the deception unmasked. "It was," Cocteau told me, "almost exactly Pablo's attitude." It is, incidentally, a fairly exact duplication of Dalí's.

say—if he chooses to be sincere—"What I see around me. An inexhaustible world that may exist in a sitting room, and a half-dozen objects that multiply marvelously, and offer their marvels to the eye of the painter, as we see in Vermeer." Anyone who doubts that this is Dalí, one of the Dalís, should look at his *Fifty Magic Secrets of Painting,* which is surely the most remarkable technical guide to painting written since the Renaissance. Like Graves, he wants to submit. Except in painting. But the world hasn't given him much chance.

He took me on a tour of the Port Lligat house around the headland from the site of his father's house, where as a youth, with anchoritic satisfaction, Dalí, stark naked and sweating, painted sixteen hours a day in a laundry room. By twenty-two, he had painted *Girl's Back,* and his bread and basket, with an incredible luminosity and Renaissance perfection which, when shown in the Gallery Dalmau in Barcelona, where Miró had had a first failure too, impressed no one. Impressed by *Girl's Back,* Picasso began to talk him up in Paris. Art dealers came down, and, although it was not suggested he cut his works up in eight parts to fit better the new apartments being made then (as happened with Miró's early classic *The Farm,* eventually bought by Hemingway), he was turned down. At Miró's suggestion he went up to Paris. What soon happened he has admirably expressed himself. With Picasso's money, he and Gala sailed to New York in third class—and then ". . . Salvador Dalí, perverse, anarchistic, Surrealist, co-author, with Buñuel, of the films *Un Chien Andalou*

and *L'Age d'Or,* still shown in the movie houses of
the underground and the great scandals of the
epoch; Salvador Dalí, supreme despot, and who
breaks everything to pieces, farting at laws divine
and human, makes the jumping through a show
window on Fifth Avenue, is arrested by the police,
and Dalí, possessed by a furious delirium, and
Dalí, avid for dollars, calm, Apollonian, Catholic,
apostolic and Roman, jesuitical, monarchal and
monarchist. . . ." Cued by Gala, he had painted
her with a pork-chop inexplicably on her shoulder,
waxed his mustache up (in exact imitation of that
of Philip IV of Spain as painted by Velázquez),
got a job decorating a fashion-house show window
on Fifth Avenue, put a naked mannequin crowned
by flowers in a bathtub among other oddments,
objected when the store manager modified his dis-
play, said, quite naturally, when his protest was
ignored that then his name would have to be taken
off the display as it was no longer his, and when
this too was refused, quite naturally went into the
store window and began to demolish the display.
This collected a crowd. A corner of the bathtub
struck the show window and broke it. Faced with
the alternative of going back into the shop, he
jumped out through the window. He had found
out what the public prefers to the terrible counter-
tension producing the precise and only brush-
stroke.

 He took me on a tour of his Port Lligat
house just over the hill from Cadaqués where he
spent the summers of his childhood and where he
and García Lorca in the 1920s had an equivocal

friendship. Lorca was always reading (in his rau-
cous voice) poems from his *Primer Romancero Gi-
tano*—then yet unpublished—into the sea-lapped
Cadaqués night from the Dalí y Cusí (Dalí's fa-
ther) porch, while the fisherfolk neighbors congre-
gated, listening in the shadows. He has chanted
Dalí's fatal love of limitation in his *Ode to Salvador
Dalí:* "I sing your longing for the eternal limita-
tion." He was twenty-eight, Dalí twenty-two; in
photographs of the period Dalí looks far more
gypsy than the subsequently celebrated poet, and
Dalí has told me: "I believe my blood is Arab. The
Dalí, the Cusí, and my mother's people, the Do-
menech, were all from Barcelona; all four of my
grandparents. And Barcelona was just north of the
Arab occupation. The separation of the Moor and
Christian is a legend. In fact, they traded actively.
They did business together and uzzer theengs." Of
Lorca he said: "He was a pederast and madly in
love with me and always tried to make me. I
thought I ought to give him my asshole in honor of
his eminence as a poet, but I didn't like the idea
and thought it would probably hurt." When he
learned Lorca was killed during the Spanish Civil
War he cried, "¡*Olé*!"—he says—which is the
shout when something particularly exciting has
happened in the bullring.

Inside the front door of Dalí's house you
are greeted by a stuffed bear covered with neck-
laces and jewels and wearing a red fez. The house
is full of the paraphernalia of Dalí's "magic." Mi-
chelangelo made snowmen, he says, and Leonardo

designed theatrical spectacles, and it is perfectly natural that Dalí make "everyzing." Among the Dalian crosses and the Dalí-designed bric-a-brac are stuffed swans, crickets in cages, and eggs. He has a thing for the egg, which the ancient Etruscans held up in their funeral rights as the housing of all incipient life. "Does it occur to no one," he asks, "that the mystery of the egg is *inside*? You don't have to make square eggs." But perhaps you do, if you have deserted, as Dalí has long since deserted, the grotesque in subject matter.

The site is on a small green-water bay, with two islands in front of it, and is completely unspoiled: a few fisherboats, donkeys lazily grazing a dry sward and then braying, three swans swimming always in a line, Indian file. This is because of Franco's injunction: the place cannot be altered or touched. Behind this, the original little fisherman's house has festooned like a sugar bun. The roof is a hanging cactus garden; beyond the patio the new wing of the house is surmounted by two enormous plaster eggs looking like Turkish turrets. Dalí repeats his comment about the egg. He really has a charming sense of humor. He remarks that everything is symbolic; for example, the crease down the crown of a man's felt hat, which is put there because it resembles the woman's sex orifice.

He takes me into one of his two studios "in function." He was dressed in creaseless cords, covered with paint daubs, a black gaucho shirt with white-working on the shoulders, suspenders upon which were the faces of playing cards, Spanish

rope-soled *alpargatas* on his feet, which were not clean. His mustache was wilted, and the two points met approximately at the flanges of his nose. He was working in a great welter. "I am about to go to Paris; I am making a new book."

"What will it be?"

"Divine."

There were photographs spread everywhere, and every sign of the artisanal, but none of painting. On one wall was an immense enlargement of the eye of a fly, perhaps six feet by four. He goes to a wall and touches a button, and at this a slot in the floor slowly disgorges a large canvas which eventually stands as high as our heads. Another touch on the controls brings the unfinished painting down to painting level. A large man in shirt-sleeves, to whom I was not introduced, comes in and begins to paint at it.

The next studio was the studio of the Op paintings. One of these was a "paranoiac projection" of his brother Salvador, who died before he, the present Salvador, was born, both of them sons of Salvador Dalí y Cusí. ("I was named Salvador, which means 'savior' in Spanish, because I was born to save painting from Modern Art."—Dalí: a frequent statement.) There were several of these Op Art paintings, one of them on an easel.

SD: This is the answer to everything. I paint this with light layers of glaze, one over the other, piling them on. That is the way the masters painted. This gives the same hallucinatory effect as LSD.

WF: It looks like the dimples in the lighthouse lantern you

have in the patio with the ridges and indentations for the amplification of the light.

SD: It is like the eye of a fly! All those dipped surfaces. The multifacets of the fly eye give the optical illusion. Vermeer did the same. All those little *couches*. So fine. They build up the Vermeer of Delft, invisible to the naked eye. That is why he is different from Pieter de Hooch.*

WF: Cocteau said de Hooch sent postcards from Delft but Vermeer sent postcards from Paradise. Of course, he said, the public preferred de Hooch at the time.

SD: Those men are the intellectuals. The adolescent romantic Rimbaud led them all astray. Our gods were Lautréamont, Sade. The eroticism of Saint Theresa in heaven surpasses the Marquis de Sade. The divine Vermeer of Delft added his genius in those little *couches,* which was all the tradition would let him. Tight shoes, tight shoes! If you sit in the position as if you were going to shit and think all the time, you will never think of anything. The thing to do is do somezing, every minute; then the ideas come.

WF: Cocteau said—asked, "If your house was on fire what would you fetch?"—said, "I would fetch fire."

SD: I am a fireman! [*pompier.* In French, *pompier* art—fireman's art—means the most conventional bourgeois art.] I am a pyromaniac of a fireman!

The irreproducible rapier rapidity of his answer is the real significance, along with the gleam in his eye. He has said—to account for why he is not a good painter, though he is the "best"— that he lacks technique, which is "unattainable in the modern egalitarian age," but that, more than this, he is intelligent. This is the *sine qua trop.* For the great artist does not know what he does.

* Contemporary painter with Vermeer in the Dutch town of Delft; de Hooch is scarcely remembered now.

WF: But you have said it is timidity to think of a thing too much, to overpolish until you have achieved the last possible nuance.

SD: I only envy Vermeer—he would correct, and correct again. And correct again. He knew the *anguish* of obtaining the last possible perfection. The perfection beyond perfection. In an age of no faith it is no wonder that the painter paint nozzing. If you switch to new things all the time you will never reach your limit. Picasso was heterogeneous. Dalí is homogeneous. If Picasso had painted one way, he would have fulfilled himself. I trick, you see. That's the trouble. I often say you should lie. I have said speech is invented for lying, and that we lie all the time—especially to ourselves. I don't know if I lie or tell the truth when I talk. [That is terrible. He means it.] I cannot deal with the disjuncture of matter. It is not a painterly subject.

Dalí sees in revolt the virtue that it will exhaust itself and cause a return to tradition. He congratulated Picasso on the supreme ugliness of his painting because "it would kill ugliness in painting by overdoing it." I asked him about the sexual revolution.

WF: Why do you associate so constantly with adolescents?

SD: I am interested in their attempt to rid themselves of sex.

He sees the sexual revolution as the attempt to purge sex by making it totally free and thus valueless. By his heroic adherence to creed, he is deprived of *counterpoint,* which is the secret of Marceau, which is perhaps *art.*

WF: Haakon Chevalier's translation of your *Secret Life of Salvador Dalí* makes it a pretty wonderful book in English— equivalent to your painting: crazy and strange within, but with

a wonderfully accomplished surface. But I found the *Diary of a Genius* in the English quite another cup of tea. A kind of *Notes from Underground* perhaps, but—
SD: But it is wonderful! All my books are wonderful!
WF: It is not as good as *The Secret Life.*
SD: But it is! It is!
WF: Did it have the same translator?
SD: No. It didn't.
WF: Maybe that's why—in *English*—
SD: That may well be! The translators are not the same. Yes, *The Secret Life* is beautifully translated. It is a very, very beautiful book in English.

I was with him when he went to the Vermeer exhibition at the Orangerie in Paris.

SD: The light of Vermeer on Delft is the *proof* that photography never will produce what painting can produce. No photographer will ever reproduce such light. I will say that the light on Delft changes the light of Paris. When I came out of the Orangerie I saw a different light on Paris, which I had not seen before.
WF: You say you and Picasso once attempted a picture together. What happened?
SD: Picasso passed me an etching and I worked on it.
WF: Result?
SD: Unsatisfactory. Our temperaments didn't accord.

A disheartening experience. Barcelona. I am coming out of the Pintor Fortuny Street. Fortuny, a realistic painter of the nineteenth century, has influenced Dalí. He has sat in front of Fortuny's immense *Battle of Tetuan* in the Museum of Modern Art in Barcelona and, with his canvas supported on apple boxes, painted his own *Battle of Tetuan.* It does not differ much save that Dalí and Gala replace two of the leading Arab warriors.

Ahead of me as I come out of Fortuny, unnoticed in the horde on the Ramblas, mustaches wilted by the fire of the sun, shoulders stooped like each and all of us, hurries along an aging actor. Probably he is in from Port Lligat for a day of shopping. But tonight no doubt the curtain will go up. He paints now with the weary clarity of David,* but the tyrant is not Napoleon.

HOTEL MEURICE, PARIS, 1972

I make my way up the rue de Rivoli in a snow that has come much too early. Dalí is very different in the Meurice suite. His eyes glitter with an intolerable vigilance: the eyes of the Inquisition, the quick, intent way he turns his head, alert to everything. Whiskey and champagne on the coffee table. Cornucopias of gladioli. Phone dancing a jig on and off its hook.

 Dalí is dressed in an old-fashioned dark pinstripe double-breasted suit, the coat open to disclose a pearl vest ribbed in gold braid. He holds a silver-headed cane. The mustaches are erect; their antennas are vibrant now. He says, possibly seriously, that with them he is able to capture psychic electricity. At the same time he gives a truly noble appearance—which at the moment he is putting to ignoble use. He is posing for a Berlin photographer with hippies. He is standing up behind them on a little platform, both hands gripping his cane *à la* elder statesman, and they are

* Jacques-Louis David, official painter of Napoleon.

grouped in front of him as if they are about to give rock voice. In a few moments everybody goes out, and suddenly we are alone.

SD: Spain is the most paradoxical, the most perverse land in the world. Our whole effort is to overcome the Cartesian rationalism of this France. Do you not think that I come from Ampurdan? That is the northernmost part of Spain, *squeezed* between Catholic apostolic Spain and rationalist France. Theoretically I am a great Catholic. But I lack faith. Because my father was an anarchist and freethinker. I see in science the proof of the existence of God and immortality. I want the scientific evasion of death which technology can give; for example, the hibernation capsule. You can go into it and wake up in a thousand years, just as now.

WF: Will you actually try hibernation personally?

SD (shocked): Oh, no!

WF: You won't go into the capsule yourself and be frozen?

SD: I will be put into the capsule after death.

WF: After death?

SD: Yes.

WF: In hopes of survival?

SD: As a precaution. A prudent measure.

At a press conference, *Figaro, Paris Match,* newsreels, Radio Télévision Française, are all there. The uninformed lackluster analphabet idiocy of the questions makes you sympathize with Dalí. The absurdity of his replies takes on a different light. What *else,* if you are possessed of a dramatic sense? Seriousness of riposte is ruled out. One person only has grave dignity on this occasion: it is, contrary to all that is written, Dalí.

DALÍ (SEVEN YEARS AFTER)

Dalí has not changed, seemingly. His subject on admittance to the French Academy (May 8, 1979) is "Gala, Velázquez, and the Golden Fleece," and he informs the academy in his discourse that the golden fleece is the pubic hair of Gala. On television a month later, mid-June 1979, he declares that he abhors the middle class, that his whole fight is a fight against middle-class art. "Museums are whorehouses—public houses. Culture is a whore with which you sleep every night. The *Angelus* of Millet and the *Gioconda* of Leonardo da Vinci are clear representations of the Oedipus complex." This last idea he borrowed from a very early book by Freud. "I am absolutely against the French Revolution. The worst example of middle-class French Revolution art is Matisse. The most inept of contemporary painters is Chagall."

He was received into the French Academy wearing a green velvet uniform embroidered in gold and a bandolier in the Spanish colors of red and yellow from which was appended the Grand Cross of Isabel the Catholic, Spain's highest order, given him by Franco, and carrying a sword of his own design with a Toledo blade of—"it is soft steel" ("soft watches")—and a hilt composed of precious stones and designed to resemble the penetrating eyes of Gala "that can look through walls." The hilt is surmounted by a gold baroque spread-winged swan. (The swan has forever been

the obsession of Dalí;* see *Leda Atomica* [*Gala and the Swan*, 1949]. The swan was the form taken by Jupiter to seduce Leda [Gala].)

The press of the world was present under the cupola, six television chains from various countries, a multifaceted fly's eye of camera lenses; and *Le tout-Paris* of snobs, "riches," and sybarites. "I will not," said Dalí, "associate with anyone who earns less than one hundred thousand dollars a year. The poor may come to my door hoping for largess. It is useless. I will not give alms to anybody—whether from Cadaqués, Rosas, Figueras [his natal town], or hell. In my house you will never see the dirty ears of Bohemia. You will never see the unwashed assholes of gypsies, who do not wash their *culs*. I have betrayed my class, the middle class, and converted myself into an aristocrat. I am a monarchist, and everyone should wear a head crowned with a gold crown on his underpants. I am happy to have reached old age. The present youth does not interest me. They serve for nothing. I hate spinach, because it is as formless as liberty. The opposite of spinach is a suit of armor."

A cast back into the past will serve as clarification. Called on to make a speech at the Republican Center at the end of World War I when he was not out of his teens: "I mounted the platform with the feeling of one condemned to death, going to the guillotine. . . . My mind went blank. . . . I could not think of a word to say. I was

* See Ana María Dalí below.

consumed by fear. My heart failed me. The Germans had just been defeated and revolutionary Russia was in ferment. Suddenly the blood rushed to my head. I lifted my arms above my head and shouted at the top of my lungs: 'Viva, Germany! Viva, Russia!' The success was indescribable. I was recalled the following day and brandished a German flag; I was received with feverish applause."

Dalí said: "Why do I paint soft watches? Because I am a mystic. The soft watches are like camemberts, and the body of Christ was a Camembert." At last he cried to the French Academy audience, *"foutez le camp"* (the polite translation is "Get out of here!"; the impolite: "Fuck off"). Overexcited, he applauded himself. "Viva, the railroad station of Perpignan! Viva, Figueras!" He said: "Velázquez painted the railroad station of Perpignan. Perpignan is the gravitational center of the universe. When the Bay of Biscay was formed mill-yones of years ago, if the peninsula had broken off at Perpignan, we would be in Australia today, living among kangaroos. What could be more terrrrible?"

A great trouble with Dalí arises not from what he says but from the way he says it. Obviously that of the splitting of the land masses and ourselves among the kangaroos is bullshit. Obviously Velázquez did not paint the railroad station of Perpignan. And yet he did. Isn't the "Gare de Perpignan" really the point of tension (of collision) between Cartesianism and the tragic soul of Spain? And isn't Velázquez, more than any other

painter, he who caught the Spanish soul with the Cartesian clarity of France? It is written, "The only soft watches are hourglasses, and all that is soft is the sand." But this misses the point: a soft watch is a metaphor. Time is bendable. It is written, "If the eternal cane of Dalí turned into a snake, like the staff of Moses, his astonishment would unseat his white magic and commercial witchcraft which sustain him far more than does the cane." Yet he *is* a thaumaturge.

"Emotion? I have never had emotion. I don't know what it means. I am moved by nothing. I am not moved by my own love life," he told Alain Bosquet.* He has always had to have strong stimulants, like anyone of weak emotion—sadist, masochist, or *clédalist.* Does he favor the sea urchin because it is delectable, because it is the one natural sea creature nowhere represented in the mosaics of the Greeks and Romans and neglected in art, or because it is of all edible creatures that which has the anus closest to the mouth? He devised the game of the foxes: they were to run in pairs, male and vixen, on tracks at social gatherings, passing over gigantic elastic bands; the celebrants, opposite and paired, were suddenly to tug on the ends of the elastics as the foxes passed over them, thus projecting them high in the air, after which they would fall to the ground and break their backs (to the general hilarity). He received a

* Op. cit.

Chinese porcelain goose as a gift from one of his princesses, which opened by means of a lid in its back. He conceived the idea of sawing off the neck of the goose and having a real goose inserted inside, only its head and neck protruding. At dinner, a violinist would enter with violin and "vibratory appendage" which he would insert into the anus of the goose. Then, playing after-dinner music, he would produce—amid the conversation of the dinner guests—the agony of the goose.

On Monday, June 11, 1979, Dalí gave his latest painting to the Dalí museum in Figueras. He said it was finished but for a few touches (he doesn't find time to paint anymore, which is his great tragedy); he said it was worth 50 million pesetas ($780,000 at the prevailing reckoning). It is *The Golden Fleece.* As it measures eight feet by three feet eleven inches, it is to be hoped its subject is not solely the pubic hair of Gala.

Dalí's house is below a cemetery of 1702. It has not changed, except that, of the two turret eggs, one has been removed and its place taken by two paired "Dioscoric" heads, one female, the other male; the male head, significantly or not, split down the center.

WF: Señor Dalí, the search for the magical is buried by the rational. The magic is the powerful but unexplained. A search for lost powers obliterated by thought, deformed by systematization or "science," kills poetry/magic. If you can *say what you mean,* isn't it terribly hard to be poetic? Poetry is inference, suggestion; but perhaps in plastic art there is a cer-

tain hard, clear poetry, akin to Dante, and better than the "smoky" Turner.

SD: The worst painter in modern times is Turner.

Impressionism was spontaneity, but it didn't work.

Cubism was formalization as a reaction to spontaneity, but it didn't work.

Breton's automatic writing, Surrealism—to restore spontaneity—didn't work.

Then came the Dalian paranoic criticism. The objective and critical analysis *ex post facto* of delirious associations and interpretations. What is this but a miniaturist objectification of hints from the unconscious? It replaces spontaneity or instantaneity, but one cannot actually recall the million-fold impulses of the paranoiac (that is, private and pristine) self. Given that the spontaneous cannot work systematically, but that "genius" (art, poetry) lies *behind* intelligence, and that you are supremely intelligent; is it not by constant unpremeditated, thus irrational, activity, Señor Dalí, that you escape the stricture of your own intelligence? Picasso told me that he liked you—it is not often, Señor Dalí, that one says he likes you—but he said you were like an outboard motor running out of the water. Is not, then, genius to you—for the highly gifted, the nonnaive—incessant unpremeditated *activity*? The hope for the future, as expressed by many, is the fusion of the anarchistic and the classic—this you have done, but you are Dalí, in perpetual motion. Isn't the fusion illusory

and the reality AC/DC? Aren't individualism (anarchy) and collective schematization (classicism) incompatible, and thus always replacing one another in a series of revolts? Art is nothing but personality today. Anarchy. A chase downward owing to the art market and dealers (like porno). A corrective offered is the turn back to the archaic (the Stone Age, et cetera). The age of innocence. I have found only two others. Your corrective is "Design is the probity of art." You alone are a classicist. Robert Graves's is "Address yourself to a Moon Goddess; a new unity (reality) is formed of the two. A reality as you must express your true self but communicate it. If you communicate it to more than the one loved one, you will falsify it, submitting to laws of communication."

THIS IS THE GALAHAD GALA HAD
Ana María Dalí, June 8, 1979

In the original family house—that where Dalí painted sixteen hours a day stark naked in a laundry room, that from the porch of which García Lorca read aloud his *Primer Romancero Gitano* on summer evenings—nowadays renovated into a handsome Cadaqués chalet. Photos of Dalí's mother, who died in 1921 when he was seventeen. Dalí's paintings of his father. *Girl's Back* (a reproduction, Ana María Dalí said). Sketches of her: trials for the celebrated portrait with curls. Photos of García Lorca ("It is here he stayed when in Cadaqués"). The house is on the seafront, but with a

large garden in back "where we can retire from the tourism" on the south side away from the center (Port Lligat is over the headland to the north— that is, opposite—side of the bay). Ana María's house is not far below the house where Gala usually lived "so she could be alone." "She appears at Port Lligat only when the press is to be present. Oh, all that has been over for a long time." "I hate Gala."

WF: Do you think she is at the origin of Dalí the *payaso*?
AMD: I think it very likely.

She is a spirited, fine-looking, gray-haired woman, seventy-one, four years younger than Dalí, with no coquetry except a little lipstick and blue makeup around her eyes. "I never see my brother. They have their mad life over there; we live in tranquillity here." She lives with younger generations who seem to be descendants, though one cannot imagine what the relationships may be as the two siblings who matured were she and Dalí, and she has never married and Dalí has had no children: for example, a very handsome woman a generation younger who seems to resemble her; a young lad in his teens with a distinct "Dalí look." There was even a baby stroller in the living room; walls of books; the *Enciclopedia Universal.*

AMD: A painter is born. My brother was always an artist. No, the stunts were not necessary. He was already known and recognized by the best critics as a painter before 1929. He is two people: a painter of genius; the "Dalí character," which is absolutely false and pure invention. The latter has no roots

in his nature; the roots of Dalí-painter are here, in this house. He was a perfectly normal boy.

WF: You yourself say in your book* that even at five he already wanted to be Napoleon.

AMD: But every boy at five wants to be Napoleon, or an astronaut, or et cetera! It is absolutely without significance.

WF: When did the change come?

AMD: Nineteen twenty-nine. When he encountered the Surrealists.

WF: You'd say the "Dalí" character is invented?

AMD: Totally! Out of whole cloth! He is not like that at all.

WF: He is timid, though. Overcompensation . . .

AMD: Over *what?*

WF: Overdoing it to reassure himself, because of his timidity.

AMD: Only as the false Dalí. As a painter, he does not need constantly to reassure himself. Listen——suppose I were to undertake to be Greta Garbo, which I am not. I'd have constantly, constantly to prove it in order to be able to believe in it, because it is not true——has no base in *me*. Salvador lies, invents incidents from his past——he knows they never occurred, but then he works out an elaborate Freudian explanation of them and their influence on him to account for peculiarities of his character, knowing all the time they never happened at all.

WF: The first Salvador as an example . . . ?

AMD: Yes. He died at less than two years of age. Dalí has made him older, but the records are in the registry of Figueras. We never knew him! Do you think our parents were such ogres that they plied us with a dead little brother who died before we were born? We never thought of him; we vaguely knew he had existed. He was never spoken of. And of this Dalí makes the return in himself of the dead brother, the double brother, et cetera, et cetera. It is all simply invention.

He is two people. The public Dalí has killed the artist. He is simply an industry now. He is in the hands of some

* *Salvador Dalí Seen by His Sister,* written in Catalan. Editions exist in French and in Spanish.

fifteen people, who eat off him. Lithographers, et cetera—and so much of it (the work and reproductions) is fake. He is alone. He has not one friend. Gala is present only for photos and publicity. He is surrounded by his clan, but they are all sycophants: he knows it. But he can't escape. Not now. I am sorry for him. He is so immensely exhausted. The constant activity. And he has no time to paint. A painter wants to be alone so he can paint. He has to have time to think about it.

The public is of course in too much of a hurry to care—about anything. It is perhaps one of the gravest matters of the century. But *nobody* distinguishes the one Dalí from the other; not the critics either. He entered the French Academy of Arts; it is right that he should—as a painter. What happens? He says, "My painting is *mierda.*" And in the speeches of the academy they speak not of his painting but of him as a genius, a writer. He belongs in the French Academy because he is a *painter.*

He is of course a surrealist. He always was. Every painter is a surrealist if he isn't a mere copier. The realist is what he sees—objective reality—and the *sur* is what he adds, how he sees it, how it affects him, how he reproduces it. El Greco was a surrealist. Who not? But in "Surrealism" it was formalized and all by the pope—the Black Pope, the *Papa Negro*—André Breton. He was a dictator. It was *his* Surrealism, his view; otherwise it was forbidden. It was said to be freedom in art—it was a prison. So little of the truth ever appears in the press. What the Surrealists said of Breton was not printed—Aragon, Eluard, et cetera, et cetera—they loathed him. They said he was a monster.

WF: How did he get away with it?

AMD: God knows. (If Magritte painted some wonderful pictures and they were not Breton's idea of Magritte, they were suppressed. They were not "Magritte.") When someone without a talent who desires to be known employs the tricks of my brother, I can understand it. He has no other way; he has nothing else. But that is not the case of my brother.

WF: But he was spoiled. *Mimado.*

AMD: Yes, he was *mimado.* He was a *niño.* He always was.

A child. He is today. He has never grown up. That is why it all has happened. He is very influenceable. He had celluloid swans. He had too many toys, but the swans were his obsession. He smashed them out of shape with a hammer. I wept to see their beautiful form spoiled.

11.

MARC CHAGALL

WF: Are you a symbolist?
MC: I am a realist.

Conversing with Chagall is difficult, because he is not chained to concrete facts. He is ninety-four, born in 1887, thus the oldest great painter of the age, perhaps the oldest of all ages, having already outpassed Picasso by two years and a half. So he has said a thousand times and so says the official record, but according to his own autobiography* he was seventeen in 1907, twenty in 1910. In fact he was born in 1889 and is ninety-two. He himself says, "It seems that in order to obtain certain privileges for my younger brother,

Ma Vie by Marc Chagall, 1957 (Paris: Stock).

David, my father advanced my age by two years on my birth record." He does not date the year from January 1, but from the beginning of the work year after vacations—presumably September. The datings of his paintings are approximate, to say the least. Every account and chronology, presumably derived from him, says he married Valentine Brodsky (Vava Chagall) in 1952, when in fact he married Valentine Brodsky in the town hall of Saint-Rémy-de-Provence on September 20, 1958. I went to Saint-Rémy and consulted the civil registry myself. Why the deception? He lived with Vava from 1952; did he, for some reason inscrutable by contemporary mores, wish to conceal that he was not married to her? And what about Virginia, the English girl with whom he lived in America after the death of Bella and by whom he had a son, and whom he brought back to France with him and who later abandoned him in 1951, clearing the way for Vava?* Why does she vanish? Where is the son? Chagall's only son? Coincidence? Carelessness of the chroniclers? Or does Chagall wish it to appear that he passed from Bella to Vava, after a suitable interval, as indeed his painting makes it appear? When Idotchka was born, his only child by Bella (he has had none by Vava), he would not go to see her for four days, so indignant was he she was not a son. So greatly he wanted a son. "I was a bad father," he said. "It was shameful."

* Françoise Gilot, *Life with Picasso,* pp. 262–264.

WF: How can creative impulse, which is an extension of the individuality, with its moods, uncertainties, and if you do not lie, ultimate mystery, be made a constant?
MC: By establishing a dialogue with your subject.

I read to Chagall from a Spanish newspaper:

"Having both capacity and terror, they experience problems solely with the reality that surrounds them, for it is a personal reality which is distinct from the reality which they consider not their reality but that of the others. Often their drawings and paintings achieve great objective reality, and adjust perfectly to the various personal styles, but there comes a moment which produces disruption, distortion—they reflect images as they receive them in their own heads, departing from outward reality."

MC: It is a perfect instance of the process of painting.
WF: It is a formula for *ergoterapia* (self-therapy) by painting for lunatics, which I culled out of a Spanish paper. Who are your favorite painters?
MC: Rembrandt. Monet.
WF: You associated mostly with poets when you came to Paris in 1910 and went to the Ruche in 1911.
MC: Cendrars. Canudo. Apollinaire. I began to write poetry as soon as I learned to write Russian.
WF: All the major painters seem to be poets. You. Miró writes poetry. Picasso was a magnificent poet. Dalí wrote poetry— rather stiff and stilted, with exotic ideas put in a rather stiff way. Who was your favorite friend among the painters?
MC: Oh, Delaunay.
WF: Did he influence you?
MC: I don't know. We did some Eiffel Towers. But that for me

was a symbol of Paris. Of course Robert was famous for his Eiffel Towers.

WF: Would you have done them anyway?

MC: I don't know. Robert was a little older than I was, and he was Parisian. That meant he knew his way around. That was very important for me at that time. And, besides, though Sonia, his wife, was from the south, from the Ukraine, she grew up in Saint Petersburg where I went to school, raised by an aunt. She married Robert the same year I went to Paris, 1910. So there was that too.

WF: Did the colorist theories of Delaunay found your own colorist theories?

MC: I don't think so. I was a colorist before I left Vitebsk. Probably it made me feel less lonely.

WF: One reads of the Jewish *verein* of the Ruche . . .

MC: That is a fiction! For one thing, Soutine was anti-Semitic. He could hardly speak a word except Yiddish, but he wouldn't talk to anybody who spoke Yiddish. And Modigliani was an Italian Jew, and that is a very different thing from being a Jew from the lands of the ghettos. It is true that Soutine, Modigliani, and I all lived in the Ruche in the years that must have been about 1912, 1913; but what it amounted to was this: they would come home after carousing at the Café Dantzig, which was just up at the corner, and, furious to see light under my door and that I was working, would throw their shoes against my door. "Still making your cows?" Modigliani would shout. I worked every night, stark naked . . .

WF: Dalí worked naked, by the way, as a young painter. It must have been a decade after the years you describe. He said it let him feel closer.

MC: I wanted to disencumber myself. In summer, too, the kerosene lamp made it hot. Those studios in the Ruche were coffins. I was impassioned to paint. We say my father was a *commis*—a clerk—in a fish warehouse, but in fact he was little more than a porter, carrying boxes and crates of herrings to the drays . . . and, later, when autos came in, he was run over by one he was loading and killed on the spot. We were ten children, the girls, and myself and my brother David, who died of tuberculosis in the Crimea . . . and in the ghetto of Vi-

tebsk. And despite all this I was let try to become a painter. I didn't want to waste a minute of the chance! I studied with a local academic painter, and it must have been when I was sixteen that I went up to Saint Petersburg. But I never seemed to be able to accept too much from outside. Even in elementary school, I knew the lessons well enough, but if called upon to recite I'd stammer and couldn't get it out. I studied, of course, in Saint Petersburg, but the one I learned the most from was undoubtedly Bakst. Through him I learned all about what was going on in Paris art. Bakst was the set designer for Diaghilev for the Ballet Russe, and they had already made their sensation in Paris. He had a small private art school for a short time, and I attended it. Who do you suppose had the easel next to me?

WF: Who?

MC: Nijinsky.

WF: In *The Dead Man* or *Candles in the Dark Street*—which is it correctly called?

MC: I don't know. I never name my pictures. Blaise Cendrars titled some of them, and Bella most.

WF: Miró says it's when he thinks of the title for it that the picture takes its final, unalterable form in his mind.

MC: You see?

WF: In *The Dead Man* one sees your Uncle Neuch fiddling on the roof . . .

MC: No, that is my grandfather.

WF: But I thought your Uncle Neuch was the fiddler.

MC: He was. But it was my grandfather who was on the roof. We all went up there; I did too, often . . . the view was excellent. But I especially remember my grandfather because on one day of a village festival he completely disappeared. Finally everybody was looking for him everywhere and feeling quite desperate; and at last he was found sitting there on the roof peak watching it all and eating carrots.

WF: Then Neuch was a shoemaker, because there is a bootmaker's sign extending from the front of the house beyond where he is sitting fiddling.

MC: No, he was a procurer of cattle for butchery, often by my grandfather, who was a butcher in Lyozno about fifty kilome-

ters away, but he played the fiddle like a shoemaker. You see, all these things melt together, transpose, combine, and what you get is a picture.

WF: You have said you don't know what your pictures mean . . .

MC: They don't have extra-pictorial meaning. For instance, in one case I have cut off a flying milkmaid's head, and it is coming along in the air behind her. I didn't do it because I had anything I wanted to say about milkmaids; I did it because I needed to fill up that space in the picture where you will now find the head.

For Chagall, a picture is a stimulus to the poetic imagination, a species of magic. It is not trying to narrate anything. "Is not color a language, like music?" he says, and, especially in his later work, the color is not necessarily bound to the forms, though he has always refused to become abstract. "I had a special reason to concentrate on my work and get ahead," he said, "and it is the same reason why I went on to Vitebsk in 1914 after a month in Berlin at the time of the showing of my paintings at the Sturm Gallery there, arranged by Apollinaire."

The fact was, Bella was a Rosenfeld, and the Rosenfelds owned three jewelry shops in Vitebsk. It was his habit to put a little rouge on his cheeks and a little mascara around his eyes—though he was very shy and "liked to weep," he was very good-looking—and would go out and court the girls. And in 1909, the same year he received a subvention that let him go to Paris, he was stretched out on the examining couch of the doctor, the father of his friend Théa, waiting for her to come over and embrace him, when they

were surprised by a knock on the door. A girl friend of Théa's came in, stayed but a moment, and left; but later, when he was embracing Théa on the bridge over the Duina, he realized it was the other girl he wanted to be embracing. The other girl was Bella. As he writes in his poetic ("the lamp drowses and the chairs grow bored") autobiography: "Her silence was mine. Her eyes, mine. It was as if she had known me forever; knew my childhood, my present, my future. As if she had grown up beside me, though we had just met for the first time. I knew she would be my wife."

Bella posed for him nude; when his mother saw the sketch pinned on the wall, she was so shocked she made him take it down. When Bella was stretched in front of him nude, he could only gaze at her with awe and wonder; he couldn't approach her. "We corresponded feverishly during our separation, but I knew that wasn't going to be enough. Even so, it was simply because Bella would not have it otherwise that the jeweler's daughter married the herring porter's son."

MC: I had papers stamped for Paris, and I wanted to go back. But the war broke out and when I went to the office to obtain my exit my papers were stamped nul.
WF: Thus you became a Soviet commissar.
MC: Eventually I did. After the October Revolution there was a meeting of all the people concerned with the arts in Vitebsk, and I went along, and to my astonishment heard myself proclaimed by acclamation as head of the arts for Vitebsk. Later, I was confirmed by Lunacharsky, who was People's Commissar of Education and Culture; I'd met him in Paris. He was a journalist there and had come along to interview me and write an article about my work. Then there was great excite-

ment and activity. I was forever running to Moscow and else-where trying to obtain funds for my school of art in Vitebsk.

WF: Why on earth did you hire Malevich as a professor—you to whom squares and rectangles are so distasteful that you gave up making ceramic walls, such as you see in the Miró Labyrinth almost directly across the road from your house at the Maeght Foundation, because you couldn't stand the rec-tilinear forms of the tiles? When you took up ceramics with Georges Ramié himself about five years after Picasso did, was Picasso pleased?

MC: He was not. As for Malevich, perhaps I thought that sort of art of his of squares and triangles was teachable. I was very young, and there was the revolutionary ferment, and perhaps I was naive. But I wanted my school to succeed. Art is a state of the soul, of memories, not necessarily solely one's own—can that sort of thing be taught? Can it? I was not myself teachable, but I had to try to find means of teach-ing others.

WF: Is it true that your mother's father was married to your fa-ther's mother?

MC: It seems a strange thing, but it is true. They had both been widowed, and they married. I had one set of grandpar-ents instead of two. The grandfather I never knew was the rabbi, but we were all Hasidic, perhaps most of all my mother's brother Neuch, though he may have rasped horribly on his fiddle in his bootmaker's style, and what can reach far-ther back than Hasidism? You have told me that you are con-stantly being told that art is reaching further and further back for its roots in humanity, and I have said that the true nature of our memories that call for expression is not necessarily al-ways personal. Hasidism seeks to evoke ecstasy, link with the elemental, by music and dance. I would like to add color. What could be more ancient? It goes back to the beginnings of mankind.

WF: And that is why you say the one thing you must learn is to know nothing but instinct.

MC: Think, the ego is the liar—it lies in the midst of the cir-cumambient cloud, it confounds the complex inner drives, it remakes life in the limitation of its image.

12.

JEAN LURÇAT

Our world is a world of accommodation, not true in the least. In lawless work, when the artist has trodden over the strewn litter of assumptions and is at last on his way, "truth is stranger than fiction" but fiction is truer. The incommensurable creators think we are fools dreaming that we are men; and by their infernal brews, of the homeliest stuffs, wake up in us imagination, the love of giants, as if in the inner, private, moated heart we are almost still the children we were not long ago. And this is easy for artists, for they too, like us, live in the fiction of the daily world which is called reality, and the truth of the heart. They know we are troubled by primitive dreams. How could we not be? Our society has evolved so rapidly that it is already in a state of obsolescence, but we are young. They know that we, as all humans do, believe in

255

assumptions that nobody believes in at all, and unarguable conclusions that are simply bullshit. We live in a clear, rational desert of the known; and our hearts *thirst*. We are accessible to the geniuses, if they take the direct inner road from the heart to the heart, and we are subject to their deviltries, for they use the shared truths all know and none speak, and diabolically they are inside before we know it. We are happy then. Miró showed me three of the ceramics he did with Artigas: suggestive, plaintive, strange, blunted, perplexed, questioning: a *White Woman* with owllike head and strangely beseeching breasts—or are they stunted arms? Or truncated? Which induces the strongest deep emotion we can now feel.

Jean Lurçat is a necromancer of the bestiary. He is a strategist of strange symbols that look back before the origin of our memories. Dialectical materialist that he is, he ordinarily claims he isn't. Essentially, he lives two lives. Summers, when traveling, he is up at six and does some painting (gouaches). He travels the world: Red China ("This is what *death* is: its horror ... you do not know what happens *after*. I will never know the China of fifty years from now"), Israel, Egypt. Dahomey and Moscow on a single day. Senegal. Winters, he is up at five-thirty A.M., has onion and lemon juice, makes his own coffee, lights his own fire in the studio. Then the crops, and the barnyard of his eleventh-century castle whose denizens are the source, he avows, of the bestiary. "I am surrounded by cocks and cattle. . . " he says. For-

getting that the cocks of his tapestries are made of flames, or fallen leaves, or stars; the bulls are primordial; a porcupine has lyre horns. Domestics arrive at seven-thirty; assistants at eight. To work. Two fingers of whisky at nine. Lunch twelve. Immediately after the meal Lurçat rises, often while finishing his fruit, and naps ten to twelve minutes; he is back for the coffee. Six P.M. to the casino in Saint-Céré below the castle, where he has a single glass of Beaujolais and conversation with the locals. Eight-thirty to bed; reads one hour. Invariable routine. Invariable routine. "Inspiration? Ha! Inspiration is continuity. Inspiration is a nymphet you rape—but you always wait for her at the same corner every day."

WF: Don't you feel your energy diminishes with the years? You are seventy-two.
JL: Physically—yes. I have had three heart warnings but never a real infarctus. An hour of angina pectoris at times, always at Paris. It is necessary to commence in Paris, for the perspective on art; necessary to quit Paris after a certain age: there is the terrible temptation *to keep up with everything.* I go to Paris and I feel like a country bumpkin, completely out of touch. How good!
WF: Perhaps no other plastic artist is such a traveler. Doesn't it fatigue you?
JL: There is the necessity of human contact. Look at the entries to see my expositions . . . at random, Colmar in Alsace, Buenos Aires: in each case some five hundred thousand people paying twenty francs to look at *tapestry.* I firmly believe that if so many people wish to see my art it is because I have seen so many people.
WF: You are a proletarian drawn toward the mass.
JL: No. Toward that which is *human.*
WF: I had come to think that great creators are solitary.

JL: No! And then, I am completely alone in total silence the first two hours of each morning. I have one hundred ten acres of fruit trees. They depend on me and so I love them. I sometimes stroke their trunks as I pass—not for the newspaper photographers! I am alone. It is voluptuous. There is a shortage of water among the peasants of Saint-Céré? I give them water and it is close to the feeling of offering a glass of wine to a friend.

WF: What do you get from travel?

JL: I am going to Egypt in two months. *Already* something monumental and enormous intrudes in some of my designs. When we get to Aix I will show you. Certain friends say, "Why, that is Egypt!" After all, Israel is just these dry hills of Provence, your Alpilles. Egypt, too: the dry cliffs . . . Except that in Egypt—something gigantic. The temples . . .

WF: Brazil?

JL: Yes. The butterflies, the incredible flowers. A decade ago I went to Brazil for a series of conferences. What happened was miraculous! The butterflies, the monstrous vegetation like human flesh. I saw forms gigantesque—inhuman. That which interested me in the butterfly was the *gratuity* of the coloration. The butterfly is saturated with colors. One asks oneself why all that riot of color on the *cul*. Seemingly, it serves for nothing—not even to attract the eye and the heart of the female. Then why? Try to understand! Isn't it Nature itself? Not *our* logical concept of nature. Some incredible artificer. I began interlacings of directions, combinations without logical value except in themselves. These latter years I greatly employ contrapuntal composition. Contrasts, not nuances. Juxtapositions. Rupture. I would say deliberate rupture, voluntary breaks in the melodic line. This has come after Brazil and my promenades in the forests of monstrous plants and giant butterflies. Those butterflies liberated me. I began interlacings in all directions, interlacing of forms that hadn't objective value. For if you look at my butterflies closely you will see that it would be totally impossible for them to fly. They are built in rigorous nonobservance of the laws of equilibrium and flight. I began to see forms . . . unexpected, disengaged. You

see it in children's art. For example, when I was sixty-eight I had an immense tapestry in view on the subject of the Rhine. I went to a children's school and asked, "Permit me to draw in the drawing class of the children, among the children." I had the conviction that among them I would regain a state of grace. When I was young, we had a saying among the peasants—if you contact syphilis, sleep with the nearest virgin to cure yourself. We, artists, we work only against taboos. There is something that you *may* not do. That form there, that *cannot* be expressed like that. That is impossible. That is old hat. That has become impossible. We work *against*, whereas the children are *desperate* to express themselves if they can.

I thank him for giving himself in talk. "No, I thank you. I have said things I hadn't really thought of myself. It is like the creative mechanism, the exteriorization."

"Some have called your symbolism Freudian."

"Ho! It's *retrouver l'atavisme.* Get back to the preconscious."

From what he said about the cock mounting the hen—"When the cock approaches the hen, she *opens* before him. *Elle* s'oeuvre *avant lui.*"—one may suppose his sex impulse is much like Picasso's. His second wife, a Russian sculptress, died in '53 of cancer brought on by despair, he says, over the murder by the Nazis of their adopted son at the end of the war, and he married Simone Lurçat two years later. "We had met during the Resistance. I was chief of the Resistance for the Department of Lot, and she was chief of the women's section. The first time I saw her she was riding a motorcycle, in a black leather jacket, with a submachine gun

slung over her shoulder. Later tragedy, in the form of the death of my wife, intervened and brought us together again."

JL: I feel shame after composition. Even when it is good I feel as if I had done in public what shouldn't be done in public. I resemble Picasso, physically. It is my Spanish grandfather. Picasso is the *unarguable* leader among twentieth-century painters. No! That cannot be discussed. No! That *cannot* be discussed. He is the opener of many ways. I am sure Picasso will still be considered first of our time five hundred years hence (if there are to *be* five hundred years hence), though I admit the changes of taste—Raphael to Piero della Francesca, et cetera—but to define this would take one far into technique. He simply does things all the time I am sure no other painter could do. The *realization* of a work of art requires utilization of intelligence, but the *origination* is instinctive. Unknown.

His wife, half his age, at dinner, wore a necklace of pendants of broad plates of beaten gold with little Stone Age North African–like figures. By her husband. The tiles in his kitchen at Les Tours Saint-Laurent, sixty of them, were all figured by him on a single afternoon. "It is not by accident that my tiles are *my* human faces, *my* symbols, *my* arrows. There are arabesques, abruptly broken by a counterline. This rupture is one of my obsessions. It is the refusal of traditional composition. There are obsessional repetitions. Calligraphy obtrudes at high speeds. The hand thinks. No time for the head. And the result is a linkage, obscure, between the different phases of my art. I put in things I do not know I will—that I

do not understand. Sometimes I have bits of po-
etry woven into my tapestries; sometimes poetry I
do not understand. But the conception comes to
me, and I know I will do it. In reality, if there is
not conscious rapport between the different means
of expression I use, these rapports exist all the
same. Simply, they are obscure, difficult to un-
earth."

Now known almost exclusively for tapes-
try, Lurçat makes jewelry, ceramics, and paints
and was chiefly a painter until 1939, his forty-sev-
enth year. He paints still—mainly gouache. His
resemblance to Picasso is startling. I have a photo
taken from left profile that could *be* Picasso: the
same bald head, the same monkey-inquisitive face,
the same penetrating eyes.

JL: I practice the strategy of the truth. The deviousness of the
truth. You know what I mean? You get it? I tell the mere
truth—and the others deceive themselves seeking the *real*
truth behind what I am saying. They cannot imagine anyone
who says nakedly what he means like that.
WF: Salvador Dalí has said that ever since the French Revo-
lution there has developed a vicious, cretinizing tendency to
consider a genius (apart from his work) as a human being
more or less the same in every sense as other ordinary mor-
tals. This, he says, is wrong. The daily life of a genius, his
sleep, his digestion, his ecstasies, his nails, his colds, his
blood, his life and death, are essentially different from those
of the rest of mankind.
JL: *Foutaise!* I am a farmer of Saint-Céré who happens to go
in for knitting. I cannot stomach books on art. I don't even
know what they think they are saying. They don't take *any-
thing* into account to account for a work of art: how was the
painter feeling *that day*, what had he eaten, had he made

love or had he not the night before, had he been reading
some pages of Sartre, how was he getting on with his wife,
did he perhaps have a very slight rheumatism in his wrist that
day? You see, they say *nothing* about the genesis of that
work of art. We have the Greeks and the Renaissance always
behind us, and they talk only of that. And we have behind us
too the Egyptians, and the Chaldeans, and the Assyrians,
and the——and the——! I think this links with a peculiarity of
mine. I think I am trying to tap into sources. I am unable to
conduct two phases of my art in the *same place* as well as
not at the same time. If I make a tapestry I never work in
gouache. I never mix the two media. Have you ever watched
a cat who is going to piss? It turns round and round before it
settles down. I am like that. I have three painting studios at
Saint-Céré. I have never used one of them *once.* I paint in
Paris, or at Antibes, or here at Aix at the Hôtel des Thermes
where I am taking the cure—in the kitchen, on the edge of
the bed, anywhere, but not in a formal situation. Surrealism,
Cubism, Impressionism, all were mocked and run down. And
now, *bon Dieu!* it's our turn! ''That blow-of-the-fist art bangs
with an arbitrary violence on tradition . . .'' But they mean *re-
cent* tradition, the seventeenth century, the eighteenth cen-
tury. *I* am rooted in tradition—but the tradition of the Middle
Ages, of the day of magic, of griffons and unicorns! And the
fields and the firmament! And who are the ''savages'' of
modern art? Van Gogh, Rouault, Picasso. Miró, *bon Dieu!* He
was the only one who approached *tapestry* in the Cuttoli ex-
periments. Because he is more a muralist than an artist of the
easel. France is not Fragonard, Watteau. France is *The
Charterhouse of Parma, The Lady and the Unicorn, The Prin-
cess of Clèves,* Cézanne, Matisse. Rabelais! Reread the crit-
ics—*at the time*—of Toulouse-Lautrec, Monet, Rodin. . . .
WF: Or Picasso himself. Despite his immeasurable success,
he never had good criticisms. Tell me about the Cuttoli ex-
periments.
JL: Madame Cuttoli was the wife of the senator from the De-
partment of Constantine in Algeria. She lived in a *menage à
trois* with Henri Laugier, a professor of the Sorbonne. Laugier
brought her to see my tapestries. She had never seen tapes-

try before. I began with *canevas** (which is like tapestry in every sense in appearance at a little distance) in 1915 when invalided home from the war. Before the war I had been an apprentice in fresco, but fresco does not suit modern conditions. We move all the time; buildings do not endure. What was wanted were movable murals in wool. I tried my first in 1915 . . . my apprenticeship. Rainer Maria Rilke once told me, "You have to be fifty before you can begin to write, because before that what do you know?"

WF: So *canevas* was your first mural art?

JL: My first mural art was scrawled on the walls of Paris: DOWN WITH THE WAR! I was a pacifist. I was even for the French-German alliance and I published a newspaper to that effect, copies of which you can still find in the Bibliothèque Nationale. But when the war came, I knew I was going to enlist. We had a very close friend who was in the War Ministry. "I am so touched by your decision," he said. "So touched. Do you want to be an officer?" What! Did I want to wear leggings, carry a swagger stick? Did they want to make of me a deluxe whore? No! War was shit, and lice, and mud. And I wanted to know the shit and lice and mud, and I enlisted in the infantry *second class,* and I knew the shit and lice and mud! I knew what war is—I was in the Argonne and at Verdun—I knew what war is, the worst plague of man! I was wounded, and to pass my time while home convalescent made *canevas.* It was no good; it was a copy of one of my watercolors—copies of painting in tapestry can never be any good—and we ripped it out, I and my mother who helped me with the needlepoint. I went back to the war and wrote antiwar letters of the experiences of a young man at the front, and they were smuggled into Switzerland and published in Zurich in *The Revolutionary,* a periodical started by Lenin. The first three were.

WF: And then?

JL: The fourth was intercepted by the military intelligence and I was arrested. I was held awhile, but they didn't do me the

* *Canevas* is embroidery or needlepoint executed on a preexistent base of perforated canvas which may be bought by the yard (Jean Lurçat, *Tapisserie Française* [Paris: Editions Bordas, 1947]).

honor of thinking I could be a real spy, and I was sent back to the front as a simpleton idealist. After the war, in 1919, I went on holidays in Switzerland with Rainer Maria Rilke and Hermann Hesse, but I was painting and writing poetry all the time.

WF: You write poetry?

JL: I have published two volumes. And I was going on with *canevas*, no longer imitating but creating original works in wool. In 1921 Laugier brought Madame Cuttoli to see my work. We became a threesome; she bought some paintings; eventually I made three large tapestries for Madame Cuttoli's home. They were still *canevas*, but the largest I had done till then, each about seven or eight square yards. In 1929 Madame Cuttoli decided to try to revive tapestry as an art. What was wanted were names. So she got Picasso, Léger, Miró, Braque, Dufy, myself, to contribute works; but not designed for tapestry, mind you. Her husband had a workshop in Sétif in the Constantine in Algeria, and there young Arab girls were set to copying Léger, Picasso, Braque, et cetera. But they were paintings, not original creations with tapestry in view. The experiment exploded in an aureate fiasco . . . much publicity, but the prices were too high and little was sold. In 1933 my first loom tapestry, not *canevas*, was loomed at Aubusson, commissioned by Madame Cuttoli—*The Storm*. It shows a knife fight, two gypsies, but it was bad because Madame Cuttoli demanded a copy after an oil painting. The origin was not a schema.* You cannot copy painting in tapestry.

The schema gives the tapestry creator complete control. The swatches of wool are dyed to an exact color, and that color bears a number. In this way the creator *knows* what color he will find in his tapestry; it is not up to the weaver to *interpret* [sarcasm] the colors in the painting.

* Diagram. Since 1940 Lurçat has used no other method. He is thought to have—he himself thought he had—invented the method, but lately fragments have been found showing that schemata were used in the Middle Ages—the skeleton outline of the forms to be woven but numeration used for the colors, the colors not painted in.

WF: What has tapestry brought you?

JL: Joy. I was a Surrealist painter, though I never joined the movement. But my paintings were desolate, despairing, bleak—showing solitude, hopelessness. I did not want it so, but the war had graven a track into my hand. Oil painting is too suave; not enough *resistance*. The ruggedness of wool gave me joy—liberation. The reality of the wool. It takes you from the sophistication of paint. You escape the facility that carries your mind into self-disgust. And—but this was later, when the great wall spaces came, areas sometimes of three hundred square feet—there was expansion, *souffle!* You do not have the same inner stature when you stand before a space to be filled of thirty by one hundred as when you are engaged in the philately of the tapestry of the *appartement,* or a gouache of three by four. You *grow* in inner stature; you fill up your chest with *souffle*—deep breath.

First of all, there can be only one creator of a work of art—either the maker or the executant. Fourteen thousand four hundred tones of color were possible in the decadence of tapestry; they tried to copy every nuance of painting. With fourteen thousand tones you cannot capture all the nuances of a Bonnard! And—*joke*—the nuances are fading, and the old tapestries are coming to look like the new ones. You cannot create a nuance which will not fade, even today. And the price of dyeing six hundred fifty kilograms of swatches to create twenty kilograms of tapestry was killing tapestry. No one could afford it except the state. There had been one hundred fifty thousand weavers in France. There remained but three hundred. In 1939, with Gromaire and Dubreuil, I was sent by the French Ministry of Culture to Aubusson, which had always been the independent tapestry center, to revive a dying industry. The weaver could do as he liked, imitating painting. He used skeins and skeins. We got back to the wool bones of the matter. I reduced the colors to twenty, thirty, forty—a maximum of forty. I use black, white, four shades of green, five shades of blue, six shades of yellow, five shades of ochre, red—*maximum!* The swatches are dyed in indelible colors, and thus I can envision what my tapestry will be, and will always be—and will be a hundred years hence! I am the

Kapellmeister and the weavers are my orchestra—they do not play *dolce* when my schema indicates *adagio, bon Dieu!* That latter way there is no art, cannot be. A work of art can have only one creator.

Incidentally, a curator discovered lately my color scheme corresponds exactly to Roman mosaics; I thought I had devised it—what do we know? . . . It conforms to the re-action of the eye to color at a distance, and this is a law, true of course for the Romans as for us. The tapestry is made on a *chaîne* ["warp"] which is a harp string of adjacent colorless threads strung across the loom, and over and under these are woven the strands of colored wool, the weaver following the schema which is spread below the warp, in reverse because the back side of the tapestry must be up so the ends can be tied, joining the different colors on the bobbins. Often the face of the tapestry is not seen by its weavers until it is fin-ished. When the tapestry arrives at Saint-Céré I do not un-wrap it. I do not want a glimpse of some part of it like a fleck in my eye to influence my view of all the rest. My assistants fasten it to the wall, and then comes the critical moment. I look at it. If I am making a tapestry *d'appartement,* small for-mat, I make a series of four. Always four. Each is different. I walk sometimes for days in front of the version, and then I make alterations on the schema as an author corrects proofs. Each time for the four.

I bought Tours Saint-Laurent for the height of the walls. They fit my purpose admirably: some are as high as thirty feet. I bought the castle without visiting it; I saw it òne day in 1944 when we were going through the hills above Saint-Céré in the maquis. The owner was the Viscountess Annie Mioche de Cotteix, and you know she was in the Re-sistance with us Communists. I bought Tours Saint-Laurent sight unseen for the height of the walls and my love for its stone, which I had seen from a distance. Every night at ten my taped broadcasts for the Maquis were emitted—instruc-tions, pleas for resistance, blasphemy of the SS. And what do I find when I take possession of Saint-Laurent after the war? The clandestine radio that broadcast my messages had been

installed in Tours Saint-Laurent! I hadn't known it! Life some-
times plays such tricks. We commenced the revival of tapes-
try. But I wove *Es la Verdad,* which was a plain reference to
the Spanish War and a slap at Franco. When the Spanish
War broke out I went with a carload of supplies for the Loyal-
ists to Madrid, and I was on the Badajoz, Huesca, Valencia,
Toledo fronts. In Madrid I was with Clara Malraux, then wife of
Malraux, who was also in Spain fighting for the Loyalists. And
then I wove *Liberty,* including a fragment of the poem "Lib-
erty" of Paul Eluard—who was underground with the
Maquis. The SS burned my studio. I had to flee from the
Nazis. I hid in a convent and my Communist friends said, "My
God, his soul will be corrupted!" Then I joined the Resistance
in the Department of Lot.

 I have put my art in a frame of limitation, acquiring
force by resistance to expansion, checking lax, self-indulgent
anarchy, but nevertheless there is *something* beyond the
control, something inexplicable even to me. I am not as exact
as my fellows. I am not *exact.* Mallarmé wrote, "Deprive the
mind of that delicious joy of imagining that it creates and you
kill art." I am a materialist in means and in philosophy—a
dialectical materialist—but I believe that the inference of po-
etry is the true human communication, the form direct human
communication takes from human to human in the multiple
and unknowable. I believe that poetry *is* life. But without
recognizable representation, I think the poetic charge is
weakened.

WF: Recognizable but not literal.

JL: *D'accord!* I can give you an example of that. I have just
made a moon and a sea tapestry for a great Dutch casino on
the shore. Yes, the moon influences the tides and is con-
nected with the sea: but I show only fish and moon. The con-
necting link remains submerged.

WF: Picasso and Moore show a strong disinclination to ac-
cept commissions; Dalí (apparently) shows readiness to ac-
cept commissions.

JL: Orders are useful against self-imitation. They force you;
they stretch you. Besides, the tapestry is too massive! You

don't undertake Chartres Cathedral or the Leaning Tower of Pisa without plans, aim, cooperation, intuition, surface, destination! This is not a century for the *demoiselles* and *messieurs* of Versailles. This is a century of mud and war and deception and crime. There exists, in our *epoque,* in practically everyone, the taste for primitive art. We are not led to repeat the primitive but are led to a new experience of the world. For this we need a certain loss of facility and of commodity of technical means. To deal strictly with tapestry, we do not need the elegance of Oudry.* In wall art on vast spaces you do not use cabinetmaker's techniques.

WF: You use motifs.

JL: A motif has succeeded. I know I will use it again. I do not will it so; I know I *will.* Poetry is for me the real language, because it expresses multiples. I utilize a fragment of verse sometimes of which I do not wholly understand the sense but I *know* I *must* use it.

WF: How do you compose a tapestry?

JL: Like this. [We are in his hotel room at Aix-en-Provence. He snaps off the table lamp.] Not theory; fact. Even this. [He snaps off the high light in the room and we are in the complete dark; he stretches out on his bed.] *Toc!* Total dark. I lie in the dark and visualize—two days, three.

WF: You compose without a piano.

JL: My assistants have fastened paper to the wall to the exact size of the tapestry in view. When I go to it and trace the first line, the tapestry is already finished. I do not deviate. The marvelous is in asymmetry and in the dark. We flinch before alterations imposed on forms known to the senses but we must assimilate the vocabulary of a further system.

WF: The *inexactitude* of your symbolism is its genius appeal. The *Apocalypse d'Angers* launched you?

JL: Oh, I had made tapestries before that. But—yes—that was the plunge. When I saw that, that was when I decided to go deeply in. Give myself to it *en bloc.*

* Jean-Baptiste Oudry, tapestry designer of the eighteenth century whose cocker spaniels dominated tapestry for two hundred years.

THE SONG OF THE WORLD

Before lunch we talked of the unseizable levels of communication, a kind of "atmosphere" that might explain the dancing craze of the Middle Ages or equally fads of today which are perhaps much more than superficial manias born of publicity. "During our physical progress man has not stood still but retrogressed," said Lurçat. "Man has lost his humility. That is the great trouble. Tapestry is a very ancient art whose origins are lost in the dawn of history. In Coptic Egypt twenty-five hundred years ago, colored wool was woven on a *chaîne* of linen. It was known to Ovid; he writes of it in Book VI of the *Metamorphoses*. The tapestry of the Apocalypse at Angers on the Loire was completed in 1380, woven throughout the 1370s. Measuring 740 square yards, it is the largest tapestry in the world. Twenty-four different hues only were employed. I went to see it in 1937."

WF: The virus incubated for twenty years.
JL: Yes.
WF: You have made more than eight hundred tapestries*— in cathedrals, museums, embassies, the Kremlin; single-handedly revived a thriving art form, dominating your art form more than any other artist of the twentieth century, even Picasso; and you have made *The Song of the World*.
JL: Yes.
WF: It is the largest tapestry since the *Apocalypse d'Angers* in the fourteenth century. Begun in 1957.
JL: Yes. It measures fifteen feet in height by two hundred and

* Jean Lurçat died at seventy-three; this indicates almost his complete production.

twenty feet in length, approximately three hundred twenty-five square yards. It is made in nine panels. Originally it was to be called *La Joie de Vivre*. Jean Cassagnade, the peasant of Saint-Céré, who, much more than a peasant, has been a candidate for the Chambre des Députés and launched the Casino of Saint-Céré, came to me with the air of a martyr or a crusader—it was in 1956. He said: "Jean, you are a *guérisseur*—a healer." I was in bed with sciatica and when the idea came to me the sciatica completely disappeared. "*You* are to make the great tapestry of the twentieth century, the *Apocalypse d'Angers* of the twentieth century." "*Bon Dieu!*" I thought. Oh, no. But then gradually: "Why not?" It was to be the joy of life; my tapestry has always been gay, the exuberance of the wool, the rusticity, the warmth of wool to eye or hand. Materials *count*. The Chinese paintbrush is more *automatic* than our softer camel-hair brushes. It is made of the hairs of pigs' ears. There is greater energy, greater attack. Once I found it in China my painting changed, and I will use nothing else. In gouache it gives you greater rapidity, less time for reflection; you tap the archetypes stamped into the lost memory. But life is not all joy. It is good and evil, black and white, fire and water, male and female, material and antimaterial. One day on the bank of the stream we were having lunch of trout and my friend Birot said: "Jean, your conception is not complete. Why not include the desolation that marks all your early painting?" *Bon!* The dialectic principle—good and evil opposed.*

* *Man Under the Menace of the Bomb* is the first panel of *The Song of the World* (a bird of prey drops the atomic bomb into the circle which represents our civilization, with on its rim figured the Eiffel Tower, a pagoda, the Parthenon; beneath is a volcano—"we live on a volcano." Man guides his ark away from the disaster but, from above, the aurochs, the primal bull, sperms down the source of life—but now it is fallout and the creatures and plants in the ark are blighted. Panel Two: *The Charnelhouse of the World*, a cycle of bones and skulls in disruption and discontinuity; *The Man of Hiroshima; The End of It All*, space filled with flecks of ash and nothing in it but a broken cornstalk. *Man in the Glory of Peace*, the owl of wisdom poised on his head, a dove posed over his

heart; *Water and Fire, Champagne,* an effervescence of bubbles and butterflies (Lurçat: "There are things that impose themselves, one knows not why"); *The Conquest of Space; Poetry,* Sagittarius fletching his arrows among the fabulations of the Signs of the Zodiac ("The Zodiac has always interested me as the expression of magic ways of thought which survive even among adult human beings").

13.

MARCEL MARCEAU

WF: Dalí hates you, you know.

MM: Tell him I love him.

WF: That was a very Dalian answer. He always takes the contrary.

MM: That's right.

WF: No, that wasn't "Dalí" who gave the answer. It was the Chagall side of Marceau. He hates you because you are not tall enough.

MM: Did he say that?

WF: After he had seen your performance, he met you and he said you were not tall enough. And it is true you are not as tall as you appear on stage. Perhaps you are taller inside than out.

MM: Dalí has understood one thing. Unless one makes oneself known by scandal or sensation, a real talent is likely to go unrecognized, or it may be recognized—but very slowly. Dalí is a great painter.

WF: You too are a painter, are you not?

MM: Yes. I was originally a painting student. In Strasbourg.

During the war I had to give it up. Until the war I had lived all my life in Strasbourg.

WF: Your painting is like that of Chagall—more like Chagall's than any other painting I have ever seen—winged Bips, Eiffel Towers tipping crazily . . . and the host of clowns—silent clowns—Chaplin, Keaton, Bip . . .

MM: Well, it's not my fault.

WF: Whose is it? Chagall's?

MM (laughs): It's true that Chagall has winged figures . . . like my Bip.

All Marceau's letters are decorated with figures of his winged Bip—a mixture of art and writing; crescent moons, a brilliant sun on which he draws a radiantly smiling face, an ascensionist's balloon with basket in ascent or descent, the signature Bip always followed by a flower.

29th of January, New York

My dear Bill: Thank you for your beautiful letter. Unfortunately, this will be a short one. But I want to answer you and not keep silent. Our tour in the United States has been tremendous. We shall be in Spain in March, and I would like to see you then. I shall send you a cable about my itinerary. We shall talk about everything and you will see my new work.

This brings back memories of our past meetings. Time has passed and still it seems timeless. We have so many ideas to exchange. There is certainly growth in our lives. Your letters are wonderful, and they always send their deep value to me.

I send you my embrace and my deepest friendship.

(Bip) Marcel Marceau

Phoenix the 13th of December

Dear Bill: Thank you for your letter. I hope you are fine. I think we shall be in Spain touring again next November. Then we can meet. Or maybe before in Paris March-April and Septem-

ber-October. Then we can meet. Concerning the record* I think it is too late now to do anything about it. You see people say, Jews are greedy for money, as they say Scotch are misers, Italians are thieves, French are stingy, and so on . . . I think men are men, there are noble ones, mean ones, educated ones, and primitive ones—this makes a world rich and poor, healthy and ill, a struggle between life and death . . . like light and shadow. I have always been very disinterested; it is really not a question of money. I think that the people who handle that are not business people, or even not artistic, because if we would have done a good record technically we could have sold it very well. Do the producers like amateur work? I can't understand this world. If we want to do things correctly in a nice studio no company will accept, but they accept when they have no money to spend. And the result is not good for them either!!! And so they say after it is not commercial!! Promise me one thing—ask them not to reissue it, or not to re-edit it. Tell them that we are willing to make a new one together. It makes no sense selling this one! OK?

The tour is very exciting. We are playing in all the major theaters and cities. We have 75% of young people. The excitement is even greater than before. I have plenty of new material you have not seen, like "Creation of the World," "The Revolt of the Robot," "The Dream," "The Four Seasons." Bip looks for a job, Bip as a fireman, Bip in modern and future time (this part is a very important piece). I shall put it all on film next year. We are now in Arizona after having started the tour the 27th of September. (We give 25 performances a month.) Now I shall have a rest for my book, approximately 15 days. I write my life story (my silent outcry).

And you, dear Bill, are you writing another play? I think your play you have written is very exciting, I have it in Paris still, and we have to discuss it when we meet in Paris. Don't you have new plans? How are you living? How is life for you? And your togetherness with your wife! This is a very indiscreet question, but I do hope you feel fulfilled and happy in

* A recorded conversation Marceau and I made.

the sense we like to feel it. A tragic happiness almost . . . Because how can creative and thoughtful people be happy? If they are concerned they suffer for mankind, the world, and our fate. We can have serenity, but it's another escape because there are millions who will remain crippled or ill or hungry or offended. I know we are going to die soon. In the history of mankind we are already dead. But our spirit will go on . . . Because if all the good people and real ones of the past would be really dead, the world would explode with hate and darkness. The balance of good and evil is still challenging, and this is what we have to live for. Once we are dead in the body our soul's creativity will remain, and as long as men will emerge on those planets we shall stride with them— May God (the gods which are our spiritual guidance and live within us) may the gods preserve you in your work and spirit!! May we find enough courage and force to overcome weakness and compromise. Let us be men as we want to be. Let us still live for light, peace, beauty, and love. Let us have compassion, and struggle, and express our outcry for the world we live in. . . . I know we are together in all brotherhood. My dear Bill, I hope to hear from you soon.

Deeply yours, (Bip) Marcel

Dear Marcel: I hope my reply, written from bed, but which I then got up and posted, reached you in Beverly Hills. Your letters, as is your friendship, as were our conversations, are of deepest importance to me. I have asked myself how I can do justice to you. I rejoice that you have new numbers and that I may see them either in Paris or in Spain; that you are getting on with your autobiography and that I may read it one day, and I know that it will be an autobiography of the soul and not that of superficial circumstances as so hurt you in Chaplin's. I did do two abortive beginnings to my book—but it will be most difficult to find continuous expression of that which is by its nature discontinuous: art in our time. I do not wish to falsify what I am trying to say in order to say it, and publishers are not particularly disposed to hear the resonances of what is a new age (since Planck, Einstein, Freud). I have brooded over the fact that yours alone is an ascendant

art in the general decline—in literature, graphics—and have concluded it is because you are alone in it. In short, you have no competitor—who could then cheapen the market, for in large markets it *is* true that the cheap drives out the fine (Gresham's Law). All this and much more, I turn round and round in my head. (About Picasso I know so much: not only because I knew him and have many times seen him and written about him, but because there is so vast much to read about him—57,000 titles to date in the Bibliothèque Nationale! Much is wrong; but you can check and recheck; with you, this is not yet possible.) I hope that upon what we did say to one another, upon what I learned of mime through you, we can build.

As for our record, I was impressed by your fluent English, as indeed Clive Barnes expresses himself to be in his article on the sleeve. Perhaps if they can now insert "impromptu" it will somewhat account for your disconcertion with your voice quality, and I must sincerely say, because broadcasting was long my profession, I am not at all sure we could have obtained the sound level without loss of genuineness and naturalness of thought. I felt keenly the sense of your remark that one cannot present an artist without giving him final decision, but in fact I was not consulted. We were all in far different places—the producer in New York, I here, you everywhere. What is wanted—what *I* want—is now to go beyond into the differences between your naturalism and your impressionism, and thence to your postimpressionism (a sort of post-Cubism in a way, as one sees in Picasso). Then one might arrive at a contribution rather than merely (what I hope has been) fairly cogent observation. In my book, at least, I will be free. You know I am not even with the literary quarterlies, and in what I published of you there I had to cut somewhat to the shape of the situation.

I have completed a short novel in which the protagonist is "the world's greatest mimic." I drew heavily on a dear old actor who subsequently went to Hollywood from radio and who could mimic any human or animal; and on Deburau, on Chaplin, on Picasso (very much), and just at the climax for one minute on you, I think, for the man's soul looks through

his joking exterior. So I have been thinking of you in various ways; also when I was literally thrown down by flu—remembering how you would say, what could you ever do if you were sick or disabled for you are the whole show? It is a heavy burden to have to guard against ever being ill or hurt. I shall send off the novel in a few days and be most anxious for your opinion of it. He is a crude man, but I think he has something in his soul.

The purpose of this letter is to reply to you, in my fashion which has to be different from yours for we are of different formation, as a way of putting down another stone (one hopes) toward the eventual crossing into your world, so that when I write about the process of genius, which I conceive to be a shape, a "stance taken toward"—for to say it is temperament screening circumstance is true but carries one not far—in this effort I do not want you to be in my depiction less than what I have seen you to be on stage and in life but which, to be conveyed, in print must be expressed in another idiom. Clive Barnes says on the jacket of the record that he can hear your being in your voice: yes, but he knows you well. Is not the trick to cause those who do not know you to hear the within of you? I wonder if mime—in the moment of building its language of gesture—isn't in its strongest hour? The symbols are still mysterious.

Dear Amigo: I was so pleased to receive your two letters. Excuse me for having taken so much time in answering them. Our meeting has been very positive to me. I saw in you a real human, I was so happy for that. It is so rare in this "dark world and wide" . . . but sometimes an angel with his wings shows us that there are also men on this earth. And light suddenly comes in our heart . . . and we go some steps forward. I would be very pleased to get some news from you again, because it is good for my spirit. Now we are touring through Germany (55 performances in two months)—then we shall be in South Africa. Italy. The democratic republics of Czechoslovakia, Hungary, Rumania. In July (Paris: film). August, Sweden. September: Mexico. October: Paris again. Please write to me, I shall answer. It is a real pleasure to express

ideas and feelings. It is years since I have really talked. Some-how, I *can't*. Most people have something to say alone—very few have anything to say in a group. Parties? Cocktails? I meet so many people. No one says anything individual. But everybody says the same thing at parties! It is *death*.

All the best to you and sincerely your friend Bip Suerte Marcel

My dear William: Thank you for your letters, and your gentle articles.* I just finished two lithographic books. And I am doing a third one with all my paintings. I miss you and would be happy to see you. Where are you? I am going to the States for 2 lectures at UCLA and one TV program in September. I shall be in Scandinavia—and October-November-Decem-ber—France!!! Soviet Union was very exciting!! Ella is well: everything is better now! How is it with your life, is your wife expecting a baby? Did I understand that from your last let-ter?? Please write; in this dark world and wide one is always interested to deal with real friends, and you know that you are my real "pal." I remain your true Bip. Always. Suerte!! Marcel

My dear friend Bill: Thank you so much for your wonderful letter. Now we are in London. The success is like in Paris but it is not quite the same. Something is missing, I can't express exactly what. The public is excellent in London but Paris for me is still the queen!

Thank you for your wonderful words. I remember the eye of the bull, the attitude of marble reminding me of Michelangelo and your words make me happy but also sad because all these moments are so very frail, so vulnerable, they are like love. Nothing lasts, everything goes. But men continue to struggle. What they feel is emotion, pity, love. I was also sad that we did our conversation in such difficult conditions. I suffered very much from my foot. It is now com-pletely healed. I was so tired when we talked I could hardly speak. I was restless, we had problems with television, I had not one minute for myself. It was a wonderful nightmare, won-

* Conversations with him published in the U.S. literary reviews.

derful because it was full of glory, nightmare because time did not allow me to rest. I remember our last night together. How much happier I would have been to see you now as a friend, much quieter, more calm. I wonder whether I could see you in January in Paris and whether you could spend some days at my estate.

I am happy that you like Ella. Indeed she is a wonderful person, full of paradox but pure. Of course you are right to choose Ella instead of Vittorio de Sica and as a man I would do the same but for the history of art de Sica has given me one of the great impressions of movie history.

I shall never forget *Umberto D, Sciuscia,* and *The Bicycle Thief.* Therefore, the only thing I could give to de Sica was my show in "The Seven Deadly Sins." I was so shocked to see how de Sica was ill, he could hardly go downstairs. Did you notice? Must he not have had an attack or something like that? I felt so sorry for the great old man. Being present beside me, walking carefully downstairs I was ashamed to be full of health and that he felt I had compassion for him. Oh, what a terrible feeling! Because he is like a hurt lion, I could feel it in his tired eyes. His wife beside him knew that I felt it. Well, this is life. We have to take it because one day it will be our turn. It is not pessimism, it is reality. There are so many people who live to be old sometimes with glory and have not achieved half of what de Sica did for our world. These are facts. You remember what I said. The way that people today are confused, putting on masks all the time. We both know what it means to unveil a face, to be left in solitude and to look at life with a great eye; hurt, touched in our heart, full of compassion for a cruel world, but also knowing that memory can be a wonderful healer. I know it is a paradox but for me memory, even of sadness, gives me the power to go on. We have to turn defeat into victory, we have to heal ourselves by our wounds. We have to take energy through our weakness. As we have to forgive but not to forget. We must remain vigilant. The rest are words and words. This is why I prefer silence, images.

My dear William, bless your heart, I am happy to be

your friend. You will always find in me a true man who will understand you if you feel solitude. Let me share it with you. My house will be yours, always. A true friend is like a part of yourself. I hope to be one of those rare friends who live with you the mysteries and passions of life.

Give my deepest regards to your wife, you need much power, strength to support what happens. A certain greatness too. You are the only man who can do it. In January I hope to see you in Paris. If I could come for a week to Spain, I would be delighted, but will it be possible? Write to me, I am always happy to read your letters. I know that you mean every word you say. This is why I take them so much into consideration. I am writing a book, based on my life. There is much to say and time is so short.

(Bip) Marcel

PS: As you know I again toured the world. U.S.A. and south (like the Pope) but my message is not quite the same as his! I speak with my silent outcry!

WF: Did you know that Voltaire wrote *Candide* in three days?
MM: Yes. I believe he had a model for it. So it is said. It has enormous verve.
WF: He wrote over one hundred books. He drank more coffee than Balzac, who is said to have been killed by it, and died in his eighties of adulation in Paris, when he went there out of his seclusion in Switzerland.
MM: My aim is to film. There are so many—become fifteen, sixteen—who have never heard of you; they were ten, twelve, thirteen, when last you were here. And the teens are the big people now. Stan Laurel's widow told me more fan mail pours in than before he died—he is *alive*—"Dear Stan," they write. I begin to call it the sanctification of quantity, and if I did not think so once I commence to do so now.
WF: How will you film?
MM: We want to find a way—something quite unknown. Not just to photograph mime. But *silent.*
WF: You don't mean to make a silent picture!
MM: Why not! Music perhaps. I don't know that speech is so

necessary. If you say of a mime, "He could have spoken too," he is a bad mime—but if you are glad he did not speak? Then he has given you aesthetic satisfaction.

WF: On the set yesterday, making your film for Eurovision, they said to you, "Isn't that a little bit broad? Don't you trust your public?" And you said, "Not completely. Not the great public of TV."

MM: Yes. That is true. I am a theater actor. There is something magic . . . But, no, the public always wants poetry, and poetry on film is becoming much more possible. Beckett, Ionesco, Antonioni—I am sure more is possible now. I am sure the public will accept less literal things. I feel something of loneliness and terror can be expressed—the juxtaposition of comic masks and tragedy. And yet it is all very complicated, very complicated, and I am sure that sixty percent truth or talent, forty percent organization, is the only formula. I am sure Hemingway was a businessman and that his naiveté was pose.

The gesture goes further back than speech. It is more primitive. I think it is, finally, more complete. You cannot lie. I do not exclude *sounds,* by the way. As my frogman is drowning we hear his gurgle—the convulsion of his death. Because that has a different kind of meaning, but speech is approximate. The man a woman always loves is the man who first gave her physical completion, her first orgasm. If a woman does not have children or some other responsibility, she does not master her own emotions. That is her tragedy and why her life is tragic. It is so strange in America: the inability of men to love, and the strange, frantic pursuit of youth. How easy for a European to seduce *any* American woman of a certain age. They long for gallantry. The men hawk their noses, clear their throats, and almost spit. Go to bed then with that?

WF: Maybe that's why a whole society is opting out.

MM: Do you think so? Do you think it is? I think they take drugs not, as is said, to escape or because of despair, but for sex—to see a woman, to heighten it. Really to see a woman.

WF: Why not simply a real woman?

MM: It may be that that is difficult for them. Maybe that is the problem.

WF: I can't help thinking of Chagall. There is gaiety some-times in your performance——more than seems possible for your physical age——Panlike, faunesque. In your painting you don't walk some Bella gaily in the air at the end of your arm to express the joy of love; you paint as a sad Chagall, all the clowns——I recognize Bip, Chaplin, Buster Keaton——the world crashing down, the Eiffel Tower tipping. A *winged* Bip.

MM: As we said yesterday, probably because my father kept pigeons. As you told me Picasso's did in Málaga, and origi-nated the Soviet peace dove.

WF: When your success here outstripped every expectation and showed you aren't for the elite but the people . . . like the antique mimes of Rome . . . the critics didn't get this. They write of a performance they don't see. They write as if you were Pierrot-in-the-moon.

MM: But the public sees.

WF: Yes, the public does.

MM: You must not blame the critics. They have so little time.

WF: But they have space——column inches. And they write as if you were Barrault as Baptiste in *Les Enfants du Paradis* ap-proximately. You are not at all! Or——yes——in moments.

MM: That is very true.

WF: You are like Pan. Dionysian.

MM: Excuse me? Oh——yes! Faunesque. Pan! The god Pan!

WF: You are like a head on a Greek or Etruscan plate. *Earlier* than the classic world. In "The Painter and His Model" you are exactly the faun-soul of Picasso. Did you have that in mind?

MM: No.

WF: But by empathy you are the spirit of Picasso, as if you were parodying his great eye feasting on the nudes in his se-ries "The Painter and His Model," although I remember you told me in Barcelona you were unaware of this and didn't know of those paintings. And in Bip Matador, the death of the bull is empathy. Abstract.

MM: Empathy? I would rather call it sympathy. No, you are

right. I briefly *become* the bull. If I want to mime picking a flower I briefly *become* the flower.

WF: There is a musicality. Abrupt changes. Lingering changes. You are trapped in the maze—in Luna Park. Slowly, the glass entombs you. But when you get out you do so suddenly.

MM: Yes, suddenly. That is it!

WF: Like a movement in dance. It isn't logical.

MM: When I began, I thought of mime as concrete. After all, earlier European mime, which stemmed from the *commedia dell'arte*, was a play without words. Dumb show.

WF: Didn't they talk in *commedia dell'arte*? They had no lines—but wasn't a scenario posted each night, and they improvised?

MM: Later, the silent miming came. But it was realistic. If you took up a prop it wasn't there, of course, but you had to put it down when you were finished with it. No—now I frequently dismiss a prop in midair. It is less *substantial,* akin to Ionesco or Antonioni. But this is a whole great change in every art. More is *possible.* In that way, at least, one can speak of progress.

WF: Are you coming back around to Decroux? Symbolic mime? As you learned from him originally?

MM: We played naked—or almost—like the Greeks. The face was masked with a veil. But it was mime in laboratory and one element was missing, the ingredient of a public. As we said, perhaps Decroux's error was in carrying over antique mime intact, not in carrying it over but in carrying it over unchanged. Because the symbols were less symbolic for the ancient world than for us. It was their way of looking at things. If you go to Japan, there is a sinuousness in the way the waitress approaches you, the formalized movements of a snake; it isn't only the samurai. It does not have to be consciously antiquated.

WF: You froze me when you told how the samurai stuffed the handkerchief into his mouth—to suppress his own scream as he kills the woman he loves and then will kill himself.

MM: Everything was *then,* in that. You did not need to see the sword.

WF: No. No. Was that Kurosawa or Kabuki?

MM: I think Kabuki. Decroux wanted me to grow in his mold, exactly formed by him. But I had to break out. Undoubtedly I was influenced by Chaplin. We were all brought up on the silents. Chaplin, Keaton, Langdon, will survive, because they had a real style—*a style of silence.* The actors were merely moving their mouths, talking soundlessly—it looks ridiculous now. But go look how stylized Keaton was. How he played. You must always take the unnatural, unexpected movement and make it seem natural—re-create it—and that is in all art, music, painting. It gives tension. Decroux called it counterpoint. I am forced by silence to an expressiveness that would only be lessened by words. I will tell you something. I made love to a woman in a Slav country with whom I could not speak a word. We understood each other. And afterward when I spoke in my language and she in hers, we understood each other. Language *interferes.* We cannot communicate—we *adapt* to our communication.

WF: We come to mean what we say.

MM: Yes, because we cannot say what we mean.

WF: But you, Marcel, describe mime like any other art—you begin in kinetic or bodily realization, you *inhabit.* Then recollection and annotation follow after.

MM: That is exactly right. Except I feel that mime is incommunicable in words. You have to have seen it.

WF: What will you do in your autobiography?

MM: I will have to find a way. In "The Maker of Masks" I must detach myself wholly from my face. At the end, when he cannot wrench the laughing mask off, the face laughs and the body cries. I divide myself in two.

As we talk, he does this. The masks, without makeup, are the same as on the stage. *Identical.* What a shattering experience. His thumbs, long, double-jointed, which make the strangely flowing fin-wave wiggles of a fish on stage, talk as he explains. He is not describing the individual he has been telling you about, but he is *inside* looking out

through that individual, who is invisibly around him like a glass ball. His face is as expressive as when in makeup: a galaxy of grimaces but with nothing of the "actor" in them, a string of balloons strung in time with the fixed point the frank, sincere eyes. His eyes "listen" to you.

WF: I thought in "Maker of Masks" the great triumph is you make something plastically beautiful out of yourself, as Michelangelo made a statue. But in fact you are not beautiful. That counterpoint . . .

MM: Which Decroux spoke of. Yes, it is that. It is *contrapuesto*. It is the forced marriage of opposites. And it has another meaning too, though a lesser: that of making the invisible visible——if I want to create the wind I lean against the wind. The force of the wind. By the way you walk a dog, who is not there, you can create the exact size of that dog——its friskiness and lassitude.

WF: Do you train, that is, condition yourself for your performances, which are pretty athletic?

MM: I used to ride. I was almost killed by a horse in Canada and ride less. I fence. But, no, I don't train. Before going on I sit alone for an hour and let my forces accumulate. That is all.

Be cruel. I like that. That is difficult for me, and that is precisely why it is good. Bip was always a man who *did something:* Bip caught butterflies, flew a kite, walked against the wind, leaned on mantels that weren't there; now the poetry is overflowing the edges. You have got a fusion in the process of becoming a new thing. You are verging on the cloud-void of the abstract. It is the tension between the two things——the realism and the abstract——that provokes the magic in the show itself. They struggle; they are opposed but they are forced to combine. Yet one must be wholly true to the elements of each. That is the stress. You must subdivide yourself.

WF: Your brother Alain told me he has taped your audiences——whether in Japan or Rome or London or Africa——

and all over the world the responses are the same: laughs, coughs to conceal emotion, silences. Always to the second. Do you find publics identical?

MM: Some are more exuberant than others: Hungarians. There are English jokes, French jokes, Japanese jokes—but there are no Italian, Russian, French, or Japanese cries or tears.

WF: The pattern is the same?

MM: Yes.

WF: How do you account for your great success in America? Isn't America one of your best publics?

MM: With Russia and Japan. Yes. And now Paris. I believe Americans like me because my performance is physical—not intellectual—poetic and physical, the poetic of the physical. It is felt physically by each man watching. The mime goes into the arena—the circle of white light—like the matador, and faces his moment of truth. He does not die all at once like the matador: but slowly he dies. He gives his life and blood slowly to the public. Harlequin says in *Les Enfants du Paradis:* "I give my love to the public: they take it and leave. I am left purged and free."

WF: When you perform, do you feel it?

MM: I must keep cold inside. All actors play cold. Diderot was moved to tears by a great tragedian and he went backstage. "You are splendid tonight, Monsieur Diderot," said the actor, reaching out with a forefinger and taking a tear from Diderot's eyelash. Do you see? We must always play cool. It is the public which must feel.

WF: You make me think of how you were with Escudero in Barcelona. He had been the greatest flamenco dancer of his age. But he was eighty. You brought him back to life. He came backstage to see *you,* and you reversed it all. You applauded *him.*

MM: But I saw him the last time he played Paris, and he carried his heel taps up his whole body to the very ends of his fingers and then into his fingernails! Snick, snick. Nothing left of it but just the snick of the nails.

WF: How does a turn originate, Marcel?

MM: In the mind. An idea.

WF: But how do you know what you are doing? You, after all, are inside the image.

MM: I try it in front of the mirror. Then, always, the body supplies unexpected ideas and changes and enlargements. It begins with an idea; then I make a plan or scenario; but when I try it in front of the mirror my body changes it all around, as of itself.

WF: Isn't mimicry a mysterious thing? Aldous Huxley wrote that it was the most mysterious thing in the universe—how *can* a mynah bird talk like a man? It hasn't a man's throat, or tongue, or brain.

MM: Of course you know that when I mime walking upstairs I never saw anyone climbing stairs like that. Many say it is a haunting image of the reality of climbing stairs, yet one does not climb stairs like that. It is the *feeling* of climbing stairs. I do not say I mime things I have not seen in some way—I cannot paint a lion if I have never seen one—but miming takes place inside. You become the other. By sympathy.

WF: Empathy.

MM: It isn't copying. If you provoke and overcome rebellions of the body, this is kinetically and unconsciously felt by the audience. You train your body to assume unnatural positions and make them seem natural, and it is that that is felt, kinetically, in the body of each spectator.

At Berchères, seventy-five kilometers out of Paris, on the road to Chartres, his house is full of the paintings of Bip—an anthology of mime, partly by his own hand: the hundreds of posters of his performances from all over the world, the Russian puppets as tall as men, the theater dolls collected, not to mention Lev and Petrouska and Maciek, Lev a big woolly sheepdog and the latter two toy dogs, and his many paintings of himself in the role of Bip.

Sitting on the lawn drawing my portrait,

Marceau told me the Chaplinesque story he wants to make, the story of a clown who plays for a little girl: all laugh as he takes pies in the face and beatings; she weeps. Ending is MM: the clown does not take the cue of "quitting" as she begs, so he can remain with her; neither does the circus keep him on. He is left alone in the road. Very Marceau.

WF: Your father was a Russian Jew, wasn't he?
MM: Yes. And he was taken by the Gestapo. They came for him in a little car during the war and we never saw him again. That was why I had to flee from Alsace. I was hidden in a house in Paris and taught painting to Jewish children hidden with me. Later I smuggled Jewish children into Switzerland and Spain as a member of the Resistance, and to disguise my activity started a little theater. I went to Charles Dullin's acting school and there I met Etienne Decroux, the father of modern mime. But, no, I don't agree with you when you say I share origins with Chagall.* He lived that background in a Russian village; with me, there may be some atavism perhaps . . . yes, perhaps. Who knows? Who can ever know? But my father rode a horse out of Russia when he was thirteen and I was born in Strasbourg, of an Alsatian mother. My upbringing was French.
WF: Do you know what Miró said about you?
MM: No.
WF: He said, "What marvelous training he must employ to prepare himself for those extraordinary feats. What marvelous discipline!" Miró, too, keeps himself fit and trains—or did. He was a boxer and swimmer. Do you know what he said about Graves? It was exceedingly characteristic. "Do you think I could go up to Deyá and introduce myself?" he asked. "I always wanted to meet him. But I have never dared."
MM: All great men are modest, don't you think?
WF: No.

* We had been looking at the paintings.

* * *

MM: I must live like a matador, from place to place. I could not stand the routine of domesticity. Meals always at the same hour? No. One day I want to eat, another day I don't. I do not answer letters, am late for appointments, forget things; exteriorly seen one says, "Marceau is in the moon," but I have never missed a performance, not *once* in thirty years, never been ill—or so ill I could not play. Sometimes I *do not want* to play. But *never* have I failed to feel the performance once I begin. A priest once gave me a bottle of Moka liqueur. I thought it was some kind of coffee and I was thirsty and I drank half the bottle. Then they came and told me it was a strong liqueur. I drink little alcohol. I am not habituated to it. In the wings, I could hardly stand. On the stage, I was as usual. I was fencing in Los Angeles. I fell on one knee and it swelled up triple size. You know how athletic my performance is, yet that night I played as before. No one can go on in my place.

Chaplin came from the Fred Karno Company, which was the London theater of mime. Had it not been for the movies, Chaplin would have been the greatest mime of the theater. He tremendously influenced me. As a boy, we children played Chaplin, miming without knowing it. I entered the theater school of Charles Dullin, who had also drawn Antonin Artaud, who wanted to make a theater of cruelty. I didn't know what was meant, but now I know it was like the Chinese theater where men *become* lions and other savage animals. Artaud had a weird, fanatic force; and all we actors gathered to hear him when he gave addresses; and he wrote his tremendous book on van Gogh and died in a madhouse. Those were the days of ferment.

At twenty, I saw *Les Enfants du Paradis*, the great film of mime, and realized I had always loved mime. I went into Decroux's mime school. We were very few. How strange that in those days of enormous technical films, et cetera, in a little rented room—naked but for loincloths—we were performing old Greek and Roman mime. Perhaps thus wonderful things begin. But I wanted something else. Decroux eventually completely broke with the realities of theater, and it is a great pity that if it were not for myself and Jean-Louis Bar-

rault, no one would be aware of his existence today. Jean-Louis Barrault, the Pierrot of *Les Enfants du Paradis*, had also been a student of Decroux. He staged a pantomime at his Théâtre Marigny, playing Pierrot, and engaged me to play Harlequin opposite him. This was at the end of the war. At the same time, in 1947, mingling the influence of Pierrot and Chaplin, I created Bip at the Théâtre de Poche, the smallest theater in Paris.

All other actors despised mime: one aspires to be great when one is young. There was an academy of opera, or drama, but none of mime. Ours was the only mime theater in existence. One does such things for love. One could have spent one's passion on making money, or in love (but that wears itself out), or killing (I think we are in that way lower than the animals, who kill only for need); many mediocre men could do something: what lacks is not intelligence; men are lazy. A creator is ravenous, selfish, takes in from all hands, but then finally gives forth. Yes, Chaplin lost something when he began to talk. However, he was a very great actor too. The evocation of the tree, the Japanese in *Limelight* for the girl— that is the heart of mime itself. I consider Rossellini a great man; why did he quit making those wonderful movies? [I explain.]

By 1950 Bip was known in the profession. In the 1955–56 season, the Phoenix Theatre off Broadway introduced him to American audiences for a limited engagement. His appeal was so great that he moved to the Ethel Barrymore Theatre, and later played the City Center. Only previous bookings prevented him from playing out the entire season in New York. His first great success was therefore in America. By 1957 he was known to the public in France. "Right after the war much was possible. There was a hunger for theater. Less competition than now . . ."

WF: While it is evident that your direct descendance is from

Chaplin, I think that your more real descendance is from Deburau.

MM: You do me honor. Chaplin was undoubtedly a genius, but so was Deburau too. He held that crazed, rough crowd of the theater of sweat and red wine and gaslight on the Boulevard du Crime and made them feel poetry and pathos and tears as well as slapstick, when all they had known before were wire walkers and jugglers and acrobats, in an age when the theater audience was far from polite. They roared at him: "Speak, Pierrot! Speak!" But he would not utter a word. He was a magic character. That is what I seek too, to create a magic character.

WF: Deburau was sardonic, ironic, and tender. You must tell of the great event of——

MM: After he died, of asthma, just before the middle of the last century, no one could take his succession. No one could say everything without speaking, as could Deburau. He was the only mime who never spoke; and after his time the mimes began to speak and mime almost disappeared until Decroux. We would know nothing about Deburau had not Jules Janin, a journalist of genius, written his life. In 1918 Sacha Guitry created the play *Deburau,* and in the forties Marcel Carné created the film *Les Enfants du Paradis* in which Baptiste, played by Jean-Louis Barrault, is Deburau. And so Deburau lives on.

WF: Your Bip is very like him.

MM: Bip is Pierrot in the Space Age, meeting the problems of contemporary man. The little man. The man who dreams. Bip as Don Juan dreams he is Don Juan but he is only a frustrated husband.

WF: Bip matador is only going to milk a cow. But at the end he reassures the cow.

MM: Yes, he reassures the cow.

WF: That is very touching. Deburau was very different.

MM: Do you believe he killed the boy on purpose?

WF: Yes.

MM: He was an expert in what they called the *savate,* a sort of karate, a fighting on stage with the feet, causing pratfalls and such. And he was expert with the *bâton.* The *bâton* was

a stick with which they administered comic beatings called the *bastonnade;* of course they knew how to withhold the force of the blow . . . fake it. But Deburau's fellow actors complained that he hit with real force. They were told they could take it or leave the company; Deburau was the essential star; they were supernumeraries. Deburau was an unostentatious man but he carried a gold-headed cane. One day he was strolling with his wife in the environs of Paris when a young man, urged on by his comrades, called, "There goes Deburau, the mountebank of the Funambules Theatre." And he began to insult Deburau and his wife. Deburau paid no attention and walked on. But when he returned, the boy took it up again. "See the mountebank of the Funambules and his whore of a wife!" And he flung ordure at or jostled the wife. Deburau lifted his cane and gave him a short, light tap. The boy fell dead. At the trial, one group of lawyers held no blow so given, which didn't even leave a contusion, could cause death; another group held that he was the master of the *bastonnade,* and so . . .

WF: What happened?

MM: He was acquitted. Business boomed at the Funambules.

WF: You commenced by giving mimodramas in which Bip was merely one of the players, though the chief one.

MM: Yes, and I would like to do so again. But you cannot maintain a mime company without government subvention. We had, in 'seventy-eight, subvention for the mime school. Meanwhile, I seek by my solo mime to create a theater, not a cabaret act.

WF: What do you mean?

MM: The greatest danger playing solo is that you will fall into a cabaret number. I create a *theater.* I prove you do not need forty people to populate a stage. For example, in my case in the assizes, they are all there—the judge, the attorneys, the witnesses, the complainants—a whole stage, a whole stage full of people. And they are suggested, made present, by counterpoint, by reaction to them, by the space they displace, by illusion. Yes, I must say it, by magic.

WF: Marcel, will you ever talk?

MM: No. If I did, the great tradition of silent mime would be ended.

WF: You are the only mime who has never spoken. You and Deburau.

MM: Chaplin did not speak.

WF: Eventually he did In *Monsieur Verdoux*.

MM: Yes, but after the talkies came in he was often asked, ''Will you speak?'' There are many interviews about that. He said no, I will adhere to the greatest and most ancient art of the theater—which is mime.

WF: Marcel, define mime.

MM: You move toward a kind of preorgasmic suspension—a sense of the terrible suspension *just before* the movement: the touch just before the touch in making love—however, not release . . . which is catharsis of comedy or tragedy. The wire walker neither falls nor reaches the platform. *A world in suspension.* It is not situation comedy but akin to plastic art in that it obtains its force from avoiding easy resolutions in favor of the fusion of incompatibles. The *inevitability* of this fusion is the mark of the great artist, for the fusion is the measure of himself. Nevertheless, without difficulties and incompatibilities there cannot be this fusion. Ambiguity arises with closeness to truth. In spoken drama, tragedy may well find the hero inarticulate, rooted in silence. The audience may share this moment while it lasts, although the actor is bound—by the convention of his style—to linger no longer than is consistent with the truthful portrayal of a lifelike situation. The mime, however, is untrammeled by a naturalistic time and by place context. He may, for instance, choose to prolong the tragic moment while he probes beneath its surface to discover the innermost impulses which precipitate his character's crisis. He gives rhythmic expression to this in mime which grows purer and more stylized as the innermost recesses of the spirit are penetrated. The audience watches the smallest gesture as in a dream; the rise and fall of the actor's chest attains a new significance: the audience breathes with him—enters the moment—bare and wordless as it is. A posture—what I call an attitude. It relates to naturalism as poetry does to prose, but if it goes any further and becomes move-

ment it leads to dance. The technique is to make antinatural movements seem natural, whereby is obtained tension—the tension of the equilibrist. And style. If I can have a few touches of pure poetry—abstract—then I am satisfied with my program containing other numbers of the lifelike world that begin and *end*.

WF: Do you feel that the mutism can, owing to its effort to communicate, be converted into a *force* of communication?

MM: It is the shortest distance between two points. In speech there is the inevitable reversion to psychology.

WF: You have said to me that what is good in art is always good, but in what does that "good" consist?

MM: What I want is the *truth*!

WF: Do you mean *the pure*?

MM: I mean the unadulterated.

WF: Do you remember saying something to the effect that it is the *shape* that is the art? The shape innate in the artist. And you said vital energy was the cause in every genius; I have come to think of this as one of the coordinates of genius. Essential, that is, to genius, but not exclusive to it. Maybe the shape, however, *is* genius. I have been working lately with the tapes of Jean Giono made at Manosque. His later work, too, is made of contrasts, which move like quicksilver under the impellation of creative desire and control brought to intensity by counterpressure. I felt sure that here was something companion to the remarkable shifts from the realistic to the abstract in what you latterly do. But the long-held last moment of "Maker of Masks" or the groping arm from out of "The Cage," which suddenly breaks—I withhold for another order of inspiration. In the final moment, when the arm breaks, it dangles like a broken flower stalk.

MM: But, after all, *I do not want* to get out.

MM: Spoken drama essentially descends from the Greek, say from Aeschylus, and was the extension of religious ceremony, Orphic cult—therefore it was serious and essentially respected. So were the performers: they were often state pensioners. Mime had its triumph in Rome and was the buffoonery of Etruscans—then a defeated race and a race of

slaves. It was entertainment, not art, and obscene (and, incidentally, silent only because the Etruscans didn't know Latin). In the last century, in France, by government edict the mimes were not allowed dialogue. The old pantomime was dumb show (speech prohibited), whereas modern mime is expressive *attitude* (for itself), the difference between narrative and poetry. *Everyone* has followed this evolution: Goldoni, Chaplin, Deburau. From what one *does* to what one *is*.

WF: Is the white mask of Pierrot—now Bip—merely traditional with you, or necessary to the *dehumanization* of your face in the interest of the art effects of mime? It suggests *vacuity*, whereas Oriental or primitive masks add—tiger face, deity, et cetera.

MM: I want to continue tradition, yes. But the white mask *increases* expression. In the distances over the footlights. But it must be put on right. Put it on wrong and it is as if you cover your face with a pancake. Putting on the white mask is a *real art*.

WF: Do you improvise?

MM: No. Improvisation is impossible because one cannot simultaneously concentrate on instinct and art (subjectivity/objectivity). A mime must keep within his space, like the matador, corseted by his imagination, but you must always force the frame and never break it. Lacking music, the mime *sings* to himself as he works, and the gesture takes its rhythm from that.

WF: Define genius.

MM: Genius is perhaps to express superlatively *the human*. A street clown is closer to the human than an academician: the academician is manipulating art but a street clown is communicating—he *must:* he is not in a crystal cage. Nonetheless, he must be a street clown of genius: he must unlock what is within souls, not merely report. He must *overfeel* if feeling is to be felt. For me, the tragedy of the unknown genius is that he cannot be sure he will be known even after death. I think if such a man could know his work was to be known even after his death it would help—a little. But he cannot know. Van Gogh suffered this. I think, really, every man is alone.

INDEX